ART
THE IMAGE
OF
THE WEST

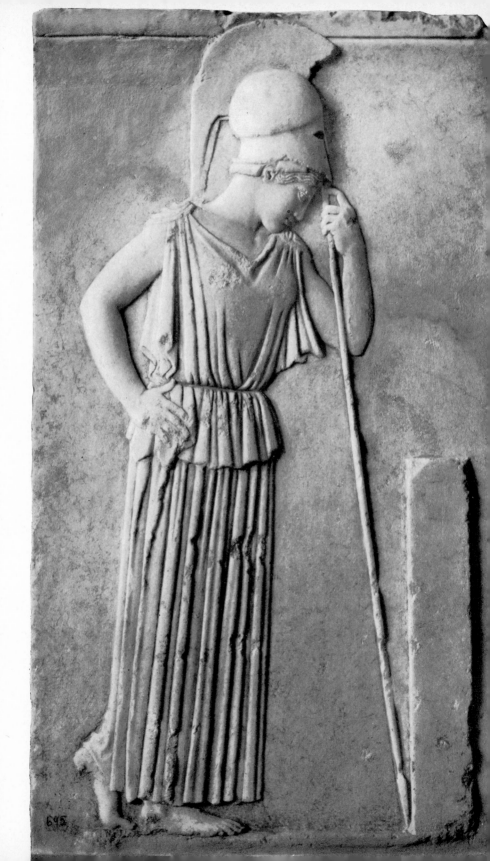

Julie Braun-Vogelstein

ART

THE IMAGE

OF

THE WEST

PANTHEON

MANUFACTURED IN THE UNITED STATES OF AMERICA

FOR PANTHEON BOOKS INC.

333 SIXTH AVENUE, NEW YORK 14, N. Y.

BY KINGSPORT PRESS, INC., KINGSPORT, TENN.

DESIGNED BY ANDOR BRAUN

CONTENTS

List of Illustrations

Acknowledgments

The translation of this book from the original German was possible through the help of several people. The gratitude I feel toward all of them cannot be expressed in words.

Mr. Norbert Guterman provided the groundwork of the nineteen chapters with a diligence and an understanding of their philosophical implications which paved the way for those who followed.

For the Introduction I am especially obliged to my friends Professor Charles R. Bagley and Mr. Wyllis Bandler, whose advice was sought and always generously given.

The rebirth of this book in the English language is due to Mrs. Marjorie Chadbourne Taylor. The relentless labor, the zeal and the love she bestowed upon this work, and her insight into the very essence of the theme have, to a great degree, made the English edition her creative work.

J. B.-V.

Grateful acknowledgment for the kind permission to reproduce photographs is made to the following individuals and institutions:

Fratelli Alinari, *Florence:* 1, 2, 3, 4, 10, 18, 34, 37, 44, 52, 56.—D. Anderson, *Rome:* 13, 30, 35, 38, 41, 42, 46, 54.—Archives Photographiques, Palais Royal, *Paris:* 57, 61.—Direktion der Bayerischen Staatsgemälde-sammlungen, *Munich:* 45.—Mr. Wyllis Bandler, *New York:* 19, 20.—J. E. Bulloz, *Paris:* 23.—The Byzantine Institute, *Boston:* 15, 17.—Mrs. Meric Callery, *New York:* 64.—Mr. A. Camoin, *Paris:* 55.—Deutsches Archäologisches Institut, *Rome:* 12.—Benno Filser Verlag, *Augsburg:* 25.—Gesellschaft für Wissenschaftliches Lichtbild, *Munich:* 32.—Giraudon, *Paris:* 27.—Mr. Walter Hege: 47, 48.—Houvet, *Chartres:* 28.—Foto Marburg, *Marburg:* 5, 7, 8, 21, 22, 26, 29a, 29b, 31, 33, 40, 50, 51.—The Metropolitan Museum of Art, *New York:* 9a, 9b, 16, 43, 58, 60.—Museum of Modern Art, *New York:* 62, 63, 65.—H. Roger-Viollet, *Paris:* 24.—Kunstverlag Wolfrum, *Vienna:* 59.

ART
THE IMAGE
OF
THE WEST

Τό μήτ' ἄναρχον μήτε δεσποτούμενον

Neither Anarchy nor Despotism

Æschylus, EUMENIDES, 696

Introduction

ART is the first evidence, the archidiom, of man's being. Indispensable as a medium of expression even in primitive times, it has remained so down the ages, never supplanted by either the spoken or the written word. Voicing the otherwise unvoiceable, art both precedes and exceeds conscious awareness, telling more than man himself knows. A word indicates, stands for something; a work of art *is* what it signifies.

Poetry, with its special rhythm, its sound relations, word groupings and associations, has a reaching power beyond that of ordinary speech. However, inasmuch as all verbal expression differs with different peoples, one and the same word often changing its meaning with the passage of time, language as a whole is no guarantee of true communication.

Art also is subject to change, but artistic form is a constant, universally intelligible for the reason that it is what it means. In spite of this, we rarely accept art as self-evident, turning rather to literary sources for its interpretation and thereby diminishing or falsifying its significance. While a work of art may reflect the outer historical fea-

tures of its period, it also, and more essentially, objectifies the inner image of man. As subtle as it is self-revealing, art requires, if it is to be understood, a way of seeing altogether different from our usual viewing of historical events.

If, on the other hand, art is approached from a purely aesthetic point of view, its full meaning is lost. This meaning, ever present in a work, is apparent only to those who are ready to respond to it. Such perception demands an act of the whole being. The senses, confronted with the form and taking hold of it immediately, see as the spirit sees.

Once this has been experienced it is not difficult to discern the order in a given work of art. The opposite approach—that is, proceeding on the basis of a pre-established method—never leads to the essential but rather to those peripheral features which are always more apparent in empty or academic works than in masterpieces. Art can no more be reduced to a formula than it can be created by one. Some method is clearly desirable, but it must be of a kind that comes to grips with its subject and not one that side-steps the problem at issue.

The form of a work of art may include laws already known and yet evince a new system of co-ordination in which elements incompatible in other fields are reconciled. Such a system enters under no standard classification. If, on the contrary, the form of a work has no relation to known laws, or if the connection is concealed, any attempt at categorization is useless from the start.

There is also a third possibility: out of the shifting balance of forms within a total form, out of the collectivity of interdependent parts, a complex order may arise which can only be grasped in its own terms, as a unit.

Works of art in which various elements seem haphazardly combined rather than integrated are not for that reason without meaning. Component parts may be mere fragments of one figure or another, and the design still have an intrinsic coherence. The logic of art is not that of the mind. When, on the other hand, the structural relations in a work are perfectly consistent to the eye, the form itself may surpass them and, extending into the unknown, intimate a transcendent reality. This does not lend itself to theoretical exposition unless the term "theory" be understood *theoria*—a beholding, in the Greek sense. What appears in the artistic form cannot be expressed apart from it. The inherent unity of percept and concept in art should be reformulated before those principles underlying a work are discussed.

Never a metaphor for a concept, art is the archutterance of a living depth otherwise doomed to silence. Thus, artistic expression is irreplaceable; it is the very language of man's self.

Without it we would have to depend for our knowledge of man on his all-too-conscious telling of himself; through it something much more basic can be apprehended— man's attitude toward the world around him, within him, and beyond him, toward the world of appearance, experience, and the unknown. Shifting down the centuries, this

attitude is operative in all the deeds and thoughts presented to us in history, but history alone cannot convey the attitude itself. An attitude is an implicit inner direction, a motive stance. And this motive stance is purely manifest only in the work of art. Only there does it escape man's silent self, only there does the universally subjective—for it is ultimately common to us all—assume objective form. The material is penetrated and transmuted into the archimage of that inner reality. A work of art, no matter what its purpose, shows the direction in which man turns his face. This motive stance determines style; imprinted in the form, it is autonomous in art alone. Even a single work reveals a basic attitude evident nowhere else in the fullness of its many-leveled, many-sided relationships.

Form, of and by itself, contains and imparts content. If by "symbol" we mean a figure with no resemblance to what it indicates but only an agreed-upon connotation, then the symbol has no place in art. Even emblems—abbreviations for ideas—are only incidental. A sign attains to the rank of art only when, as an integrated element of the form evoking that for which it stands, it speaks directly to the untrained eye.

There is in art a great diversity throughout different cultures and periods in the regard paid to the empirical world of facts and events. Sometimes "reality" in the most obvious sense is all but ignored; sometimes it seems to be closely adhered to until, on examining the style, it becomes clear that the actual features of the period are

represented only in a very general way. Artistic form says both more and less than any other record—more because it includes the longed-for, the not-yet-realized, less because it treats not of the given, the factual order, but of the order of things in terms of their meaning to man.

Classified according to essential human attitudes, art styles fall into six categories.

The first shows the inanity of life, life itself appearing as an instinctual drive. Through the misshapen, the monstrous, this style offers a picture of the chaotic forces assailing man from within and without, while the sense-perceived world is represented as illusory, meaningless. Many works in Indian art give this impression.

The second style is order itself, as if the function of art were but to mirror an *a priori* harmony, a universal and sovereign equilibrium. In the face of this, any original creative conceptions would be superfluous, even arrogant. The style is elusive, evocative, irreduceable to fixed proportions. Floating or swinging calmly in unheard-of rhythm, this art reiterates its own eternity. Chinese painting shows what high values can be achieved within the established range of such an attitude.

Dreamlike is the order of the third style, presenting a realm of fantasy where every freedom is accorded to the play of form and color. Here no conclusions can be drawn as to the historical realities of the period. Such a turning away from reality, however, is in itself indicative. Aloof from conflict, the Islamic imagination runs riot, transforming everything into an ornamental design. Persian

miniatures in particular take even the wildest and most cruel scenes into the heart of fairyland.

The fourth style offers the supersensory as the real, objectifying a human attitude which takes the Absolute as the one and only value. Form, divorced from any scene familiar to the eye, does not appear to have penetrated the material or to be wedded to it, but exists as a vision of compelling power. The technique of its construction veiled, all solids divested of their material effect, this art stands as a revelation of another world. Thus, the Christian churches of the East reveal the miracle forever taking place, the transcendental eternally present.

The fifth style, governed by a rigid mathematical order, controls everything in art, even to the manifestations of life itself in the sculptured body. Variations are restricted to the barest minimum, the scale of values is forever fixed. Here the basic attitude is unmistakable: submission, not to an instinctual drive, but to an unfeeling abstract ordinance allowing no challenge, a tyranny from which there is no escape. Under this relentless rule Egyptian art arose and proved its might.

Besides these five styles with their implicit attitudes there is a sixth, the Occidental, which cannot be classed with the others as it overlaps them all. In spite of the mutability of its forms and the highly individualized signets of its great masters, Occidental art retained its inherent character. For more than twenty-five centuries it concerned itself with the human dilemma, intent on giv-

ing it form and thereby visible meaning. Out of the world's confusion, the petrified and the constantly moving, out of the tension between life's insufficiency and man's yearning for fulfillment, artistic form comes incessantly into being. Bridging the gulf between man's inner and outer reality, it retains elements of conflict, but they stand in a new relation to one another as parts of a created whole. This art springs neither from the given world nor from the pure imagination, but from that power in man which enables him to overcome his own limitations as well as those of existence itself. Appropriating some of the skills and techniques of the Orient, the West adapted them entirely to its own ends.

Despite its many forms, Occidental art is characterized by one enduring and persistent theme. The question behind it, re-posed again and again, is answered by style after style. Between the limited existence we have and the limitless state we desire, the tension can never be wholly resolved, there can be no final solution. This basic problem has been the greatest single source of energy for all stylistic changes in the West. Whether the challenge can be met again today remains to be seen. Inasmuch as the meaning of styles is beyond time and bears witness not only to Occidental man but to mankind, a study of art and its value for the West may be of help as an approach to the future.

The multiplicity of artistic forms would seem to preclude a general theory of style. However, as art is a syn-

thesis of man's entire inner being, the mind, with its power
to synthesize, should be able to make a theoretical in-
tegration of art forms.

The term "form" as used in philosophy, is badly in need
of revision because of the revolutionary changes of concep-
tion called for by the new developments in physics. As a
prelude to this, a reinterpretation of artistic form is at-
tempted in this book. While Western art has been dis-
cussed over and over again, it will be treated here from an
essentially new standpoint.

In the course of writing this book, a vast number of
works have been studied, relatively few of which have
been included, lest the reader become lost in a maze. Dis-
tinctions have been drawn as to variations within the same
style and different styles within the same period. A life-
long intimacy with every branch and style of art has led to
this study and may serve others in their search.

No universally valid criterion can be established for the
comprehension of art forms. Each style—and ultimately
each work of art—has a countenance of its own, the sum
of whose features is never identical with the whole. What-
ever preliminary period of contemplation a work of art
may require, our grasp of it when it comes is immediate.
Comments and explanations can lead us no further than to
the threshold of experience. If we are ready, the door
springs open of itself; if we are not, nothing can force it.
Form reveals itself solely to the intuition. Not until one
has met a work of art through one's own direct perception

—and there is no other way—can one correctly analyze its structural components.

If art is the expression of the otherwise inexpressible, how can its meaning be rendered, save in poetry? If a work of art *is* what it signifies, no interpretation of it should be necessary. However, it is not so much an explanation of art that is offered, as a further way of seeing. A re-evaluation is attempted in this book, by which art may become more effective in exercising its inherent formative powers on man.

Even the best photograph must fail to convey what only a genuine work of art reveals: its immeasurable dimension. Where the original lacks subtlety, a photograph may be adequate, but a masterpiece is likely to be distorted rather than illustrated when it is reproduced. Language, despite its shortcomings, may succeed in communicating to the mind's eye those specific qualities which evade the camera. Thus in this book the pictures play only a minor role as an accompaniment to the text.

1

Greek Architectural Forms

*Structural forms in Greece combine strict meter with
free rhythm, pattern with spontaneity. Tension is not
avoided, conflict not eliminated. The Doric and the
Ionic style, each in its own way, embody the Greeks'
conception of an order appropriate to man.*

THE Egyptians derived their architectural forms
from geometric figures and plant motifs. Mathe-
matical law was given perfect expression in art
before the middle of the third millennium. The Gateway
of King Chefren's Tomb Temple consists of rectangular
pillars precise in structure and spare of form. A rigid rule
governs everywhere. The so-called proto-Doric columns of
the Benihassan Rock Tombs, actually round pillars, are
equally subservient to a geometric formula.

Plant columns, on the other hand, follow the natural or-
der. Within these limits certain variations were possible,
but the form remained arbitrarily decreed.

Ornamental and decorative design was determined by
the same rules. Geometric patterns were strictly calculated

down to their elements and the linking of their parts, while flower motifs evinced the natural order.

Ruling with equal force, the geometric and the standard plant type completely dominated Egyptian art; nor did they conflict with one another. The Lily Pillar of Karnak conforms to both orders; shaped as a rectangular block, it is decorated with plant reliefs.

The Egyptian style, adhering to this dual principle, developed early and lasted practically unchanged for thousands of years.

The Greeks, repudiating any such rigidity, sought for an artistic form independent not of the natural order, but of bondage to it, not of geometric law, but of its finality. They strove to find and objectify a principle appropriate to man, in architecture as everywhere else. While searching for that basic unity which to them was the source of all things, they conceived of a whole wherein each element would have meaning. As mathematical law was incontestable, they used it to direct, but not to decree, artistic form. Certain laws are evident in standard geometric types; but Law, to be conceived as universal, must be implicit everywhere.

Rebelling against tyranny of any kind and aiming at autonomous form, the Greeks created a new realm in art. Yet before they attained to real freedom, they showed themselves, in architecture as in life, unruly and imperious. The Temple of Apollo at Selinus is overbearing in its proportions, the Temple of Zeus at Akragas (Girgenti), the embodiment of *hubris*. Though the giants hewn out of big

stone blocks are here represented as slave laborers, the hugeness of the temple itself shows to what an extent the gigantic outlasted the rule of the giants.

The wars against titans and giants, recounted in Greek myth, were actually fought in architectural terms during the fifth century B.C. In those temples at Akragas and Selinus massive blocks and enormous columns rose up against space, as if to take it by force. Thus the Greeks pitted sheer violence and disproportionate size against the immeasurable. Shortly afterward true greatness triumphed over the merely huge, the majesty of the sublime over arrogance; many ruins still testify to that evolution of form, that victory of the creative spirit.

Is the difference between those early exaggerations and the balanced temples, built slightly later, only a matter of mass and measure? Critics, baffled by this question, have sought the answer in ancient Greek writings, Plato's above all.

Save for certain passages, Plato is either vague with regard to appropriateness or else he claims that that which is "appropriate" is so by virtue of its standing in a "true" relation to the "indefinable." If appropriateness depends for its definition on an indefinable, then as a concept it is meaningless. Those who attempted to define it, in antiquity and in more recent times, interpreted it as the "golden mean." While Plato rejected the notion that essential knowledge can be conveyed in words, we tend to take words at their face value and art as a kind of marginal comment, an illustration of something already known.

Since the Greeks were the founders and masters of philosophic exposition, it is assumed, in spite of Plato, that their concepts completely embrace their insights. Concerning the appropriate, this is clearly not so. Plato's examples give only specific instances of appropriateness, not appropriateness as such. Knowledge of the appropriate can be attained neither by deduction nor by induction.

Art, however, resolves this dilemma by presenting a universal within a particular, created form. This is evident in the Doric column, which, appropriate to both its structural and artistic purpose, fulfills its function as if pursuing a vocation.

The Doric column attained significance when in the mature style it became an expressive member of the architectural community. Apart from this whole, it has no standing. The columns are set on the stylobate, their common base, not merely as supports rigidly resisting the weight of the entablature, nor, as in Egypt, disguised as plants and bearing their load furtively. Ennobled by their work, they soar with a motion of their own. Erect and fluent, the Doric shaft expresses free energy in its buoyant ascent, life and vigor culminating in the capital. Proportions, while carefully calculated, are not fixed but in each instance artistically rediscovered and thus vary slightly with each temple.

The building itself is sufficiently regular to indicate a mathematical principle, but it also appears to follow its own impulse. The autonomous and the decreed complement each other, suggesting a free acceptance of the law.

The particular and the universal, thus mutually clarified, evince their interdependence.

Though the joints of the stylobate regulate the whole structure as well as the distance between and the thickness of the columns, the style itself is characterized by the interaction of this rigorous meter with a spontaneous rhythm, just as music has measure and melody. Since the metric relationship can be computed, theoreticians and historians have judged it to be the decisive factor. Hermogenes, according to Vitruvius, rejected the Doric style because it was not conducive to a strictly regular arrangement of metopes and triglyphs in the frieze. To a Hellenistic architect, this perfect regularity may have been desirable—even the hexameter in those days was forced into a rigid pattern—but for the Doric architect of the fifth century B.C. the relation of rhythm to meter, freedom to law, was the essential, and not mere mathematical precision.

In the columns and in the groups represented on metope and pediment, metric and rhythmic elements blend; the stylobate, the triglyphs, and the gable triangles are specifically geometric. Thus a tension is created between the spontaneous and the decreed, between rhythm and meter. With the Doric style the column becomes a vivified form, whereas the animated figures on metope and pediment suggest a certain discipline, however furious their positions of attack and defense. Tangled and strained, they follow, as of their own accord, an almost geometric but never repetitive pattern. No strict symmetry is observed;

men, centaurs, and animals are not standard types, yet the movement is as orderly as the steps of a dance. The figures space and enliven the area; every stance of leap and assault is in keeping with the mathematical frame.

The triglyphs are always identical, the scenes on the metopes always different; the one is geometric, predetermined, and fixed, the other lifelike and unpredictable. Of the two alternating elements that compose the frieze, it is the static pattern that yields—though but slightly—to the vital order. There are certain small deviations that mitigate the severity of horizontals and verticals in the temple. These, as well as the diminishing intervals between columns toward the corners of the peristyle, serve to correct optical illusions; they also have a specific bearing on the intrinsic proportion of the building as a whole, a proportion that, based on the unfathomable relation between mechanical measure and free rhythm, cannot be calculated. The movement of the groups on metope and pediment, however dramatic, relates to a mathematical law, evident even when one group is isolated from the rest. The sculptures possess their full form only within the framework of the temple inasmuch as they refer specifically to the space they occupy. When these triangles and rectangles combine with the flowing life motion, they lend it an impersonal dignity, while the life motion in its turn imparts some of its animation to the rigid geometric design. This interplay of elements suggests a law which embraces both the free and the determined.

While meter and rhythm combine in the frieze, they

unite in the column, which has an inherent proportion of its own, not to be confused with volume and scale, but evident in its stance and *élan*. The columns on the main level are perfect, the smaller ones on the second level strangely inappropriate. Their reduction in size deprives them of essential form. Though the grandeur of a work of art does not depend on its size but on its intensive magnitude, each form calls for a specific size and is rarely amenable to change without loss of character. Today, we are so accustomed to reproductions that we tend to overlook the distortion involved.

As the Greeks' sense of the appropriate was evident almost everywhere in the mature Doric style, it is all the more surprising that they placed those dwarfed columns on the second level above the well-proportioned ones. This inconsistency may be partly explained by the fact that the small ones played only a secondary role in the temple, but it also shows that artistically the Greeks considered the interior of a building far less important than its outer form. Conceiving of space as a void to be filled, they saw the intervals between columns only in terms of the solid structure and not as spatial forms in their own right. For us, who value formed space, this disregard of it is hard to understand. To the Greeks, however, only the definite spoke.

The Ionic column, unlike the Doric, has a base of its own and is heterogeneous as to form. Its diverse parts can be studied separately in the early Naxian column at Delphi.

A fluted cylindrical shaft, crowned with a wreath of

leaves, rises from a built-up base. The leaf capital does not, as it does in Egypt, represent any particular plant. Across the top of the leaf crown lies a rectangular slab,

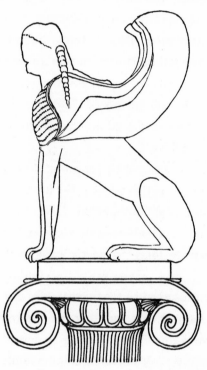

Capital from Naxian Column, Front View. DELPHI

narrower in width than the wreath and overlapping it in length with a spiral curve. This slab, supporting the votive figure, appears to be merely superimposed upon and arbitrarily linked with the leaf capital. Originally the column seems to have consisted of base, shaft, and crown; only later was the volute added to carry the offering. The

whole is a multiform sculpture, each of its parts clearly defined. Though the winged palmettes help to mitigate the contrast between the round and the rectilinear shape, the conflict remains.

When the column stands in a temple, this discrepancy is further accentuated inasmuch as the slab, instead of bearing the sphinx, supports the straight entablature. Its

Capital from Naxian Column, Profile View. DELPHI

spirals make it akin to the leaf pattern of the capital, but in terms of shape the oblong slab and the circular wreath are incompatible.

This incongruity could have been avoided. A rectangular pillar would have been in keeping with the slab, or a square slab, like the plinth on a Doric column, would have fitted the round shaft perfectly. A third method was developed by the Aeolians: the leaf crown was made to rise into a spiraling flower oblong in form that would carry the beam. Apparently none of these solutions satisfied the Ionians. They chose not to evade the conflict but to give it meaning. An active relationship between discrepant forms

was achieved by giving a slight curve to the otherwise level slab. The point was to prove that co-operation could be established in spite of basic differences; the wreath became more stylized, the slab less rigid.

A flower or a wreath of leaves is scarcely appropriate as a support for an entablature, though this never bothered the Egyptians, who stressed the crown of their plant column and concealed its function. While the Aeolians sidestepped the real issue, Mnesicles, working in the Doric style, dealt with it in his Ionic columns in the central structure of the Propylaea. Here the volute almost hugs the shaft and, vying for importance with the wreath, receives the silent mandate of the column and passes it on in an eloquent flow of lines. It is in this spiraled slab that the upward-tending energies of the shaft are released and its function is made evident. Graceful, the column stands as if independent, its vital role expressed in the volute's response to the weight of the entablature.

In the north hall of the Erechtheum the volute has definitely become the capital, serving both as support and crown. It embodies the relation between functional and autonomous form, complementing the column with an elegant gesture of participation, while its spirals give a pantomime of the forces at work.

In the Caryatid Porch the human form itself stands for resilience and support. A circular wreath of leaves is inserted into a square plinth with an intermediate ring adjusted to the head. While these structural elements are not incompatible, a certain tension is sustained by the juxtapo-

sition of the architectural design and the caryatids them-
selves. Thus Ionic temples always contain a strong element
of contrast. This is due to the stressing of particulars and a
predilection for complex forms. Should it still be con-
tended that the Ionic volute derives from the Egyptian
plant capital, the problem remains as to why the Ionic
shaft should not have been given a round instead of an
oblong crown, and why such a flagrant discrepancy should
have arisen in the first place and endured.

In a peripteral temple this conflict threatens to ruin the
effect of the whole building. The side and front views of
the volutes are utterly incompatible and, when seen in the
same row of columns, distort the view. The corner capital,
in spite of the many attempts made to modify it, became
an insoluble problem.

While this problem is always treated in the Ionic col-
umn, the Corinthian avoids it entirely. The round capital,
its spirals nonfunctional and scarcely to be seen, is en-
circled by quasi-naturalistic leaves. Thus it lapses from
the structural rank of the Ionic capital into a purely deco-
rative form. Shaped like acanthus shoots, the leaves un-
fold around the bell and reach up to those tiny scrolls
posing as supports to the architrave. The structural body
is thus obscured and bears the load in concealment. There
is actually no Corinthian style; the architecture is basically
Ionic. Instead of expressing the function of the column
artistically, the Corinthian capital is purely ornamental in
character and thereby changes the whole appearance of
the building.

The Doric temple is characterized, in its frieze as in its column, by the interplay of dynamic and static elements. In the Ionic temple all tension is concentrated in the column. The Greeks were driven to the Sisyphean labor of attempting to resolve the discord of the corner capital not by decree but by their innate yearning to preserve the autonomy of individual elements within the whole form. In the Doric temple it was the whole that determined the parts.

Structural supports in Greece developed into free artistic creations. Neither patterned after nature nor subject to a mathematical formula, they present us with a fundamental attitude toward life. The Egyptian pillar submits to necessity while performing its function; the Greek column proclaims its active participation in the architectural community by its stance and *élan*. It stands as the embodiment of a universal value, the Greek concept of a task appropriate to man. The difficulties inherent in the reconciling of the ever-identical and the movement of life, or the tensions resulting from the existence of heterogeneous elements within the same structure—none of these were passed over in silence, but recognized and voiced as inevitable.

The integration of law and freedom meets with no obstacles in the abstract, but to represent it in solid form involves coming to grips with every kind of problem. Neither in Doric nor in Ionic architecture are freedom and law completely reconciled; the Greeks, however, saw no reason to relinquish an objective consonant with man's

creative spirit. They sought to render a valid and dynamic relationship between man's longing and the laws that govern the world. The degree to which they succeeded is evident from the actual and the inherent proportions characteristic of their art.

2

Greek Sculpture

Greek statuary by fusing geometric and organic forms imbued the human figure with permanence. Dramatic scenes were rendered in stone long before drama was written and performed. By integrating the shadow in the sculptured face the Greeks accepted man's tragic fate. The Specific Relief Style related the defined and the known to the undefinable and the unknown.

THE free-standing statue, threatened with invasion by formless space or lost amid incompatible surroundings, has always presented a challenging artistic problem.

The Egyptians solved it by encompassing the figure in an abstract rectangular container that defines its physical circumference. This intangible geometric frame protects the statue and gives it a space of its own. While such a boundary leaves little room for variety of posture, it allows nonetheless for lively characterization. Limbs and joints often appear on the verge of motion, the head is carried freely, and the features are eloquent.

The formal principle thus imposed from without exempted the statue from chance and invested it with imperishable form. Mastering the style skillfully, the Egyptians did not succumb to the sheer weight of mass, as did

some of the primitives. In this way the human figure as a
form acquired an absolute status and character. The statue,
subject to mathematics, participates in a lifeless, hence
deathless, order.

The Greeks solved the same problem very differently.
They established a mutual relation between organic and
geometric form. The *Hera of Samos* is a prototype of Greek
statuary. The subtle curves of the body enliven the cylin-
drical shaft, while the cylinder in turn instills the human
figure with an ageless composure.

In the Egyptian statue the implied geometric frame is
extrinsic and sovereign to the build; in the *Hera of Samos*
the geometric type is intrinsic and constitutes the rectitude
and austere bearing of the body. The dense columnar
shaft of the *Hera* is not inexorable as is the Egyptian
statue's superimposed and intangible confine. In the *Hera*
a new authority, that of organic form, is implied, upheld
by the geometric standard. There are other archaic statues,
compact and based on a similar shape, that suggest per-
manence, changeless being as conceived by Parmenides.
Though some of them equal the *Hera* in terseness, none
can compete with it in intensive magnitude. With the
Hera of Samos, the theme of Hellenic sculpture is an-
nounced.

The Greeks first attempted to animate their statues by
giving them the signs of life rather than the living form.
They decked them with curls and pleated draperies, add-
ing a strained smile as facial expression.

As a group member within an architectural setting, the

statue began to acquire a life motion of its own that was later transmitted to the free-standing figure. The pre-eminence of group sculpture is indicative of the Greeks' concept of man as a member of society. Only the image of the deity inside the temple remained utterly alone; single statues elsewhere appear to communicate, if only in soliloquy. As a rule, figure refers to figure either by action or by attitude.

The grouping of rounded sculptures is a creation of the Greeks. In other countries scenes were depicted only in relief, painted on walls and panels, or, as was frequently done in Egypt, several statues were placed one beside the other, linked physically but otherwise quite unrelated. Greek figures, on the other hand, act in concert or meet in combat; a passion for the human body and for artistic expression gave rise to this lively group representation.

Pediments and metopes, for a time covered with painted plates, were later decorated with sculptured imagery, either with massive, fully rounded figures or with high reliefs. These two artistic genres led to the development of sculpture in action. The outline of the relief is more distinct than that of the statue, its movement more clearly defined by virtue of the background, and no gulf separates one figure from another. The Specific Relief Style, an outstanding creation of the Greeks, was rarely used on buildings as its subtle qualities were not effective from a distance. The empty space of the pediment and the interstices between the triglyphs called rather for vigorous three-dimensional bodies. When first introduced, these

were isolated; later they were combined into groups, as had been done formerly only in relief. Thus a new form of art came into being. The life motion implied in merely structural supports, such as the Doric column, was now brought to full expression in Greek temples where sculpture in the round had a place of its own, a field of activity.

Long before Aeschylus created the tragedy, these dramatic scenes were enacted on the pediments of temples—myths and legends, always present to the eye. While sculpture deals only with selected events, it may avail itself of any number of actors. Could Aeschylus, originating the drama, have been inspired by what he had seen on the temples? In any case, the pediment constituted the first stage for the performance of legendary and historical events.

On the Temple of Aegina single sculptures are still separate; they do not, however, imitate life, but render it. Each has its own posture, its own gesture of attack or defense, each plays its part, striding, running, thrusting, falling. Yet, despite this expressive pantomime the composition is tenuous. It is as if the actors, halted in the midst of battle, were under some inexplicable spell. The figures, though in motion, have not yet attained to relation.

On the western pediment of the Temple of Zeus at Olympia figures are no longer isolated, but united by a close formal, sometimes tangible bond. The reclining, squatting, or crouching figures at the corners, though representing onlookers, participate in the action, while in the violent scenes the figures embody the action. The arrange-

ment is never forced, the tension never relaxes. Indeed, as one continues to look, it seems to mount, though always within the limits set by the design. In order to grasp the role of meter in dramatic effects it is necessary to understand the relation of the individual figure to the general movement.

In the group of the centaur and the kneeling Lapith girl, bestiality is sharply contrasted with grace. Hewn from a single block of stone, the two figures are chained, welded together, presenting a direct clash of irreconcilable extremes. Yet the impression is a gratifying one. The two figures belong together, not by nature, but by form: they compose an almost symmetrical pattern. As if in process of transformation, the group is in a state of fluid equilibrium, its shape verging on a trapezoid or rhombus. Neither the geometric type nor the outcome of the struggle is definitive. The ornamental design is the stable counterpart of both the drama and the forces involved, playing the role of the disinterested or neutral actor. Through contrast and parallelism it emphasizes the vital form, divests the scene of all contingency, and objectifies without depersonalizing it. In this way the group responds, even amidst the tumult of battle, to the mind's demand for order.

Brutality and lyricism are freely expressed. The girl is as pliant as a flower, yet unyielding, the socle of her body widened by the upraised heel and advancing foot, the lightly curved double arc of hip and rounded knee suggesting that the strength of rising is in her. The sharp contrast between the two is not so much in their faces, as

in the centaur's massive trunk and the woman's delicately articulated body. She not only pushes the centaur back with her hand, but pushes herself away from him. He is about to seize her, pulling her by the hair to carry her off. Her gesture of defense and his of attack are almost identical, this ornamental accord further accentuating the contrast. The girl's dignity is in her lucid form and in the clear design of body and face, while her essential attitude is in the quiet inclination of her head as she avoids the centaur's fist. A youth intervenes, rushing diagonally toward the ravisher. This opens a new phase in the combat; the vital rhythm varies, the meter is sustained.

Beside the kneeling girl another Lapith comes to grips with a centaur, fending him off and threatening to slay him. Several such scenes interlink, constituting the various stages of the struggle. Apollo stands calmly in the middle, determining its outcome with a single gesture. The tension of the work is controlled by the firm design that permeates the scene as a whole and each of its component groups with an ordering meter. Unlike the stereotype arrangements of figures on Assyrian or Persian friezes, the organization of these pediment groups allows for impulse and never stifles the movement of life.

While the sculptures of the Temples of Aegina and Olympia show human or subhuman figures engaged in individual or group combat, the Parthenon pediment treats of the life of the Olympian gods. The birth of Athene is represented and her peaceful triumph over Poseidon symbolized by the olive tree. Of the three female figures, "the

three fates," on the eastern pediment, one reclines against
her companion, alert in every limb; the other two are
seated, as if ready to rise at any moment. Their forms are
saturated with life, their robes fluid; each figure has its
own motion, its own character, while a common outline
blends the three bodies into a group. Following the slant-
ing border of the pediment, the movement nonetheless,
like the rhythm of free verse, goes on unconstrained.
Viewing this group in a museum today, one tends to for-
get how closely it refers to its absent frame. Only by
imagining it in the original setting does one realize that
the composition corresponds to the pediment outline. No
longer ranged in a straight row in the foreground as for-
merly, the figures are variously spaced so that the light,
fluctuating, further animates the form.

The famous *Hermes* of the Belvedere, praised by
Winckelmann, though less mutilated and visible in action
from several sides, cannot compare with the Parthenon
Hermes, who, without arms, legs, or head, gives an im-
pression of completeness, the fragment signifying the
whole. The *Iris* on the western pediment of the Parthenon
has such an *élan* that she seems to sweep forward, wing-
less, self-sustained, powerful. Greek sculpture no longer
represented life by means of drapery and emphatic ges-
tures alone.

Faced with new problems concerning sculpture in the
round, by its relations to the pediment, the Greeks were
stimulated to new solutions. On the Parthenon the corners
of the triangle, instead of delimiting motion, stressed it.

Helios with his horses seems to rise out of nowhere, Selene sinks into it, already half lost. The pediment groups filled a fairly wide area, while the metope figures occupied small rectangular fields all around the building.

On Temple C at Selinus the sculptor forced horses and chariot into that space; on the Heraeum the design is perfectly consistent with its setting. The solemn moment between Zeus and Hera is intensified by the shadow, falling like a pause between them. In the Actaeon group, motion predominates, the hounds performing all kinds of leaps, as if independent of the background.

The interplay of scenes and their geometric borders is evident even in the isolated metopes from the Temple of Zeus at Olympia. The few broken gestures that remain of the figure of Heracles are enough to indicate him sweeping out the Augean stables. The full impact of his motion is in the spread of his limbs as he prepares to swing forward. His stance marks a parallel to the diagonal of the rectangular frame. Very erect, Athene, watching over him, further stresses the geometric figure, her outstretched arm recrossing the sculptural area. Here the blending of the mathematical and the vital element produces an order in which both are preserved and each is transformed.

A few metopes from the Parthenon have survived. The figures are carved almost completely in the round, deep shadows setting them off from the background. The conflict between man and centaur is presented ever anew, the bodies coming to grips differently in each group. The shadows on the smooth panel accent the fury of the fight, solid

and immaterial forms locking in combat. Intersected by the triglyphs, which act as metric bars, various groups recur in a dramatic procession around the temple, constituting an integral form of freedom within order—the norm, as conceived by the Greeks.

These works in themselves refute the view that the measure or norm at which the Greeks aimed was the mean, the average. The architectural and the sculptural, the metric and the rhythmic elements are not intrinsically related; the problem of how they became compatible as parts of a whole is insoluble at an abstract level, and resolved only in art.

These fifth-century works may be severely damaged, but the works of Scopas in the Temple of Tegea are literally in fragments. Nevertheless, had we no other sources, these relics would still be enough to give us some insight into the nature of tragedy.

It is the body in the Parthenon sculptures that gives the movement of life; the few heads that remain have but a statuesque repose. On the western pediment of the Temple at Olympia the faces of the centaurs are distorted by lust or agony, while those of the Lapiths express fortitude. Noble beings were not supposed to betray anguish or strain in representative art of the fifth century B.C. It was *ethos* and not *pathos* that was sought. With Scopas another conception came into being in sculpture, and suffering gained a new nobility by the achievement of *ethos* through *pathos*.

In Sophocles' drama, Heracles urges Philoctetes to be-

come venerable through suffering; Scopas rendered suffering as a challenge to the human spirit—the sovereign agent of man. The ineffable is communicated in a certain kind of gaze, and this intense and expressive look he gave to his sculptured faces. No colored stones remain, nor is the effect produced by any shiny material; the eyes are of the same marble as the head and limbs. A head of Scopas, today at least when the paint is gone, is a blind thing; the eyes have no pupils, yet they look and see as if meeting the eyes of Fate. Instead of illumining he darkened them by projecting the forehead till shadows collected in the sockets, and it is this shell of shadow that gives the gaze a depth suggestive of the intangible. Darkness itself is made to speak where any artifact of the living eye would have failed. Here, shadow elucidates meaning and grips us with its tragic power. The form of the brow and the bearing of the head give answer to Destiny. To whomever the head be turned, it makes a reply. Alone, it evokes an adversary, whether human or inhuman. To this encounter between man and Fate, Scopas gave visible form. He created the face of this drama, its telling face. In later styles the carved figure was modeled with light and shadow falling on it at random; Scopas made shadow an integral part of sculpture by presenting it in the human countenance as a sinister force from which there is no escape.

Both in architecture and in sculpture the close relationship between geometric and artistic form is characteristic of Greek art. Hellenic sculptors produced artistic parallels to Harmonia, daughter of the highly incompatible gods of

war and love: Ares and Aphrodite. Greek thinkers sought knowledge in the hope of discovering the origin of the world, while Greek artists sought the fullness of life. In the statue they infused the human body with imperishable form, thereby creating a deathless image of man.

A fragment possibly from a work of Scopas (Metropolitan Museum in New York) reveals the various elements that Greek art blended together, enabling us to distinguish between the values that give this style its form and the value of the form itself. It is perhaps the broken part of a metope or of another relief group. Studying the head, one finds that there is a baffling difference between the front and profile views. The profile expresses resolution, defiance, and courage, the high forehead protruding as if too narrow for the spirit. The youth fights for his inner life, his courage an expression of his spirit. The head, turning very slightly, issues from its protective reserve and meets the external world. The will is all in this passionate profile, in the shadowy gaze with which he confronts fate. The full face reflects the inner life, pensive and calm. The cheeks are soft, the mouth tender, just verging on firmness.

Did the artist intend to give us in these two views the prototype of the whole human being, the once fully rounded man who, as Aristophanes relates in Plato's *Symposium,* was later cut into man and woman as punishment? Physically the androgyne is a hybrid, but artistically it designates a harmonious synthesis of sternness and sensitivity, drama and lyricism. Such was the implicit ideal of

the Greeks, and with this head Scopas rendered it in marble, presenting that combination of qualities which, Aristotle claimed, distinguished the Greek people from all others.

The tomb relief of the youth of *Illyssos* gives quiet expression to the human tragedy in the melancholy accord of its three figures. The old man leans on his staff, pondering, the little boy mourns, listless, forlorn, and the youth, his shadow on the background rising like his dead self, stares out into nothingness, faced with the mystery of death.

The Specific Relief Style, a unique genre of Hellenic origin, opened a new dimension in sculpture, transcending the boundary between the formed and the unformed. It is so unlike anything we are accustomed to that it remained undiscerned even by people who admired the reliefs themselves. Figures in this style appear in a space of reality unfamiliar to the eyes, yet close to the source of man's being.

The sculptured form consists of a very thin, almost flat layer of stone that gives a paralogical effect of depth. Barely protruding from the background, it sometimes combines three or four figures at infinitesimally different levels. Neither a mere linear picture nor a silhouette, the relief does not produce the illusion of volume as we know it, yet has a subtle amplitude of its own. The clear outline in no way separates the figure from the background, but sets it off without impairing the oneness of the sculpture

and the relief panel. The empty background, as if giving rise to form, harbors and sustains the figure, which never quite emerges, never quite dissolves. There is a constant communion between form and background, the figure holding to it as to a world.

Of all the friezes in Greek architecture, only that of the Parthenon is in the Specific Relief Style. A long, narrow belt of figures, it appeared in the shadow of the mighty Doric colonnade, decorating the outer walls of the cella. This frieze, representing the Panathenian ritual pageant, is like a symphony, each of whose four movements has its own tonality, rhythm, tempo, and harmony. Here a large orchestra plays, here only a few instruments; for a while the music is polyphonic, then the main melody is emphasized by accompanying voices or repeated at regular intervals as in a canon. Agitated and stately measures, legato and staccato notes, runs and sustained chords, alternate. At one place horses break into a wild gallop, at another a light chariot is drawn briskly down the track; here stragglers are hastily mounting, here they are taking their time. One chariot driver leaps into his seat, another races off at headlong speed; this rider holds his horse back, that one spurs his on, still another checks an intractable stallion. Athenian maidens walk rhythmically in pairs, old men hobble along, limping behind their staffs in syncopated measure. There, where the gods wait serenely on their thrones, the mighty stream comes to a rest.

No art can be interpreted in terms of another; each has its own language, its untranslatable mode of expression. In

this case, however, comparison with a musical form is justified. Music transpires in time, in music everything is in a state of flux; relief sculpture presents everything at once, its form crystallized in space. The illusion of movement is given, but not in an unbroken flow, as this would require a lapse of time. Those who wanted to see the four sides of a frieze had to look at them successively; this involved fragmentation, and only in the Parthenon frieze was this division into parts used to advantage. As the beholder walks around the temple, the procession passes before his eyes. Figure after figure recedes, yet all unite in the total form, just as in music tone after tone dies away, living on in the melody.

The life rhythm is so strong that the stream of figures neither halts nor slackens. The vitality of the sculpture is not dependent on the relief outline alone, but on artfully contrived lines and lights, shadows and reflections, planes and gradations, hollows and projections. Sometimes the form ebbs in the background, sometimes it surges over it; occasionally a horse rears forward, massive and compact, its nostrils often thicker than its whole body.

The Greeks intended this sculpture to be looked at from a distance and from below. Those relief panels now in the British Museum lack something of their original effect. It is possible that color once added to their animation; now light serves to unite the figures, weaving them through with dull and brilliant threads, while the shadows cast back from rider to rider accelerate the movement. In some places a quiet brilliance pervades the background be-

tween separate figures, slowing their pace to a solemn walk. The unity of the work is apparent, though just how the relief and the background pass into and are sustained by one another is hard to explain. Nothing seems to impede the free motion of the figures, though at some points they crowd mightily together.*

In high-relief sculpture the function of the background is chiefly to group the figures; it sets them off and, by protecting them against the encroachments of outer space, brings them into relation with each other. In ordinary bas-relief the forms represented might conceivably be severed from their background and transposed to another surface. But a figure in the Specific Relief Style lives by and through its background and would cease to exist without it.

In the Giustiniani Stele, a mortuary monument in the Specific Relief Style, the figure of the young girl is shallow and only slightly modeled. Form is achieved by means of lines, thin planes, and an almost imperceptible undulation of the surface. The relief panel both secures and releases the figure, which, resting in it, emerges dreamily, present yet remote, as if on the threshold between being and illusion. It is as if the unfathomably silent background had become eloquent with form.

In Egypt painting and relief were determined by the plane; its laws governed the figure and determined its position. The head and legs were shown in profile, the torso in frontal view; both in painting and in relief, figures

* From the author's unpublished work, *Relief Sculpture.*

remained two-dimensional. This severe treatment, while allowing for a great wealth of form and much movement, precluded anything approaching the Specific Relief Style.

A fifth-century votive figure in the Acropolis Museum represents Athene leaning on her lance, her head and legs in profile, her body turned forward—a position not unlike that of Egyptian relief figures. But Athene stands in a different kind of space, a space created entirely by the background. Though only slightly raised, the body seems to gain substance till it takes on the fullness of a statue. Athene's helmet juts into the upper edge of the frame, giving her a further height. The monumental form of this tiny stele is out of all proportion to its actual size. The arms are flat when seen at close range, the body scarcely occupies any space at all, but if a proper distance is observed, the limbs appear softly modeled, the figure majestic, graceful, and in repose. In this subtle work each linear accent, each curve, however slight, has a formal value. It is as if the artist had given us a magnifying glass by which to see a reality that would otherwise escape us. Shadows, while contributing to the form, serve also to dematerialize the figure.

It is clear in painting that actual volume is not dealt with but represented; in the Specific Relief Style, where volume has to be considered, the solid form seems weightless, the figure itself insubstantial by virtue of its union with the relief background. As from a sphere beyond sense perception, Athene emerges, complete, ethereal, and clearly defined. The layer of stone that holds her is not

a prison but a sanctuary strengthening her presence and responding to every slight variation of the form. She breathes in it, grows through it.

Thus, in the Specific Relief Style, space extends indefinably, while the figure remains eternal. A dimension is revealed, conveyed only by the indissoluble relation between the background and the figure. The curved surface, the lucid contour, the thin edges, are subtly shaded, subtly aglow, as if the marble had come to life, its transparence evoked in the name of a form beyond form.

3

Greek Painting

Since all murals from the Hellenic period are lost, their style is here surmised by implication and a unique rendering of space assumed. As the Greeks found a specific form for all the arts, the inference seems justified that they also found one for their monumental painting—the most renowned of all their visual arts.

ORKS of art are documents *sui generis.* Had the Doric column not been preserved, we would have no way of knowing that a functional part can be so imbued with a life motion; were there no example of the Ionic, we would not see how, despite the stressing of incompatible elements, such an effective co-operation could be established. Without statues such as the *Hera of Samos* we would ignore how man first brought life to bear upon the geometric figure, which in turn gave permanence to the form of the human body. Had the group of centaurs and Lapiths in Olympia perished, that type of dramatic sculpture, wherein conflict is enhanced by the ornamental design, would never have been as clear. If some fragments of Scopas' works had not survived, the shadow filling the eyes of statues with an implication of tragedy would have passed unperceived.

Were nothing left of the Specific Relief Style, we would not dream that the communion between a sculptured figure and the space in which it dwells can be such as to suggest a relation between man and the unknown. Thus the work of art is an entity unparalleled, unique.

Each form has its own character, each voices an inner reality otherwise mute. Though there is too little material to warrant any definite conclusions as to the pre-Hellenistic style in murals, the Specific Relief Style in sculpture suggests that painting may well have been significant in its own right.

Greek and Roman authors tell anecdotes about painters, or describe the subject matter of pictures, alluding only vaguely to artistic form. Since all mural and panel paintings of the fifth and fourth centuries are lost, a documented analysis of their style is out of the question. We still have many vase paintings, some of which answer to descriptions of once-famous murals. However, anyone who has compared drawings or engravings copied from paintings with the originals will be reluctant to judge Greek pictures by these reproductions. When the draftsman or engraver was a master, his work was effective in its own way; when a bungler, the result was a distortion.

The development of architecture, sculpture, and vase painting gives a clue or at least some notion as to Greek murals. When monumental pictures had ceased to be merely two-dimensional in design, vase paintings either remained so or were forced into competition, to the detriment of their own particular style. A two-dimensional

form was in many respects an advantage; the fluid line, running always on the same plane, constitutes a direct image of movement. Relying on gesture and posture, it emphasizes certain features that would otherwise be scarcely noticed. However, this gives little indication of the mural style during the Hellenic period.

There is another method of investigation that may be better. Vase copies of murals, instead of being accepted as reliable, could be studied in the light of architectural or sculptural works. Three-dimensional art yields no information as to the essential quality of painting, but it does express the Greek idea of appropriateness, which, manifest in each art form, must have existed in paintings as elsewhere.

Early in the period figures were painted on metopes and steles, while linear designs and colored silhouettes decorated small and large objects. This two-dimensional imagery was soon superseded by sculptured ornaments, which in architecture were more effective than painted ones. With the emergence of a dramatic style in sculpture, paintings on buildings assumed a subordinate position. Purely graphic and silhouette art was still practiced on wall and vase surfaces, but was finally supplanted there, too, by a more three-dimensional representation. The influence of sculpture pervaded figural art as a whole, sculpture itself having gained a further eloquence by the power of the shadow.

For a long time the Greeks had rebelled against this constant and sinister companion. Regarding life as the

supreme good, and immortal fame as man's one compen-
sation for the loss of it, early Greek artists indicated the
deathless by representing their figures without shadows.
The archaic statue, by the very compactness of its mass,
escaped that eerie darkness, but on buildings sculpture
could not avoid it. The higher the relief, the more con-
spicuous the shadow, till it threatened to interfere with the
whole effect. The Greeks, however, turned it to artistic
advantage, using it to suggest the unseen.

Low reliefs before the third century rarely have per-
spective and give no effect of depth; high reliefs, on the
other hand, appear almost detached from their panel.
Plutarch tells us that Agatharchus, a painter of stage
scenery, was the first to extend the pictorial field in depth.
Does this mean that he represented the figure as detached
from the background and thereby sought to imitate high
relief?

It is possible, however, to give quite a different inter-
pretation to Plutarch's statement. At about the same time
that tragedy came into being, the Specific Relief Style
revealed a new dimension by merging the background
and the figure, abolishing the boundary between the form-
less and the clearly formed, the indefinite and the well
defined. In view of this, it might be assumed that painters
of the same period also created a unique form, a specific
pictorial style.

According to ancient writers, Greek painting was su-
perior to sculpture. The "painting of reality" mentioned
by Plato must relate to his conception of reality. Socrates

censures the picture of a stick refracted in water, on the grounds that its true image was thereby distorted. If only Ideas were considered real, then the painting Plato praised—that of the epoch preceding his—must have referred primarily to them.

To paint an idea seems absurd to us, but to the Greeks before Plato, "idea" was related to discernible form. This should give us some insight into the Helladic style of those fifth-century masters, Agatharchus, Micon, and Polygnotus. Considering that the Specific Relief Style, born of the same period, suggests a relation beyond the known, it is not inconceivable that paintings objectified a mental picture.

The problem may be studied further on the basis of a few surviving fragments of an earlier period, such as the painted stele in the Metropolitan Museum of Art in New York. The term "shading" is here scarcely applicable; the modeling is achieved by means of flesh-colored tints balanced so subtly that gradations are almost imperceptible. Yet, slight as they are, they give more than a two-dimensional impression without allowing for three-dimensional form.

Micon is said to have distributed his figures over the wall surfaces, Polygnotus to have indicated scenery by arranging his figures at different heights. Vase paintings where these same methods were used are supposed to resemble their originals. But the artist who incised the Argonaut Vase (in Paris) may well have deviated from his model to suit his medium. If the Specific Relief back-

ground is significant by its relation to the figure, why should the wall surface of a painting not be significant in its own way? There was no need in murals for the contrast between black and red that characterized vase painting. An artist like Polygnotus did not have to depend on the sharp outlines that, in vase pictures, were inevitable by the juxtaposition of the glazed surface and the unglazed parts of the design. A severe style need not be a harsh one. Touch, pressure, and flow determine the value of a line in drawing, just as they do the quality of a phrase in music. Ancient authors say that changes in distance were indicated by undulating lines; this would have constituted a field somewhat analogous to the relief space of that time. In the Specific Relief Style the figure entered into perfect relation with the uncarved background. Polygnotus, in creating a like relation, could, without loosening and certainly without dissolving the form, have blended it with the unpainted surface.

Whether influenced by Polygnotus or not, the Gjölbaschi reliefs and the vase paintings of the Amazon on horseback (Metropolitan Museum) show an attempt at perspective. From then on an element of depth or foreshortening was always in evidence somewhere. This innovation was of tremendous importance; the gap between painting and the world as we see it began to close. In the Gjölbaschi reliefs each line, however slight and tenuous, is raised, the end effect often running counter to the intended illusion of depth. A wide view is crowded into a small area, and the eye is led from level to level not grad-

ually but in jerks. The relief gives no feeling of depth, in spite of the artist's careful calculation. Shadows only further destroy the illusion of distance by stressing the exact space between the forms and the background.

The Amazon, pressed flat against the dark vase surface, seems rather to tumble out of it. The artisan's lack of skill alone is not responsible for the miscarried foreshortening of horse and rider. Having chosen a model so ill suited to his medium, he had to cope with much greater difficulties than the master whose mural he copied. Free only when drawing the lines within the figure, and hampered in the outline by the drastic contrast between black and red, he was barely able to transpose the theme onto the vase. There is another reproduction even worse, representing a figure from the Parthenon frieze. This is the one case in which we still have the original, and can see to what extent the copy is a distortion.

The white-surfaced lecythi give quite a different effect. Though almost every trace of color is obliterated, one can still appreciate the delicacy of the design. The drawing was done with alternately broad and thin strokes, the picture neither cutting into nor emerging from the bright pictorial field. Form and background are blended, the artist having created his own shading and shadows.

With Apollodorus, known as *skiagraphos*, the style of painting in general underwent a change. His figures, gathering volume and thereby advancing from the background, required for their interrelation a new arrangement in space. Apollodorus, to achieve that grouping, may have

opened the background in such a way that the wall sur-
face no longer looked like a boundary. It might well have
been this that led to the painting of pictures on separate
panels, as the Greeks probably objected to the disruption
of the wall in terms of its architectural function.

In the *Philebus* Plato defines the perceptible world as
both limited and unlimited, claiming that space, itself a
nothingness, can nevertheless assume form. In the *Sym-
posium* Diotima declares all art to be *poiesis*—creation—
in that it brings the nonexistent into being. Here Plato
formulates the essence of art, as no one before him and no
one since. His frequent attacks on art and artists sprang
from his desire to establish the pursuit of knowledge as
man's supreme goal, and to guard against any possible
distractions. Through Diotima he refutes his own censure
and voices the truth about all artistic creation.

The Greeks sounded the unknown and gave it form;
they shaped concepts by which the phenomenal world
could be ordered and contemplated; they succeeded, by
the interplay of meter and rhythm, in reconciling law and
freedom; they incorporated music into their dramatic po-
etry as a further means of expression, until the chorus and
the Ionic solo became essential parts of Attic tragedy.

Greek music, the only art that Plato did not condemn,
is entirely lost. From the profusion of rhythmic forms in
poems and tragedies we can infer its artistic value but not
the music itself. Literary sources tell us little, and the fact
that Pythagoras discovered the relations between tones

and based harmony on numbers does not help us to determine the style.

The appropriate, as an idea, was born of a deep feeling for the discrepancy between man as he is and man as he longs to be. Greek art testifies to the Greeks' concept of form, artistic space constituting a perspective of the mind —a mindscape.

4

Hellenistic and Roman Art

A new conception of space made itself felt in Hellenistic times. An explanation is ventured for the fact that, although known, the arch was not used in ancient Greek architecture. A further change in the way of seeing occurred in the later Hellenistic period; it reflects a change of mind—of "mindscape."

EVERY period has its own mindscape, as shown in art by the spacing of a given field. Empty space was for Plato nonentity and remained so for the Greeks throughout the first half of the fourth century B.C. Up to then the body politic—the whole area of public affairs—had been limited to the city-state. With Alexander the polis, though not altogether abolished, was definitely weakened, its legal boundary invalidated. The political horizon receded out of sight, and this profoundly affected both the outlook and the conceptions of the Greeks.

Only a short time before, Isocrates had urged the Greek states in vain to unite on a basis of equality against the Persians; now Alexander, his rule unrestricted, encompassed Greece and the East as well in a world empire of unlimited extent. Aristotle had stressed the superiority of the Hellenes; Alexander discounted this caste system and

strove to wed East and West. Half barbarian by birth and Greek by education, he followed the example of Cyrus, who had not only respected the religions and customs of conquered nations, but, unlike the Greeks, had neither massacred subject populations nor sold them into slavery.

The empire collapsed with Alexander's death, but a new era, the Hellenistic, had begun, and space itself acquired a new meaning. Hellenistic sculpture was determined by two trends, one deriving from the style of Scopas, the other from that of Praxiteles. With Scopas, the conflict between inner and outer reality had been faced and resolved. With Praxiteles, artistic form, while traditional, had lost its austerity; his figures are pleasing by their relaxed postures, their fluent contours. Whereas the archaic statue has a formal, impersonal space of its own, the figures of Praxiteles are merely sheltered, denizens of a private world.

The sublime was thus replaced by the agreeable. The marble *Hermes* is polished, its excessive smoothness highlighted, and the skillful interplay of individual forms fails to modify the too-harmonious effect. If this *Hermes* were as weather-beaten as the *Hermes* on the Parthenon or broken into pieces like the fragments of Scopas, he would have no essential character. While storms shook the Greek world to its foundations, the sculptor sought to render form not by resolving but by avoiding conflict.

Scopas chose rather to come to grips with reality, saving the heritage of the Greek spirit not by guarding but by furthering it. Artists of lesser courage, daunted at the sight of

passion so destructively at work all around them, escaped into forms more mild, more gentle.

Though Praxiteles has been called the classical artist *par excellence,* he was actually the founder of pseudo-classicism. His artistic conception held sway for centuries, and while other styles asserted themselves along with it, his continues to this day. The works of his followers became less and less creative, artistic achievements fewer. Pseudo-classicism lacks a genuine impulse, but has the historic merit of having preserved certain elements of traditional form.

In the time of Scopas not only artists but philosophers had already begun to despair of integrating the incompatible elements around them. During the Hellenistic period, philosophic conceptions were not so much acts of the spirit as reactions to the stress of events. There was comfort in believing that, despite everything, the world was rational or that only inner peace mattered; philosophers believed in the ideal world of the Stoics or cultivated friendships in the gardens of Epicurus; they undertook special studies or practiced syncretism, recognized only the universal or stressed every particular, proclaimed either the all-exclusive One or the infinitely multiple. The artist betrayed the same ambiguity; if he did not confine himself to previously established forms, he exaggerated newly discovered ones. This led to the building of enormous or tiny structures, gaudy or playful.

While Alexander drew the polis into his vast empire, Lysippus led the statue into outer space. The sculptor

proceeded cautiously, but the formal geometric boundary between the sculptured figure and the surrounding world was lost.

The *Wrestlers* in the Naples Museum are represented on the verge of fighting; they reach out separately into the void and never come to grips. Only in a relief would these figures appear as a group.

Although art was collected on a large scale after the end of the second century, little of it has come down to us from early Hellenistic times. What remains gives evidence of a dual style, bound on the one hand to the classical tradition, on the other released into space. The capitals in the Didyma Temple are ornamented with lateral leaf clusters. Heads of deities sprout from the volutes without transition, their hair curled as if each lock were a living thing. This jumble of forms, carefully calculated, has something of the unpredictability of life itself. A palmette on a column appears to have been blown there by the wind. This trend in the Hellenistic style is characterized by stupendous proportions and mass, while the other is sparing of form, its columns like stilts and its narrow entablature scarcely a structure at all.

Hellenistic artists either indulged in fantastic representations or produced exact likenesses; they sought to shock, or adhered rigidly to the familiar. Every aspect of the natural, including the monstrous, was taken seriously, while formulas were often presented as form. The overweening and the insignificant, the despot and the most degraded of creatures, were represented with a like emphasis. The

same kings who in defiance of time built huge architectural and sculptural monuments burnt great works of art for the whim of a moment. The passions, running wild, tore everything down, carried everything away. Side by side with this violence was an attitude of proud and impassive reserve. In art as elsewhere rhetoric flourished and pedantry taught its dry lessons. Despite the tremendous variety of philosophic and artistic forms one thing was common to them all: the claim of each to the absolute truth.

In his desire for unity man either stressed one particular as the universal or else equated them all. The Syncretists glossed over contradictions; the Skeptics declared knowledge to be delusion and life a matter of chance; the Stoics considered everything in terms of reason and law. After the death of Alexander there was no common purpose left, no frame of reference, or direction. Intellectual energies were dissipated or severely channeled; the will power stiffened under the pressure of events into the *ataraxia* of the Stoics or slackened to the gentle cadence of the Epicureans.

There were many new modes of expression, no genuine style. Philology, grammar, the idyl, and the novel came into being. Court history was introduced and held sway for a long time, its purpose to flatter the ruler. Historical personages were no longer represented as people, but as superhuman beings; only the personal letter allowed for a free and more intimate picture of men and events.

The absence of any really new architectural style until

the time of the Roman Empire may have been partly due to the change in man's attitude toward nature. Superstition and the scientific approach flourished side by side, both betraying man's doubt of himself as creator. The Cynic, claiming to live according to nature, threw off the restrictions of society; the Stoic, professing the same, adhered to the dogma of a rational universe. Artists in general followed suit; their works either imitated nature or referred back to classical forms. Just as the body politic lacked integration, so architecture lacked a style. Counter, however, to Aristotle's view that no slave could be free, man's inner sovereignty proved independent of circumstance.

The integrity of the individual withstood the times to a remarkable extent, as witnessed in sculpture by the free-standing statue. In the fifth century B.C., drapery was used to give a soaring movement to the figures of the Monument of the Nereides; the *Nike* of Paeonios appears to glide from a great height, motionless, abandoned to movement, her robe like a sail. The Hellenistic *Nike of Samothrace* owes little to drapery. Herself one mighty and immediate gesture, she sweeps forward, winged with a dimension adequate to her freedom.

Hellenistic reliefs as a rule either follow a traditional pattern or mimic nature at the price of artistic space. Thus disregarding both the possibilities and the limitations of their medium, sculptors often defeated their purpose. Where perspective is used, the lack of depth is obvious, foreshortenings giving anything but the intended

effect. This is particularly evident in reliefs where the figure, protruding, casts its shadow across the entire landscape in the background, destroying not only the illusion of space but the form as a whole.

The Hellenistic reliefs on the altar of Pergamum are remarkable for their treatment of space. The figures on the *Telephus Frieze* seem to reach back into the relief panel for their volume, unlike those of the Specific Relief Style, which float, self-realized, in their expressive space. Each figure in the *Telephus Frieze* and every object exist as if still in the making. All is transient, in process, to be completed later. The future and the formal connection between events are suggested as never before, preceding and heralding the conception of history as an evolutionary process.

The *Battle Between the Gods and Giants* on the same altar in Pergamum involves an entirely different treatment of space. While pediment groups occupy a kind of stage set, which frees them for action, the Pergamum figures, almost sculptures in the round, have no private world. The background loaded with twisted bodies and coiled serpents no longer looks like a two-dimensional surface. Solids and shadows mingle, figures are grooved till they seem pierced by the darkness, and their panel, less a space than an abyss yawning around them, a blackness looming up, behind and between them, threatening all form. *Acherontem movere,* upheaval in the nether world, was thus expressed long before Virgil. Both the Gods and the Giants, though fighting with passion and

strained to the extreme, seem instruments of fate without choice or will of their own. Everything appears governed by a furious and implacable force, the scene suggesting a cataclysm.

This Pergamum *Gigantomachy* has been defined as pictorial inasmuch as its form is more given to light and shadow than to volume. In Hellenistic painting, however, form is rendered by means of depth, light and shadow playing only a minor role. The *Odyssey* pictures from the Esquiline are framed by painted pilasters; through these, one sees a segment of the landscape. The figures, less important than the space represented, are small in size. Everything is shown at long range. More and more elements of depth and distance were introduced into Hellenistic painting until, breaking up the two-dimensional appearance of the surface, they began to determine design and proportion.

In the Roman era, actually a new phase of the Hellenistic, nothing significant was achieved in art up to the second century A.D. Sculpture was dull: it merely imitated human features. If we knew Greek works only from Roman copies, their essential form would be as hard to discern as the lyricism of Sappho in the verses of Horace.

Though the Ionic column had already lost its *élan* and the fluid lines of the Doric become fixed, its capital stunted, Rome worshiped the Hellenic and Hellenistic styles indiscriminately. As Plutarch tells us: "When I saw the columns in Athens the relation between their

width and height was most beautiful. In Rome they are trimmed and smoothed, gaining not so much in polish as they lose in their proportions."

Parallel developments took place in every field of art under the Romans. Myths paled into moralistic fables, creatures of Greek legend became empty abstractions. Cicero went to great lengths to explain that the Erinyes of Aeschylus were not actual powers but mere allegorical abstractions. One wonders why Aeschylus took the trouble to convert and assign them another function. Such a talent for pedantry can dispense with the essential in art. Content to imitate, the Romans produced merely functional or decorative forms, a type of classicism combining Greek traits with some of their own.

Only on former Greek and Hellenistic territory did artists treat the classical forms with a certain freedom, bending and breaking them till architectural parts took on a new life, a new movement in space. In the round Temple of Baalbek and in the rock façade of Petra cornices actually seem to swing backward and forward, entablatures and pedestals to rotate. The Temple is furrowed with niches, shadows intensifying contrasts and adding to the structure's effect of unrest. Architecture began to behave like a living thing, abandoning itself to space, while space came to be evaluated as a creative power in its own right. Quite another attitude is evident in some of the buildings of post-Augustan Rome. Here the roles are reversed: space is the material to be acted upon, to be given a shape. Alexander's world rule, Stoic

universalism, and Oriental technique all contributed to this development; but it was the might of Rome that finally brought it to full expression.

The Romans prized the usefulness of buildings just as they esteemed the practical virtues. Frontinus, the engineer in charge of aqueducts, ridiculed the nonutilitarian architecture of Egypt and Greece. Behind him lay three hundred years in which the Romans had excelled in the building of aqueducts and arched bridges, and now, in the first century A.D., these practical structures began to initiate a style in representative edifices.

It is doubtful whether a purely functional can be termed an artistic form, though today, weary of pseudo-styles, we call any good technical construction a work of art. The ancient Greeks were of another opinion, as can be inferred from their very rare use of the arch—to them a purely functional structure and known for centuries. It seems strange that they made no attempt to rejuvenate the hackneyed neoclassical style by means of this form, particularly as they considered the circle the epitome of perfection. Yet they used it only in subterranean chambers or occasionally on gates. For us, to whom the spatial value of the arch is evident, this attitude seems illogical, but space to the Greeks was something to be filled, not shaped. Only the concrete, the definite, was taken into account. An arch between pillars would have impinged on their clear outline, depriving them of formal identity. If we look at a Roman aqueduct, ignoring the arched spaces and focusing on the pillars alone, it is plain that they are not

integral, definite forms. The arched spaces outweigh the concrete body as to effect, space predominating over and fracturing the unity of the solid structural form. If the Greeks, concentrating on the solid, saw the arch in this way, it becomes understandable why they never used it in representative architecture.

In bridges and aqueducts it was space, not the solid, that the Romans stressed, shaping it into a balanced geometric figure. When arches were first used in buildings other than bridges and aqueducts, sham columns and a rectilinear entablature were placed in front of them. Thus formally disowned, the arch made its appearance. Even in the Colosseum a pseudo entablature with half columns was superimposed, to dignify the structure. Actually it only serves to stress the clearing under the arches. These spaces dominate the whole impression, their width exceeding that of the piers, the half columns further breaking the effect of mass.

Thus, at the beginning of the Christian era an amazing development took place; no longer conceived as a mere emptiness to be filled, space became the main medium, the sovereign architectural expression.

Vault structures, while used in Hellenistic times, did not attain to full rank until the Pantheon, like an embodiment of the idea of empire, rose—a mighty, whole, and simple form. A triumph of the new conception of space, its rotunda is a world in itself, immediately expressive of a valid order. The dome is almost exactly as high as its supporting wall, the sum of both equaling the diameter of

the floor. From the single central opening in the purely rounded cupola, light enters, suffusing the great hall below. This cupola is arranged, ring upon ring, the gradually narrowing soffit coffers indicating distance and guiding the eye to the apex. Thus, circle joins circle up through the successive rings of the vault and on to the calotte.

Spatial form had never before been majestic and was never again so thoroughly secular in character. The world here represented excludes all others, its self-assurance proof against anything. On the outside the effect is quite different. Fortresslike in appearance, the exterior wall is inanimate, massive, inert, and would have been repellent to the Greeks, who expected an edifice to be a vital form composed of visibly interacting parts. This outer rampart is not the wall on which the cupola rests, but an additional fortification. Between the rampart and the supporting wall there are connections, spans, and other structural parts performing their services in the dark. The cupola is a dead weight, overruled by the imprisoning rampart wall and entirely out of keeping with the interior vault.

The exterior of the Minerva Medica is less massive and has no additional counterfort. Niches, no longer hidden as in the Pantheon, have a share in the total effect and differentiate the building; the cupola and the decagon combine, radiating out into buttressing piers and giving a rich spatial effect evident even in the ruins. Formerly the light from the lateral windows must have spread out in all directions, the central hall predominating, without— as in the Pantheon—constituting the whole. Though the

Minerva Medica is less imposing than the Pantheon ro-
tunda, its differentiated form is more an expression of the
Western spirit.

It is difficult, in judging vaulted structures, not to over-
evaluate the technical ingenuity involved. While form is
dependent on structure, it is not wholly determined by
it. The choice of one out of all the structural relations pos-
sible arises from more than mere technical knowledge.
A vault may be a cave, a dungeon, a cellar, a tomb, or a
treasure chamber. It may be spacious, yet without spatial
form. It may be heavy and oppressive or appear self-sus-
taining.

The cupola of the Pantheon is supported by a cylinder,
a type also basic to the Santa Costanza; from the floor to
the apex of the interior everything is round and the spatial
form at rest. Unlike these two buildings, the decagon of
the Minerva Medica is linked with its round cupola by
means of corbeling. As in the huge cross-vaults of the
Thermae, this interior seems to rise counter to its own
structural laws. Its support visible, the vault soars, rush-
ing the space form along with it in a mighty upward
thrust.

Such cupolas and vaults, despite their solidity and clear
construction, give irresistibly this impression of a cause-
less ascent. Form in them is so absolutely dominant that it
overrules mass, confounding the rational order. In this
way they refer to man's inner world, where pressure is also
resolved, a downward pull transformed into a rising of the
spirit.

Formerly it was the body of the building that was shaped; now the architect concentrated on space. The central cupola of the Baths of Caracalla is higher than that of the Pantheon, the spatial effect of the building enhanced by countless arches, niches, and vaults. Rooms, one leading into another, create a vista. Highly curved vaults span the enormous rectangular halls with the ease of ethereal beings, as if space in each case determined its own bounds.

This effect of vastness predominates even in buildings like the Basilica of Constantine, with its imposing columns. No column, however huge, however ornate, can compete with the powerful *élan* of these vaults. Thus, structural ornamentation in the old style paled before this extraordinary architectural innovation. Here was a form which shaped space and not matter; it seemed to transcend earthly conditions and to reach a new freedom.

5

Byzantine Art

In Byzantine architecture and mosaics the intrinsic principle is identical. When examined from various points of view, the mosaic style shows the use of stone fragments and mortar to symbolize the Christian concept of the inconsistent being consistent in God's eyes.

SSENCE in the noumenal world is omnipresent, existence identical with Being. Let man become aware of that spiritual reality abiding forever radiant around him."

Had Plotinus, the third-century pagan philosopher, been a Christian devotee, he could have invoked no truer image of the fifth- and sixth-century churches than in these words.

The builders of San Giovanni in Laterano took over the hall of an ancient bath, and without changing its structure divested it of its worldly appearance. Plotinus was so intent on intrinsic reality that he had no need to be converted or consecrated. The spiritual kinship between the neo-Platonists and the early Christians is most evident in their concern for the infinite. Man's attitude toward both the temporal and the timeless can always be deduced from his treatment of space in art. Rarely is this

as clear as in Late Antique and Early Christian architecture.

With the close of the pagan era Hellenistic civilization entered a new phase. The ancient Greeks had dismissed the boundless, the infinite, as empty, formless; the neo-Pythagoreans, the neo-Platonists, and the Christians exalted it into an attribute of God. Plotinus defined Supreme Being by negating all that could be said and thus exalting It beyond words. To him, in contrast to the Christian, "the One" was unqualifiable, depersonalized. Though Plotinus praised beauty—and praised it for the last time in the Greek language—beauty with him was unrelated to the body. He was concerned with an inner value apprehensible only to the mind, and it was this that claimed all his love. According to him, a man of lofty soul is neither repelled by outer ugliness nor attracted by outer charm, but perceives the essential alone.

The Stoics considered themselves citizens of the world; Plotinus was at home in eternity. Art in the Roman Empire appealed directly to the senses by means of a clearly circumscribed spatial form; Plotinus demanded a vision, spaceless in terms of the space we know, measureless by virtue of the spirit. In ancient Rome the arch and the vault, like everything else, had served a utilitarian purpose and given a secular effect; in Byzantine ecclesiastical art they suggested loftiness, their spatial forms presenting the "intelligible sphere" of Plotinus as well as the Christian idea.

Tertullian's creed—*"invisibile est, etsi videatur; incomprehensibile, etsi per gratiam representatur; inestimabile,*

etsi humanis sensibus aestimetur"—expresses the fact that faith transcends intellect, and vision rationality. Byzantine artists evinced this truth by subjecting the materials at their disposal to their highest longing. Thus, man, impatient for deliverance, wrought an image of the kingdom of heaven in his art.

In ancient Greek architecture all solids were permeated with form, form being conceived as matter's entelechy. In Byzantium form was rendered by abolishing the effect of matter. The builders of Christian churches availed themselves of those pagan structures—nymphaea or thermae—which allowed for spatial representation. These halls, fitted to Christian needs and converted, offered eternity to the eyes of the faithful.

To achieve an effect of complete transcendence, mass had to be divested of weight and etherealized. Iridescent marble was used to transform columns and walls into mere figments of color, the vault into a realm of shadow light. Shimmering mosaics diffused a strange and unquenchable radiance; the daylight flowing in through the windows spread not a brightness but an unearthly glow. As the structure shed its solid appearance, it became a translucent, glittering vessel, its space indefinable.

Seneca called the body a prison; the neo-Pythagoreans considered immateriality an attribute of the spirit. The Christians, though they taught the resurrection of the flesh, conceived of the body of the Lord—the Church—as a spiritual one, and this conception was substantiated in Santa Sophia. Its interior appears neither built by human hands nor composed of solid forms.

The figures in the mosaics are represented as standing, but without a base. They walk in pathless space without foothold, never lost, in no particular place, yet always in their own primordial realm. All measurable dimensions dissolve in a vision that has neither shore nor end, neither tide nor season nor sequel, but simply *is*. The walls of the church are less boundaries than the boundless made visible, the spaceless spaces of eternity.

This effect of the supernatural was achieved by going counter to nature. The Mother of God on one of the vaults is not centered: her throne glides obliquely toward a window from a glittering golden background; her footstool, though foreshortened, has neither surface nor volume. In Egypt pictures were strictly two-dimensional; in Hellenistic painting they approached the three-dimensional; on the concave surface of this apse vault, the figure of Mary, neither one nor the other but utterly improbable, gives an effect of the absolute.

Here the opposition between spirit and matter is ignored, and the human body, represented as weightless, signifies spirit. To be without place is to be at home with God. Above time, space, and matter, precluding all doubt, all conflict, this style renders the Christian idea, meeting the senses with a supersensory experience.

Whatever the basic design of a Byzantine church, its interior gives a mystical effect, communicating a religious experience that would otherwise remain inward and solitary. The object of faith gains objective reality.

Such an achievement was made possible by the refined techniques developed during the preceding Hellenistic

period. Rationality and mechanics were made to serve the irrational and the miraculous, technical skill was subordinated to spiritual fervor. The distribution of pressure, load, thrust, weight, and tension was carefully calculated in order to eliminate such elements from the beholder's mind, and to produce the effect of the structure's being "in some unfathomable way suspended in mid-air," as Procopius said of Santa Sophia. Although the interlocking of all parts was perfectly planned and executed, the way it was done remains a secret, the result a revelation, not an explanation.

The worshiper who enters finds himself in a world of religious ideas come to life. The kingdom of heaven unfolds before him. When he leaves and looks back at the church from the outside, he cannot help feeling that all earthly things are a burden. He has just experienced the divine promise, but the event occurred in another world altogether.

Surrounded by hostile nations, exposed to attack on every side, Byzantium stood as the champion and fountainhead of Christianity, as well as the repository of ancient civilization. Not only did it have to defend Christianity against the heathen and the infidel, but it also had to protect its own culture against Latin Christendom. The heritage of the Greek Empire was alien to the North, and had gradually become so to the Romans. In Byzantium, however, it was preserved and suffered but little from Christian intolerance. The prayer of a pious eleventh-century Greek bishop that God should consider

Plato a Christian shows how the Byzantines loved the Greek past. Though there was a conscious return to the pure language, literature, and history of ancient Greece in the ninth century, after the end of the iconoclastic controversy, we cannot speak of it as a revival; classical antiquity had never died out. As early as the fourth century, the philosophy of Gregory of Nyssa and the poems, speeches, and letters of Gregory of Nazianzus bear witness to the fruitful union between the Hellenic heritage and the Christian creed. Later, in the sixth century, Hellenistic elements, Oriental forms, and the religious fervor of Christianity were all fused, as shown by Santa Sophia, the churches of Ravenna, and the hymns of the poet Romanus.

According to Gregory of Nyssa, all knowledge rests on logic and deduction, all faith on revelation, the sciences providing a rational basis for the Christian dogma. Thus Greek philosophy and Christian theology were reconciled in Byzantium, which, as a culture, proved solid and durable. Whether a citizen belonged to the complicated administration or read Homer, or wrote history after the model of Herodotus and Thucydides; whether he studied Aristotle and Plato, or immersed himself in the mystery of the Trinity—he was still within the Byzantine framework. Pursuing his daily tasks, he was linked with the poets and thinkers of the past and at the same time bent on the goal of redemption. The form of his state was in the Hellenistic tradition, and lasted until the end of the Empire in the fifteenth century A.D. The Byzantines adapted

their military strategy to the equipment and methods of their enemies; they chose their literary style according to subject matter; they enjoyed subtleties of rhythm in prose and poetry which the "barbarians of the West" did not even perceive; and they worshiped divine revelation as the uniquely true way of knowing the unknowable.

According to Gregory of Nyssa, the divine nature is to carnal nature as fire is to fuel. The same simile may be applied to the relation between form and matter in art, especially in Byzantine art. Classical in their posture but utterly alien to antiquity in their negation of the body, sculptured figures are monumental, regardless of size. Even the tiny ivory reliefs of the Mother of God have an awe-inspiring effect, despite their lovely faces and tender gestures. Here spirit is revealed directly to the senses without the mediation of the intellect. This is the realm of pure being, of inwardness, severed and remote from actual life. Even the ancient figures of cupids and satyrs survived, ornamenting small objects of everyday use or disporting themselves boldly on murals. With antiquity as the source of their culture, the Byzantines lived actively in the present, while religion took them to another world, that of the saints whose wonders could be glimpsed in the churches. It was there, through the conquest of earthly limitations, that the spirit proved its identity with the divine, and the possibility of freedom was revealed to man.

An architectural form whose construction is inexplicable, mosaic figures independent of physical law—these were expressions appropriate to the religious longing of

the period. Standing in no visible relation to the known, this art allowed man only one attitude: to believe and to contemplate the vision it presented, to behold Christ's meaning: The kingdom of God is not of this world. Such an image was definitive; nothing could be added to it, nothing essential could be changed. Who could transform eternity? As long as faith endured, man would conceive the Spirit as beyond the known.

While the goal was redemption, release from earth's bondage, the Byzantine style was appropriate. Any other would have involved a different conception of the world and a different faith. There could be no reinterpretation of the way within the framework of fixed tenets. Architecture underwent many changes, but the interior of each church and the figures within it continued to represent the supernatural.

The citizen of the Byzantine Empire strove to preserve whatever values he had; he searched his heart; he found refuge in the hermit's cell; he sought recreation in study, edification and consolation in spiritual and intellectual pursuits. But all these aspirations and activities stood in juxtaposition to each other; they were not integrated. To have envisaged Gregory of Nyssa's polysynthesis was in itself an achievement; to have accomplished it would have required the bridging of the gulf between popular speech and the language of the educated. Nothing of the sort happened. No literary work became the common possession of all sections of the population, none gave full expression to the life of the people.

The Hellenistic tradition, Oriental and Christian other-worldliness—all three formative elements in the Byzantine style—remained constant. Their relation to one another changed, but neither a new impulse nor a new goal made itself felt. Thanks to their religious fervor, the Byzantines escaped pseudo-classicism and the West's imitation of Greek art forms. Their spirituality resulted in a creative act, wholly consummated. The style became petrified only when the Byzantine Empire, confined to an ever more restricted area and overrun by enemies, exhausted its energies in self-defense. As late as the eleventh century, however, and prior to the disastrous Fourth Crusade, when the Latin Christians for the second time ravaged the empire, Byzantium raised its voice again in a moving appeal: *The Crucifixion* in Daphni.

"As though suspended in heaven," "erected by divine not human hands," enthusiastically proclaimed those who first saw Santa Sophia. According to Procopius, the structure gives one the feeling that God Himself has chosen it as His dwelling. The huge vault takes one's breath away. The main dome rises on spherical triangles (pendentives) and arcs, the sequence of half domes and arches maintaining the movement as if free of gravity. Tension and pressure are so distributed as to be nowhere evident. The dome gives the distinct effect of floating just above its supports, merely skimming their crowns, while they in turn look like airy shapes gliding in rhythm. The down-pressing seems to rise, the space-spanning to be winged. No single

part creates this balance, but rather the interaction of all parts. Stress and thrust are caught up in the vaults and arches, which divert the eye from the real points of support.

The space form is enhanced by a light that fountains out into a shimmering, everywhere present. The central dome alone has forty openings, while row upon row of windows line the side walls. Some broad, some narrow, some low, some high, these openings did not serve to clarify the interior, but to confound light, to intercept one stream with another and scatter them all into a sparkling mist. This is not lighting; it is a miracle of illumination. The ripping of sunlight into radiance almost dissolves the stone frame. In the dance of gold and rainbow colors, every figure, every structural form, melts into a vision not lucid, but dreamlike, intense.

The brightness in the Pantheon comes from the apex of the dome; the upper space of Santa Sophia is in shadow. Nowhere in this church is the light constant: a marble tone takes fire like a jewel, the metal in a capital flashes, blurring everything. Even these light effects, however, would not give the effect of revelation were the framework of the building obvious, its mechanism explicit. Support and reinforcement, discharge and tensile strength—all these, the elements settle quietly among themselves.

While the spectator is still absorbed in vision, the picture changes, the slightest shift in the direction or intensity of the light resulting in a new impression. Now here, now there, something flares up, something subsides, some-

thing emerges, something disappears. Common to all elements is what Plotinus would have called their "intelligible substance." Dionysius the Areopagite lived in the century when Santa Sophia was built. According to him, abstraction must be made of everything definable in order to conceive of God. This church, as if abstraction had actually been made, grants a certainty past understanding.

In ancient Greek temples individually significant forms make up the architectural community; in Byzantium the architectural form presides over the communion of parts in themselves insignificant. A Greek temple expresses freedom in its outer form, while the exterior of a Byzantine church provides but a shell for the spatial idea. The temporal world remains outside; only in the interior does the miracle take place. Later church exteriors were modified. The dome, which had been half sunk in the wall, was raised on a drum, so that it appeared less heavy, and arches were differentiated by the use of stones in two alternate and contrasting colors.

The architects of Santa Sophia—Anthemius of Tralles and Isidorus of Miletus—believed that all struts and abutments required for the construction should be met and counterbalanced by spatial forms. Byzantine architecture is an internally integrated system whose spatial arrangement leaves no room for anything that exists as an individual agent. The additions made later in Santa Sophia distort its original structure beyond recognition. As it had been, the interlocking of its innumerable parts was reminiscent of the complicated political administration of

Byzantium, in which everything was subject to the final authority of the emperor. The religious sphere stood high above the government, inasmuch as it was considered to transcend human understanding and therewith all finite institutions. Gregory of Nyssa says that man becomes aware of God only when he attains to a spiritual state. According to this first philosopher of Christian mysticism, the inward path leads to a realm inaccessible to the intellect. It is this realm that the Byzantine church presents to the eyes of the believer.

An ancient Oriental custom was to ornament buildings with multicolored stones or tiles that might either form a flat surface or protrude; but the special advantages of this technique had not been exploited. In the marble mosaics of the Hellenistic pre-Christian era the piece-by-piece construction was deliberately concealed, and the mosaics made to resemble paintings on unbroken surfaces. The artist who made a mosaic floor in Pergamum went so far as to depict remnants of food with mice nibbling them, and this fashion was enthusiastically imitated in Roman houses. Such artifices were probably prized as a triumph over the limitations of the technique. The illusion was so complete that not even the grooves were visible; it was a triumph of ingenuity. The figures on the floor of the Caracalla Baths give the effect of shadow against a bright background, striking a note of boldness appropriate to the imposing structure of the great halls. This silhouette style fulfills a decorative function, but the same thing could have been done in another medium. In the

mosaic representing the Empress Theodora in Ravenna, the figures were placed side by side, statuesque yet not three-dimensional, their contours predominant. There is a well in the foreground, the main group is arranged in a single line in the middle ground, and this opens into the background. Stone upon stone is set close together, forming the pattern of garment and curtain as well as the shading of the figures.

It was in Santa Sophia that a genuine mosaic style first appeared. These recently uncovered mosaics give the impression of an irrefragable whole, though in photographs their piece-by-piece construction is evident. Instead of being adjusted stone by stone with infinite care, the tesserae appear to be thrown together pell-mell; instead of concealing the rifts between the shards, the artist treated them as parts of the picture. Tracing and modeling are not given by means of shadows and clear outlines; all contours are divided and decomposed. The mouth, a simple stroke, looks like a slip of the artist's hand, the nose consists of dark verticals ending in a flat arc. The tesserae are not cubes, rhomboids, or trapezoids. To distinguish any pattern at close range one must focus the oval of the head and the circle of the halo, though these curves are secondary to the design.

The unity of these mosaics as they appear from a distance results from the merging of disassociated elements. The figures fall into place in a glittering realm, while from the duller hues in the tesserae, as from a breath of colored

shadow, faces shine forth and hands emerge in bright light. As Gregory of Nyssa said: "The goal is wrapped in the shadow of the inscrutable," "the human body pervaded by spirit." In the figure of Mary, the lines of the fingers traced back to the wrist do not indicate bone structure; on the contrary, they make the hand transparent—a hand become spirit.

Color values determine the degree of holiness; everything contributes to the form, including the cement. Opalescent and opaque fragments of different sizes, shapes, and materials, irregularly set, are completely integrated. Pieced together from countless particles, the mosaics are of one cast, immutable. Despite the baffling disorder at close range, every shard is in perfect place relative to the effect from a distance. No longer concealing his medium but using it to full advantage, the artist achieved a representation apparently free of both material and technique. It would almost seem that the Byzantines had created these mosaics as a credo that the insignificant gathers meaning in the light of a higher reality, that the humblest things are part of the noumenal world, of the unfathomable One.

How these masters could unite four ways of seeing—the metaphysical, the intuitive, the representative, and the formative—remains a mystery. Later on, when Renaissance or Baroque painters covered ceilings and vaults with figures, they could calculate the effect from the spectator's point of view by means of geometric projection.

The Byzantine artist not only ignored mathematical perspective but had to be continually in touch with another order of reality.

From the unearthly sphere of these mosaics the face of Christ radiates an ineffable light. Gazing into eternity, inaccessible yet compellingly present, He endures by constant reappearance, His form fluctuating as though still in the process of becoming. Gregory of Nyssa claimed that the image of God is mirrored in the pure soul; had he seen these mosaics he might have wondered if the image had not been wrested from that mirror.

6

Romanesque Architecture

*The manifold character of the Romanesque period—
its worldly as well as its spiritual elements—is brought
out in its architecture. With the shaping of space
artistic form has conquered a new medium. The effect
is all the more impressive in the stark simplicity of the
space-shaping structure which marks Aquitanian
churches. Their interiors vaulted by mighty domes
represent a spacial universe, a microcosm.*

THE secular structure of the Roman Empire
carried over into the Byzantine, the Greek herit-
age acting as a counterbalance to Christian
otherworldliness. Following the political severance of
East from West, Christianity spread; thus at least the
spiritual union of the two seemed secure.

Both the Greek and Latin churches were rooted in the
Hellenistic-Roman world, but in Byzantium the highly
organized state continued to support agriculture and in-
dustry, educational and social institutions, hospitals and
sanitation, while in the West the Church was for a long
time the sole repository of civilization. It had to provide
the newly converted peoples with crafts, tools, and a
minimum of general education in countries incomparably
more primitive than Byzantium.

There is a letter written by Otto III, in 997, to Gerbert

—who shortly afterward became Pope Sylvester II—in which the young emperor complains about the crude customs and the low cultural standard of his country. The son of a Byzantine princess who had come to Saxony accompanied by Greek poets, Otto had been educated by a Greek tutor. He might well have hoped for understanding and sympathy from Gerbert, who was considered a miracle of learning, but the cleric, instead, called upon the young ruler to improve conditions in his realm and thus surpass the Greek emperor. As a Gaul and next in line for the throne of St. Peter, Gerbert could scarcely have answered otherwise. Furthermore, he foresaw the dawn of a new civilization; and indeed with the turn of the millennium the Latin West awoke.

Two hundred years before, Charlemagne had attempted to take over the style of late antiquity; the Cathedral of Aix-la-Chapelle must have seemed a mirage in an artistic desert. However, it was this very effort to create a link with the ancient civilization, if only by imitating it, that opened the way for future developments. The Late Antique Style was never really assimilated, but it proved a powerful incentive toward the achieving of a new and authentic one.

Although the Church maintained some degree of communication between monasteries, even in wild and remote regions, roads were so poor that the old centers of urban civilization drifted further and further apart, this isolation resulting in a multiplicity of architectural forms.

Romanesque churches are infinitely more varied than

either those in the East or ancient Greek temples. They may have round, angular, or both types of pillars; they may be built on the basilica plan—flat-roofed, barrel-vaulted, cross-vaulted, or domed, with three or five naves, one or two transepts—and as a hall may be single or partitioned. In view of these many possibilities, a purely schematic description of a Romanesque church is out of the question. Nevertheless, while ground plan and construction vary to such an extent, all buildings have one feature in common.

The Romanesque style stresses the definite, the concrete; what the East strove to transcend, the West had yet to acquire by a strenuous effort. A Romanesque church stands in the here and now, a sanctuary, austere and calm, utterly lacking in the festive radiance of the early Christian churches in Rome or the mysterious shimmering of the Byzantine. Resting on large pillars or short sturdy columns, it offers stability in an insecure world, its style combining the heritage of a foreign half-buried past with the requirements of its time. There is less and less of the luxuriant fantasy that in earlier stages determined ornamentation and structure.

This disciplined trend is particularly evident in the churches and monasteries of the Cistercians and the Benedictines of Hirsau. Built under trying conditions and in the most barren regions, these edifices present the Romanesque style at its severest and, like the lives of the monks, bear the mark of renunciation. The flat-roofed nave with its rectangular choir and the round pillar topped with its

sober knob are both in keeping with vows of poverty, labor, and obedience, the cubiform capital being as terse an expression of asceticism in its way as the Doric. The Doric acts as a crown to its column, the cubiform as a purely functional part, whose only hint of expression, the curve at its base, is abruptly cut short and made angular. Here the contrast between the circle and the square is striking, whereas in certain Byzantine capitals—as in the Aeolian—one geometric figure passes imperceptibly into the other, the transition masked with ornamentation. In the Ionic capital the contrast between the round and the angular is retained and neither element sacrificed; the weight of the entablature never appears oppressive. The cubiform, on the other hand, seems dominated, almost crushed, by its superstructure; it bears the stamp of forced labor on its flattened forehead. This is not asceticism as the Greeks understood it: self-mastery, self-fulfillment— but rather an expression of self-abnegation, submission.

The column in terms of artistic value had undergone a change centuries before. As long as it supported the entablature it determined the effect of the whole building; with the advent of the arch it lost the leading role and retained only its proud bearing. The entablature had seemed motionless and the column to soar; as the arch swung into movement, the column lapsed into a more and more static stance. Where motion had once ended it now began, the arch sweeping over from one capital to the other. Even when the shaft is emphasized with a leaf crown, the rhythm of the arch predominates, so that where round and

rectangular pillars alternate, the accent is always on the angular ones that agree with the arch form. Arches and vaults were increasingly used to relieve the massive appearance of buildings till they became essential factors in Romanesque architecture.

The domed churches of Aquitaine, built in the twelfth century, are rarely given their rightful place in the history of art. They had no influence on architecture in general, yet they epitomize that extraordinary civilization of the *langue d'oc* ruined seven hundred years ago. Nowhere is its value as clear as in the interior of Saint-Front at Périgueux.

The Greek-cross ground plan of this church is more or less like that of San Marco in Venice, built about a hundred years earlier. Domes rise over the four equal arms of the cross and one over the center. Yet, despite this similarity, there is, artistically, an unbridgeable gulf between them. In San Marco the play of brilliant and dim elements etherealizes the frame so that it seems to melt into an iridescent realm or hover in darkness; in Saint-Front light clarifies the structure. Geometric law is in evidence as it was in Greek buildings, but here it determines the interior. The ancient Greek temple was a corporate body; Saint-Front is a spatial form. Entering it, one is immediately aware of a world perfectly balanced and complete, an order nowhere obvious, everywhere perceptible. While offering a great variety of views, the church is utterly uncompromising in structure, clearly articulated and distinct

in every joint. Each spatial unit has its own center, all units have a main center in common. Determined by a single mathematical principle, the interior of Saint-Front has the power; it is the seal and its frame the impression.

Soaring as of its own accord, each pier, divided into four rectangular shafts, arches over into its neighbors, joined at the point of meeting by pendentives that carry the dome. The change from the rectangular to the vaulted form is signaled by a molding. The pillars, on reaching that point, relinquish their static stance to curve majestically into motion and as arches give *élan* to the vault spanning the hall.

The problem of reconciling each square area with its round dome is once again solved by pendentives. These spherical triangles, dovetailing into the angle made by the archvaults, take flight from a point slightly above the pillars, as if weightless, their wings spread. Quietly led, all structural elements culminate in the dome, which is entirely poised, fulfilled.

The organization of pillars, arches, calottes, spherical and ellipsoid sections is everywhere consistent. Form unfolds into ever-freer form. Each part fits flawlessly into the whole, giving an effect of both independent and co-operative action.

Saint-Front is a configuration of spatial units, an ordered space ensemble. The Pantheon rotunda offers itself complete to the beholder; the complex interior of Saint-Front allows but glimpses of its wall, the pillars suggesting always further spaces, further forms. At no point can it be

seen as a whole. Space-shapers leading from vault to vault, from hall to hall, the four central piers are distinct as carriers of the main dome. Each spatial district has a domed center of its own, and linked with its neighbors refers to the prime center. Thus, nothing stands isolated, nothing exists for itself alone, all architectural members contribute to and culminate in the whole, which in turn responds and vivifies them.

Santa Sophia lays a spell upon the beholder; Saint-Front discloses a system that allows for the dignity of every element within the total structure. The Byzantine church presents a vision, a miracle; Saint-Front offers a profound, secular reality. A slight deviation from the circular motif modifies the geometric standard, lines becoming fully rounded only in the dome form. The order that prevails does not appear imposed from without but rather inherent in the structural design.

The exterior has neither the same plenitude nor the same composure. A complex multiform group, its various structures are huddled together around the center. It is a conglomerate rather than a whole, an aggregate and not a self-contained entity. It stands at the edge of Périgueux, a separate architectural realm, almost another town.

The interior always gives the impression of being seen for the first time. Its rise can be traced from foundation to crown, yet one is never prepared for the total effect. Saint-Front is simplicity itself, its perfectly accordant structural units, all centered, evoking the idea of the Catholic, the Universal Church as Ecclesia.

What building since Hellenic times could stand so naked? Even a Doric temple is enhanced by sculptural representation. Any addition to Saint-Front would impair the justice of its form, although in the past it may have had more decorative elements. Its structural sufficiency is not typical of the Romanesque style; on the contrary, Romanesque interiors often seem empty, even deformed, when deprived of paint and ornamental detail.

The church of Gensac is built on a smaller scale. Although its single nave leads straight to the altar, it constitutes no mere passageway but a dwelling in itself, an arcade of dome-crowned spatial units. Each has its own center and is connected with its neighbors by a wall pillar and with the opposite wall by an arch held by a half column. The rectilinear wall pillar acts as a springboard to the pendentive, which makes a perfect transition to the round dome. The participation of every stone in the structure is clear, all upward-going elements furthering the effect of space.

Aquitanian churches of the twelfth century, such as Gensac, Saint-Front at Périgueux, and Saint-Pierre at Angoulême, are completely self-realized in their domes. The dome form is both defined and flowing, solid and fluent. Clear of contour and without ornamentation, it is articulated by stone blocks superimposed one upon the other in circular layers. This rise of matter into form reveals an attitude in man toward the outer world unlike the early Christian. Things of the earth are here recognized as the very medium of meaning.

In the combining of structural units into an architectural ensemble, Aquitanian architects initiated a federal system where all particulars, retaining their full value, join in the expression of a universal. The calmest of forms, the dome rises as if rounding the limited span of a life into eternity.

Not far from the churches just mentioned is Saint-Saturnin in Toulouse. Strikingly different from them in structure, it has a long nave rather like a tunnel, its ceiling accented by arches in the shape of hoops. This ceiling is supported by engaged shafts which in one blithe gesture ascend past two stories to the girder hoops bracing the deep vault. Interlacing the whole interior these arches, arcades, and clerestories vary in effect according to their placement in relation to the light. Romanesque in its equipoise, the barrel vault, rising into dimness, is somewhat lacking in clarity of structure.

The Cathedral of Speyer is built according to the "fixed system"—its aisles being half as wide as the central nave. In the right aisle the triangular spaces between the ribs of the cross-vault are as clear and taut as a blown sail, the ribs themselves meeting and parting as they run down the hall. The energy that goes into the shaping of this space streams through all parts of the structure, engendering form. Each vault section is a step, a station on the pilgrimage to the altar.

Only a few monumental churches remain in the pure Romanesque style. Many were completed in the Gothic period, or else spoiled by reconstructions intended as improvements. The Church of the Apostles in Cologne was

intact until recently. Its interior and exterior corresponded to each other perfectly, the solid outer forms giving answer to the spatial forms within. The church, although oblong, looked from the east like a centrally planned building, its compactness emphasized by semicircular structures topped with slender turrets.

Securely balanced, polymorphous, and full of movement, this church constituted the reconciliation of dissimilar geometric types in an integrated artistic effect. Of the many elements blended, some were typically Romanesque, others Roman, and still others characteristic of the Rhine. Almost all types of vaulting were in evidence; half-barrel and square cross-vaults rose side by side, while the main dome, octagonal in shape, stood on a drum with windows, its center lit by a lantern. This lantern form derived from the East, the niches in the choir from late Roman buildings. Original in itself, the church incorporated the knowledge of a thousand years. Moreover, it contained an invention imported from France: the six-ribbed vault. With the dissection of that one vault, a new and final chord was sounded in the music of Romanesque architecture.

The exterior of a church in this style can be reproduced with building blocks; but the interior no miniature model or photograph can ever suggest. Its size is essential; these dimensions and no others accord with the form, producing an effect of solemnity. More expressive than its outer structure, the Romanesque interior relates to a reality nowhere objectively present.

18 S. Giorgio in Velabro, Interior
Rome

19 St. Front, Interior
Périgueux

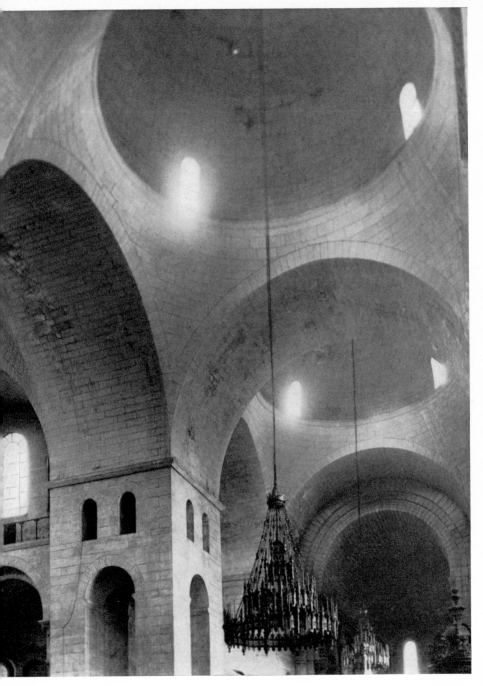

20 St. Front, Vaulting

Périgueux

21 Cathedral of Speyer, Right Aisle

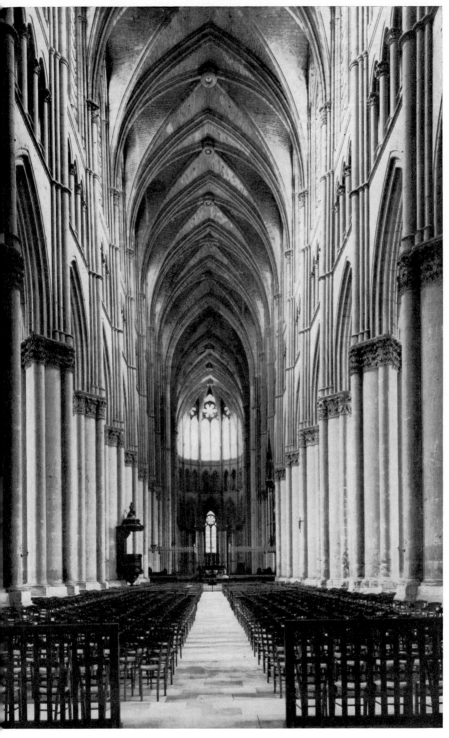

22 Cathedral of Reims, Interior

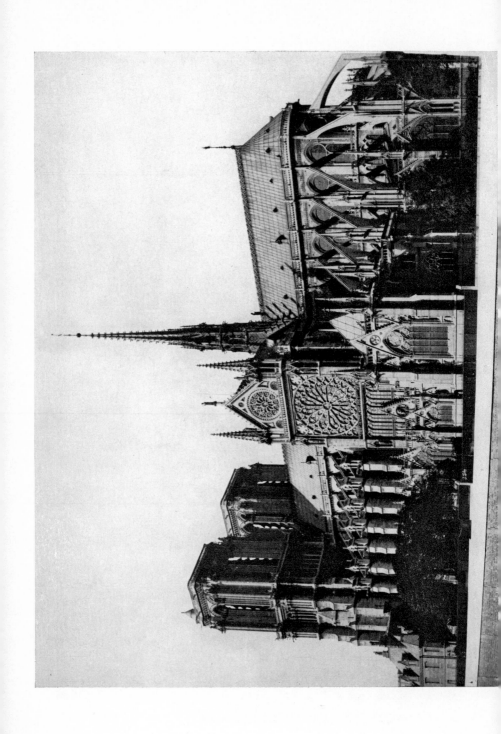

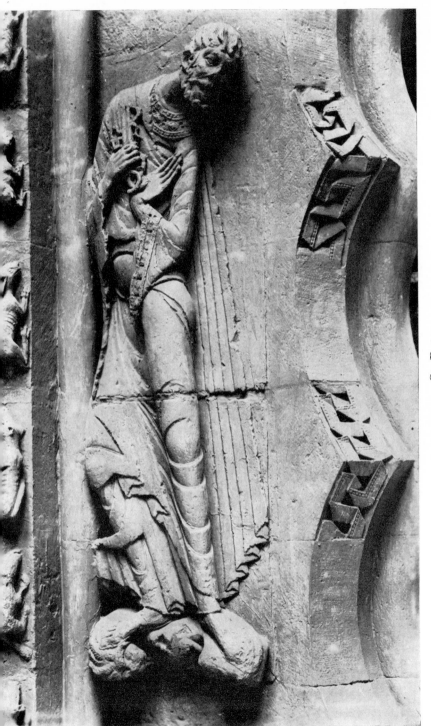

24　St. Peter

Church of St. Peter, Moissac

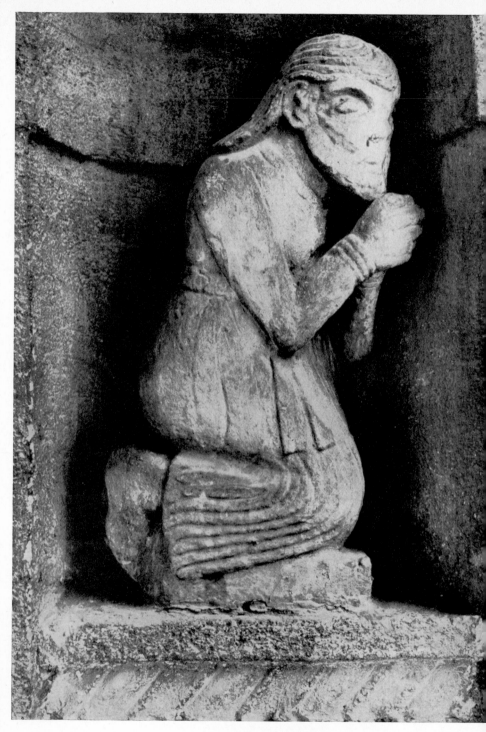

25 Praying Man
St. Jacob's Church, Regensburg

26 Griffin from Tympanum

Museum, Angoulême

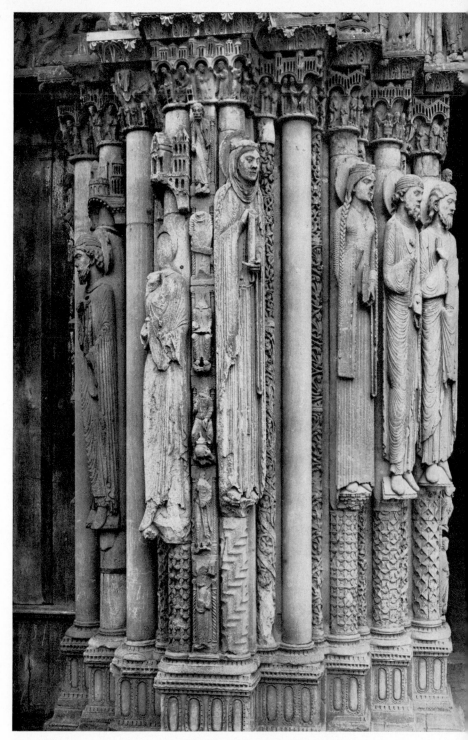

27 Pilasters of Royal Portal
Cathedral of Chartres

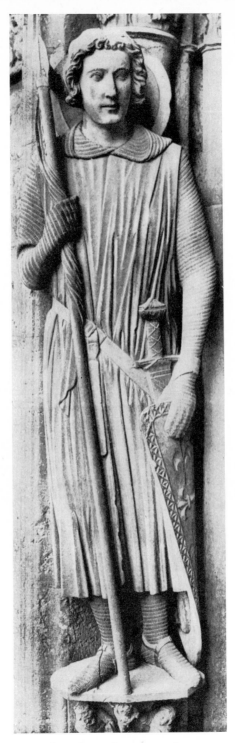

28 St. Theodore, from Southern Portal
Cathedral of Chartres

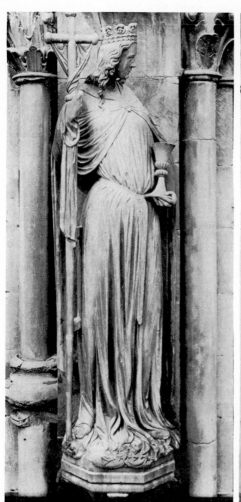 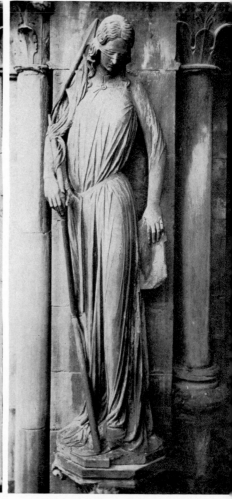

29A Ecclesia, Portal Figure 29B Synagogue, Portal Figure
Cathedral of Strasbourg *Cathedral of Strasbourg*

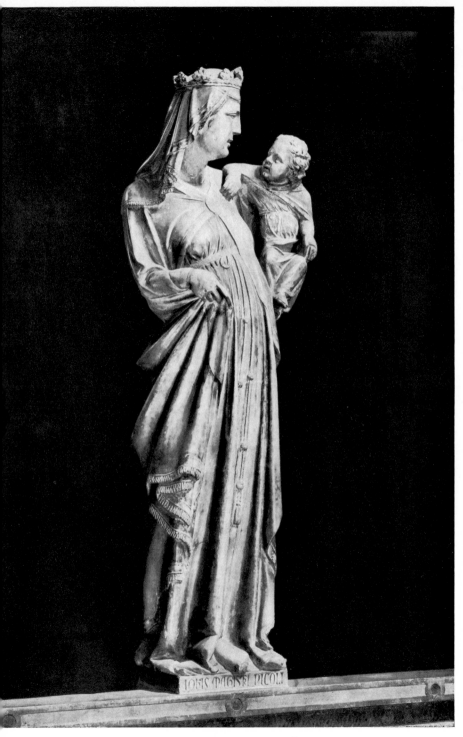

30 Giovanni Pisano: Madonna

Madonna dell' Arena, Padua

31 Folio from the Gospels of Kells
Trinity College, Dublin

32 Frontispiece from the Gospels of Otto III

Staatsbibliothek, Munich

33 Folio from the Gospels of Henry II
Staatsbibliothek, Munich

Within the church one is aware not only of oneself as part of it, but of something the space form itself communicates. While Santa Sophia abolishes all connection between man and the known world, Saint-Front calls upon man to meet the known with all the freedom he has, till life, responding with increase of form, reveals that freedom through the achieved, the integrated whole.

"What is man?" demands the Psalmist, leaving no doubt as to the misery of the human state. Then he concludes: and yet this puny being, contemptible in the face of God and all creation, is by his spirit "crowned with glory and honor." Saint-Front evokes both aspects of the psalm. Man is nothing; man stands, creator of a world redeemed through form—the same that towers above him, and within.

7

Gothic Architecture

The mystical and the rational are blended in Gothic churches. This corresponds to the completely new structural system of the Gothic style where the interdependency of all elements tends toward the common transcendental goal. In this way St. Thomas' hierarchy is anticipated by the building as a whole, whereas the stained glass windows will symbolize his conception of individuality.

CROWNING the spatial forms of Romanesque churches, the domes of Aquitaine evoke the words of Hölderlin: "The perfect knows no complaint."

While entirely different in character, these churches, by the co-operation of their independent elements, are somewhat akin to Greek temples of the fifth century B.C. The austere architecture of classical times had been superseded by a dual style, tenuous on the one hand, elaborate on the other. The solemn interior of Saint-Front could scarcely have been prettified; a dry academic reiteration of it might have been possible. What actually was done can be seen in the Cathedral of Laon, whose portals and windows are deeply recessed, its single parts overemphasized, impinging on the concerted whole. This trend was cut short; a new fervor had taken hold of man's spirit.

Though certain Gothic elements became evident in Romanesque architecture, the change from the old to the new style really marked a break with the past, a fracturing of earlier Medieval forms. Arches and vaults were no longer equipoised, space was no longer limited; man found no answer in the round harmonious dome. Earth held no peace, nor could life rest till reaching home in God.

Thus St. Augustine's words, *"Inquietum est cor nostrum donec requiescat in Te"*—the heart is restless until it rests in Thee—rose up as stone in the Gothic style. Discarding the perfection of a self-contained form, Gothic architecture points beyond its immediate to its transcendent goal.

In the Cathedral of Reims the technical construction is apparent; joints look like hinges, shafts like stilts. Only the clustered columns retain some independence of form, though they are not crowned with genuine capitals but decorated with sculptured wreaths. The interior is so overwhelming that these details are not at first distinguishable; one sees only a surge of upward-rushing lines. With scarcely a pause at the molding, the pipelike shafts shoot straight from story to story, then separate and curve, meeting as ribs in the pointed vault. The naves seem almost to flow one into the other; nowhere does the form come to rest, nowhere is it self-realized.

Looking toward the altar, one covers the distance of the central nave in a flash, the columns in perspective appearing more and more like flutes. Nor does the transept give pause to the eyes. The choir and its garland of chapels branch out at the end of the nave, suggesting a new and

luminous realm. The light, refracted by the stained-glass windows and interrupted by the rhythmic shadows of pillars, arrives like a messenger from another world. Penetrating the church, it almost dissolves the walls, belying the difference between matter and space, form and air. All is expectancy, everything absorbed in listening.

Steep vaults receive the upward movement as it threatens to pierce the ceiling with its countless, ever-renewed thrusts. The columns alone affirm their base, while the continuing half shafts quicken the eye with the song of their flight. Pointed arcades reach from the lower almost to the second story, their impulse only strengthened by the transom.

In Saint-Front the carved molding marks the change from one shape to another, in Reims it merely accelerates the pace. In Saint-Front the domes round off and appease motion, in Reims the keystones of the vault catch up all tensions for further effort.

Everything is on its way, the interior made evanescent by those windows which outshine the day, the exterior with its flying buttresses and widespread counterforts overlapping the building into outer space. Spun out like spider webs, all solids dwindle, the frame itself a lacework of plants, animals, human and geometric figures. Instead of synthesizing, the Gothic structure unites them all under a shared and sovereign principle. Some critics see this architecture as ecstasy pure and simple, others as a strictly rational system, a triumph of mathematical ingenuity. The style, indeed, contains mysticism and mathematics;

both, present in the form, are pushed to an extreme where the two meet. Number is the scientist's key and the architect's as well, but who knows the meaning of number? Even the mystics have wrestled with this problem. In the Gothic equation all known factors refer to an unknown, all calculable elements to the incalculable.

The interior rises on pillars and shafts as if they alone held it; on the outside the mechanism is clear, but the scaffolding is so delicate, it seems barely able to support itself. One would think there was some hidden energy at work, lending a supernatural strength to those frail forms.

Gothic architecture is a movement, a process requiring the consecration of all structural members to the continuous rising of the whole toward its transcendent destination. The wealth of shapes and the attenuation of the frame give the church the effect not of a solid, but of an act, a straining of nerve and will to outreach the reach itself, an expression of the highest devotional intensity. The spire, neither an end nor a consummation, rises like a signal, flashing from world to world.

Light and shadow take on substance, matter trembles on the verge of dissolution. Here is no Byzantine representation of infinity, nor is the Gothic church like Santa Sophia a massive protection against the outer world. Its exterior strives with the same energy as the interior away from the earth and up. In the maxim of St. Thomas, "*Ars imitatur naturam in sua operatione*"—if *natura* is understood as that which is ever about to be born, continually becoming, then this dictum could be applied to the Gothic

cathedral. Plants, animals, saints, and devils, as creatures of God and capable of redemption, all have their place on the church.

In Santa Sophia the interior is sovereign as to form; in the Church of the Apostles the interior and the exterior correspond perfectly to each other; in the Cathedral of Reims the interior and the exterior join in a fervent ascent away from what is toward what is longed for. Byzantine architecture consists of interacting parts whose function is entirely concealed; Romanesque architecture is composed of regular geometric figures that give it a convincing simplicity; Gothic architecture is an intricate system whose primary effect is one of motion. In this style the pointed arcades between the main and lateral naves, the ribbed vaults of the ceiling, the walled triforium and choir arches, all have an imaginary center outside their immediate frames, inasmuch as their two-way-traveling lines are the partial peripheries of huge and separate circles. The radii thus implied, intersecting aisles and columns, crisscross the whole church. This same principle holds in the exterior. The Gothic is a dynamic structure, its every center projected out of architectural context into infinite space.

Late in the style when transoms and capitals were completely eliminated, pillars were made to flower out into multiple ribs rounding the vault. Tension thus resolved, motion flowing back and forth on itself, the form lost its transcendent implication; the goal fell within reach. This solution, far from consummating the style, merely weakened its expressive power.

In Byzantine mosaics the nonessential had been turned to full advantage, the cement contributing almost as much to the effect as the brilliant shards. The role played by the tesserae in the Byzantine church is comparable to that of the stained glass in the Gothic cathedral. These glass fragments have slightly more shape than the shards, and, inset by means of narrow metal bars—themselves a pattern—give a composite picture. Those windows, shutting out the world, seem to generate their own radiance as if shining with the inner light referred to by the mystics. Although fragmentary, each glass piece participates in that pictorial community which is the whole. According to Thomas Aquinas, man, unlike the angels, who are entire, is limited by matter and only fulfilled within the community of men. Thus, mankind as a whole, and no one man, is an entity indivisible.

The Gothic church draws the eye irresistibly from the actual to the transcendental, prefiguring St. Thomas also in his claim that the mind ascends through the senses to the Idea. A follower of Aristotle, he erected his philosophy on a thoroughly rational foundation. However, though he opposed the neo-Platonists, he took over the mystical hierarchy of Dionysius the Areopagite and with it crowned his system. Society, as he conceived it, was but a substructure for the kingdom of heaven and should be regulated in accordance with that sovereign order. Only in heaven is the human community consummated; on earth all endeavor is but *praeambula gratiae.*

The similarity between St. Thomas' philosophy and the

Gothic cathedral shows that art may precede theoretical formulation. With a logic inherently different from that of the conscious mind, art is immediately self-revealing, its meaning identical with its form. Architecture, with its own set of facts, presents its own conclusions. Based on the laws of physics, the cathedral stands, an actualized spiritual body concentrating every effort toward the Christian Idea. While Saint-Front suggests self-realization within a self-contained world order, the Cathedral of Reims presents the striving for redemption through self-surrender, a unique relation between the taut and the relinquishing will, between will and willingness. Matter almost becomes energy by virtue of its upward drive, just as man, in his straining toward the Absolute, surpasses himself.

The Beauvais Cathedral, because of the extreme tension to which its fragile frame was subjected, collapsed while under construction. It was as if human strength, having reached the limits of the possible, foundered and fell.

The interior of Saint-Front, as a conception of earthly fulfillment, might have tempted man to forget his essential inadequacy, and, indeed, there was a trend in this direction in the country of the *langue d'oc*. At the same time, however, just prior to the brutal Albigensian War, came a new call from the Church to renounce, to repent. Orders with rigid rules were founded, self-abnegation praised as the authentic Christian way of life. This extremely ascetic trend was epitomized by one man: Bernard of Clairvaux. His correspondence with Peter Venerabilis, Abbot of Cluny, reveals the same divergence of values between the

two monks as there was between Gothic and Romanesque architecture. Bernard demands absolute obedience to religious disciplines, regardless of the different constitutions of men; he rejects the requirements of the body and of the world. Peter Venerabilis, on the other hand, recognizes such needs and advocates a variety of methods for the religious life and the salvation of the soul. Bernard, though only Abbot of Clairvaux, was actually an unofficial sovereign in Latin Christendom. From his monastic cell he wrote, chiding popes, monarchs, and noblemen; preaching, he held sway over great masses of people, rousing them to frenzied enthusiasm. A decisive influence in both the clerical and the secular world, he dominated by sheer force of personality.

Just as on Gothic cathedrals creatures emerged so vital in appearance that it seemed they had only to abandon their setting to take part in the temporal world, so Medieval man, strengthened by the discipline of a religiously ordered system, was now ready, as the authority of the Church began to wane, to step forth, an assertive individual.

8

Medieval Sculpture

Animals in early Medieval sculpture are corporeal and lifelike, while the human body is denied either volume or expressive form. The understanding of this discrepancy is also a clue to the later stages of Medieval statuary.

THE relation of sculpture to architecture varies in every period, with every style. The Egyptian statue is mathematically delimited, the Egyptian plant column patterned after nature. The Greek statue gives the deathless form of the human body; the Greek column suggests a life motion. Byzantine sculpture lacks mass and volume; in Byzantine architecture the spatial form is sovereign to the frame. Romanesque statues, heavy in appearance, have little relation to the actual body. Linear in their expression, they stress the inner life as against structural form.

The Descent of the Holy Ghost on the semicircular tympanum of the church at Vézelay grips the beholder at once with its rapture. In this scene the event represented is supernatural; but there are individual figures also in the Early Medieval style that give the same effect. The *Proph-*

ets on the corners of the Vézelay church, as well as *Peter* and *Isaiah* on the portal of Moissac, are in a state of ecstasy. Occupying impossible positions, as if transported beyond themselves, they seem independent of foothold and background. The ability to portray exaltation in such a way would indicate a familiarity with the spiritual themes treated in Byzantium. However, Byzantine relief figures, icons in particular, impart a vision. The Vézelay and Moissac figures, on the other hand, show rather a visionary state.

On the façade of Saint-Gilles, *Cain* and *Abel* are represented in heraldic style, their two forms contrasted as in a graphic design. By the ornamental ordering of wildly moving lines, the action of a moment becomes everlasting. Fixed in that pattern, the two figures converge, giving a sense of inevitable collision.

Since late antiquity sculpture had been done primarily in relief. This art has some of the advantages of painting and drawing: freedom of line and security of movement. Bound to and supported by the solid background, figures emerge convincingly as form. Relief was to Romanesque sculpture what the vault was to Romanesque architecture: a means of lessening the effect of gravity and mass. In architecture solid and spatial forms correspond to and determine one another; in sculpture the line predominates, set off by the stone.

The linear stress is particularly evident when a heavy, compact mass constitutes the volume without having the form of the human body. The kneeling and seated statues

of St. Jacob's Church in Regensburg are not so much
sculptured from as carved around their inert and clumsy
blocks. Outline and gesture speak, but dispiritedly, gagged
and muffled by the stone. Human figures are crammed into
that formless mass, their faces and hands sketchily indi-
cated, while animals are shown realistically crawling and
leaping, tangled snakes, no matter how ornamentally ar-
ranged, appearing alive.

Even fantastic creatures seem real, the Griffin at An-
goulême an aristocrat among them. Descended from a
fabulous family, this Griffin surpasses his forebears in
form, organic structure, and vitality. Oblivious of his
frame, his tail repeating the palmette pattern of the
border, he has a gait, a motion of his own. Carefree,
haughty, and very alert, he prances forward, delighted
with himself, to take his place among the living.

An art so sensitive in the shaping of slender animal legs
and supple necks, so candid in its representations of
crawling, eating, crouching, grabbing, cannot be said to
lack sensuality. Had these animals been intended only as
symbols, a stereotype ideography would have sufficed to
characterize them. Nor is their amazing physical direct-
ness merely derived from the Oriental and Nordic tradi-
tions, where animals, though compellingly rendered, are
primarily ornamental in type.

An animal in Early Medieval art was granted what was
denied to man: a completely natural body. Man, being of
another order, had to be represented accordingly; into man
God had breathed His spirit, and this spirit alone was

worth expressing. Since the eternal dwelt only briefly in the body, the body could not image it. Therefore, the essential had to be signified by either showing the figure in seizure, as in Moissac, or making it a prison where the soul is immured, as in Regensburg.

The continued influence of the Late Antique and Early Christian styles is evident in the statues of Saint-Gilles. As compared with the *Cain* and *Abel* relief in this church, or with the *St. Peter* at Moissac, these sculptures appear solid and somewhat personalized. Actually, they are only statuesque images; they do not embody form. The rectangular stone block, while constituting volume, does not compose the figure. Because of its strictly frontal, almost rigid posture, the statue is monumental but not a genuine sculpture in the round. The chiseled lines and darker furrows enhance its graphic aspect, giving it somewhat the same effect as Late Antique and Early Christian reliefs. Placed between lateral pillars and the lintel, these saints, as in a picture frame, gaze significantly into the void, rather like icons. The animal forms and ornamental plant motifs next to them, in contrast, are well rounded and very animated. As compared to Hellenic and Roman statues, the Late Antique, Early Christian, Byzantine, and Early Medieval figures all appear strangely incorporeal. There had to be a change in man's attitude toward the human and the natural world before sculpture could re-emerge in its own right and the single figure assume its rightful status.

The style of the Saint-Gilles statues marks an important step in this direction. It might have led to true sculpture

in the round, had the civilization of the *langue d'oc* not been destroyed. But the troubadours were silenced, the countryside devastated, townships and counties no longer autonomous. The language, which as literature stood second only to Latin, lapsed into a dialect. The new life, however, did not entirely die. Dante's *Vita nuova* bears witness to the enduring influence of Provençal poetry—those forms which for the first time since antiquity voiced man's natural feelings. The trouvères of the *langue d'oïl* followed the troubadours of the *langue d'oc*, but never attained to that first wealth of poetic themes and rhythms.

With the destruction of the Provençal civilization, a sculptural style developed, very different from that of Saint-Gilles; an effort was made in the Île de France to resolve the strained relationship between matter and form. Firmly fixed on slender columns and thus integrated into the building, statues looked out from the church façade, having as yet gained little more than a new bondage. The figures on the Royal Portal at Chartres are rigid, their bodies tenuous and very thin. The stone, however, is no longer an inert mass, a mere vehicle for a linear image; the stereometric and the human form are inseparable. The circumference of a cylinder, described by a robe, holds each figure in a geometric and hence permanent form. Backed by its column and carried by the energies rising in the shaft, the statue hesitates, afraid to breathe.

Here, as compared with the archaic Greek statues, the mantle is not accessory to but composes the figure. The *Hera of Samos* gives organic form to her solid cylindrical

shaft; the saints at Chartres with their hands and their robes merely draw the periphery of the cylinder. A cylinder is determined throughout and artistically meaningless, while the human body, however slightly indicated, implies the uniqueness of the human being. With the rapprochement of these two orders—the abstract and the animate—the impersonal and the expressive were no longer mutually exclusive as to form.

The statue of *St. Theodore* in the transept of the Cathedral of Chartres does not itself describe but stands within a cylindrical area, defined by the pedestal and canopy. His face is surprisingly lifelike. Intent on an inner voice, he emerges as a responsible agent, more the heroic saint sustained by a mission than the meek saint carried by the column. Unlike *St. Peter* at Moissac, whose every gesture is ecstatic, *St. Theodore,* by the expression of his face, reveals an inner resolve. Thus the head in Medieval sculpture came to be the spirit's dwelling place. The body is more tangible than that of the early portal statues and has a certain motion, but it is the head that communicates being. Secure as defender of the faith, the saint took his place in this world, just as medieval man, his freedom restricted, began nonetheless to assert himself as an individual.

The statues of the *Ecclesia,* personifying the Church, and the *Synagogue* on the Strasbourg Cathedral have a motion, a rhythm, of their own. Diaphanous and noble of bearing, their bodies shine through the light veil of their robes, delicately formed. The *Ecclesia* is all triumph and

joy, the *Synagogue* sorrow and humility, her eyes symbolically bound. Their garments, draped at the base, help carry their slender figures and in the flow of those lines echo triumph and joy, sorrow and humility. Each is flanked by columns and supported by a rectangular wall pillar. Severed from that architectural setting they would lose in clarity and effectiveness; it is their link with the background that gives them their lyric stance.

The statues of *St. Mary* and *St. John* in Freiberg (Saxony), erected later than the *St. Theodore,* the *Ecclesia,* and the *Synagogue,* are monumental in character. They have a tragic stillness, an austerity and grandeur of form, equaled only by the archaic robed figures of antiquity. Suggestive of columns, they once stood high on the arms of a cross in the church interior. There is a Byzantine ivory Madonna in the Metropolitan Museum of New York that, despite its tiny size, has a dignity of bearing, a marked presence, reminiscent of the *Mary* in Freiberg. It is almost as if this small relief had been transposed by a Romanesque artist into sculpture in the round.

Compared with the calm, gently undulating folds of *Mary's* robe, the drapery of the Naumburg figures surges up like a gathering wave or falls straight and heavy to the pedestal. Everything is calculated to animate the mass, to divide and break it up in order to enrich and stress the forms. Far more robust than *St. Theodore,* these male statues at Naumburg are unmistakably of this world, self-confident and full of life, their physical character strongly marked. The support afforded them by the church wall is

concealed; they appear to be their own masters and to stand by their own will, though somewhat unsteadily. Most striking in the Naumburg crucifixion group is the figure of *St. John,* tormented and writhing in anguish. His vehement gestures, while equally exaggerated, are entirely different from the transports of *St. Peter* at Moissac. The Naumburg sculptures are highly dramatic and subjective in expression, but unlike the earlier figures, they are not stirred by suprapersonal emotions.

The Italian artist Giovanni Pisano strove for unity of form, while introducing a new dynamic relationship between sculptures in the round. He created monumental works at a time when the Gothic style was beginning to become ornate. In all his statues of Madonna and Child the two figures are in close and active communion, although physically less linked than ever before. The Child, no longer held close to its Mother, rests on her arm, a small individual with a life and direction of his own. The new nearness is conveyed by the gaze between the two, unifying them in silent dialogue. Time and again Giovanni creates this intangible communication, more powerful than any physical proximity.

A mutilated fragment, the *Madonna* from the Campo Santo of Pisa, surpasses by her stern bearing and the severe angle of her head all of Giovanni's later works. His Paduan *Madonna,* in contrast, has a swinging contour and a sovereign motion. Without the Child clinging to her shoulder, she would be less a mother than a queen.

The last work in the medieval monumental style is

Claus Sluter's *Madonna* in Dijon. This statue, supported by a large pillar, has a powerful *élan* enhanced by the strict self-containment of the form. The sweeping upward fold of the robe accelerates her forward step, framing her face and giving volume to her figure. Animated by lights, shadows, and swirling waves of drapery, she has a sureness of stance and an energy that transfuses even the weight of the material.

The concentration of all spiritual forces in the sculptured head is the culminating achievement of the Gothic style as regards the individual figure. The *Moses* of Sluter's fountain, with his mighty self-assurance, majestic carriage, and leonine head, overrules the submissive and suffering figures of late Gothic art, while his *Madonna* oversteps the Gothic boundary and forsakes the pillar, reaching out with a gesture into space.

It might be claimed that Sluter's *Madonna* marks a stage of evolution comparable to that of the *Nike of Samothrace*. This would imply that styles develop according to morphological law and follow a recurrent and predictable pattern. To assume this is to identify man's creative power with a natural process and to negate spontaneity. Great works by their very essence rise above their time, and, having no forerunners, refute the mechanistic theory that confines our understanding to the already known. If we study Greek and Medieval sculpture without clinging to preconceptions and disregard at least in the beginning

what we have read of these periods, we may achieve a real insight into the art of both.

Statuary in Greece was disciplined from the beginning by its reference to the geometric standard. Never extrinsically bound to it as in Egypt, the free-standing figure came to evince an entirely mutual relation between its vital and geometric elements, neither overruling or outweighing the other. The Greeks, considering nature to be essentially consistent, strove to bring that coherence to light in the sculptured body. Out of the meeting of rational structure and the human image the statue rose, the epiphany of a universal order. Epiphany to the Christians was a miracle, the advent of the Divine. The less there was of the sensual, the material, the closer a thing was to the Truth. They desired not evidence but vision, not knowledge but revelation.

Permanent being to the Greeks was proved by the concrete, the clearly defined. Not until Plato was their conception of reality shifted to the realm of ideas. Permanent being to the Christians was spirit. The main theme in sculpture must be the soul. This was done by stressing linear expression to the utmost while diminishing the structural form. Just as the pious man was an instrument in the hand of God, surrendered to the divine will—his body a mere hindrance to his soul—so the sculptured figure was either shaken by religious fervor or else so frail as to be almost nonexistent. Only as a Christian saint— and hence a symbol of the spirit—could the statue have a

leading place at the entrance of a church. Subject to a pre-established order in the same way as a good Christian is subject to a prescribed mode of life, the statue remains within the area assigned to it.

Bowing to no decree, its motion released by its architectural frame, the Greek statue gained animation. The ability to assimilate heterogeneous elements is peculiar to the living organism; the Greek figure, by a like absorption of its own dissimilar elements, gathered expression and an effect of spontaneity. In this way the statue attained through form what the organism achieves through life, and without being naturalistic it appeared organic.

The Medieval statue moving from bondage to freedom was eventually united in line and volume but never acquired a convincing bodily form. If the figures of the *Ecclesia* and the *Synagogue* in Strasbourg are lifelike in shape, it is because they represent religious communities, not actual people. What was granted to the collective entity was denied to the individual. As spirit moved into the foreground, the body receded. All personal expression was localized in the head, as in the *St. Theodore*, or in the glance, as in the *Madonna* groups of Giovanni Pisano.

The *Nike of Samothrace*, dynamically integrated, advances as a unit, accompanied by robe and wings, her breast almost bare to the wind, her whole body intensely alive. The swirling folds of Sluter's *Madonna*, lending volume and resonance to the figure, give visible expression to her interiorized emotion. The Medieval pathos of

the soul has nothing of the Greek passion for life. Never asserting itself against a superior power, it suggests a stormy self-abandon. With Sluter's *Madonna* the statue rejects confinement, stepping away from the pillar that had once determined and sustained its form.

Strengthened within the architectural community, the statue, like the individual in Medieval society, forsook the area assigned to it and laid claim to an increasing freedom.

9

Romanesque Painting

*Size—generally as essential, in works of art, as propor-
tion—is unimportant in Romanesque pictures. Murals
and miniatures could be exchanged by simply reduc-
ing or increasing their size. The reason for this startling
fact and the uniqueness of this style are set forth.*

ARCHITECTURE as solid form gives shape to
the space it frames; sculpture corporealizes the
space of imaged being; painting disposes freely
of the space it renders.

Egyptian murals and Greek vase paintings have a self-
evident consistency; the formal unity of Romanesque
pictures almost eludes analysis. To trace the influences at
work in Early Medieval miniatures is not very revealing;
never as an agglomerate of parts, but only as a whole can
this style be grasped.

Irish illuminated manuscripts stand somewhat apart
from the rest. As a rule, they consist of a vigorous tracery,
a kind of ornamental design that, despite its geometric
character, has no coherent pattern. Coiled and whirling
lines run unpredictably around or over the page, restless,
emotive, almost too intricate to follow, as if the style

lacked any underlying law or frame of reference. Unroll-ing aimlessly without end, its motion seems subject to mere impulse, change occurring for the sake of change. Such knots and twists are all the more interesting when a figure appears among them. Stiff and symmetrically ar-ranged, it does not much resemble a human being but it can be identified, whereas the maze of lines composing the borders of the page or the page itself strains percep-tion.

Since the character of such a style is scarcely to be de-scribed, it might be helpful to compare it briefly with East and American Indian art. East Indian forms are luxu-riant representations of the instinctual, sensual world in all its absurdity; American Indian forms give fragments of limbs, misplaced and resulting in monstrous shapes—wild impulses and frightful specters become tangible, expres-sive of horror and lust. Next to such ghoulish fantasies Irish imagery seems almost sober. At least its lawlessness is im-personal, abstract in that it neither renders nor purposes a real object, while the human figure represented is se-curely fixed in the welter of lines with an order, a certain status, of its own.

These Irish illuminations are further removed from the Greek and Christian conceptions of form than any other Early Medieval paintings. Traces of the Irish style can be found, however, throughout Romanesque decorative art and in almost all the illuminated manuscripts of the pe-riod.

In contrast to Irish miniatures, the Gospel Book of

Otto III is clearly traditional in style. Despite its modest size, the title page is monumental in character, its focal point the figure of the Emperor. Enthroned and dominating the scene, he receives the homage of figures moving toward him from either side. The intensity of the picture is stressed by its restraint. The Emperor, in frontal position, constitutes the motionless center, the goal and the occasion of all activity—rather like Aristotle's Prime Mover.

This picture could just as well have been painted on the wall of a coronation hall as on the page of a book; many times enlarged, its form would remain unimpaired, neither size nor placement being of the least importance.

Although there is no question as to the two-dimensional character of this work, it contains certain elements of perspective and foreshortening that formerly had been used in painting without depth to indicate space. In the Gospel Book of Otto III they serve quite another purpose. Striking the figures out of any familiar spatial context, they make them appear totally nondimensional. This is done by means of irregular lines and breaks, which, disturbing the planimetric effect, give but the slightest illusion of depth, and just enough to ruffle the surface. The sense-perceived world, neither transposed, as in Egypt and Greece, nor supernaturalized, as in Byzantium, is literally thrown out of kilter. From this remarkable disorder, this spatial anarchy, a new order comes into being—not mindscape, it has nothing to do with the mind. The retention of the plane attenuates the forms, while the faint

suggestion of volume somewhat estranges them from their pictorial surface. All distinctions between spatial values known in the world of things dissolve in this realm. Figures are represented in the nowhere, but with such force that they are immediately plausible.

On other folios of the same Gospel Book a stricter ornamental technique is applied. The geometric pattern with its reasoned restraint and the free-flowing rhythm with its emotional intensity set each other off, interdependent as the factors in a mathematical function. Animals in unconstrained and natural positions are perfectly integrated into the picture, compatible with both the metric and the rhythmic order. Each illuminated page speaks, evoking instantaneous response.

A scene from the Gospel Book of Henry II reveals the style at a later stage. The lid of Christ's tomb, flung open, cuts abruptly across the pictorial surface. An angel points to the empty grave, his robe, wings, head, and limbs arranged radially in a wheel pattern. The signaling arm, disproportionately long, is thrust out in an imperative and solemn gesture toward the place of miracle. This inconsistency of scale, odd in the physical world, is psychically valid. In yet another picture the angel brings the tidings of Christ's birth to the shepherds. One impetuous motion —the vibrant space of a wingbeat—and the whole scene is caught up in the angel's stance, the event projected somewhere outside of time.

The joining of the geometric, the predictable, and the vital, the unpredictable, has always characterized West-

ern art, but their specific combination in Romanesque painting and what that blending expresses was unprecedented. The Greeks infused their functional structures with a life motion, and gave permanence to their sculptured figures with geometric forms; they exemplified their conception of a universal principle, showing how it could embrace both the geometric and the organic. In Romanesque painting geometric motifs serve not to objectify anything independent of man, but rather to indicate where accents fall according to the human heart. Thus, proportions are determined by emotional points of stress, the size and order of everything presented entirely in terms of how man feels.

Ornaments, as the Greeks well knew, can be enlarged or reduced without detracting from their artistic effect. The same is true of these miniatures. This peculiar fact, however, is in no way explained by their ornamental character; artistically they far exceed any purely decorative form.

As a direct expression, unaffected by the corrective mechanism of the mind, the singular idiom of these illuminated manuscripts can be apprehended at once. These miniatures, with a set of relations hitherto undisclosed, communicate psychic processes more than actual scenes. What we generally call abstract is here a prime experience, an ideographic expression—the keynote of all Romanesque painting. The sudden halt in the running lines enacts emotion arrested. Just as medieval Latin, the horror of classical scholars, released the language from its tight

and logical structure to a new eloquence, so the Romanesque style gave painting a new freedom, a further intensity.

In the sense that an inner picture is neither "large" nor "small," Romanesque miniatures are immeasurable, their virtual distance unchangeable. It is this "distance" and not their actual size that is essentially theirs. The contradiction of a nonspatial representation having a barely suggested depth makes for this independence from numerical proportions. Resisting the third dimension, yet never confined to the plane surface, Romanesque painting is only at home in the measureless within man.

While the miniatures could be enlarged without loss of form, most Romanesque murals could be shrunk to page size and retain their full value. The murals on the crypt of Notre-Dame de Montmorillon are not in keeping with the church's austere architecture. The Virgin Mary, although the main figure, is engulfed in a tumult of lines. This mural falls short of many a miniature in intensive magnitude.

Others have a truly monumental character, particularly those where the Byzantine influence is strong. The *Madonna* at Hoch-Eppan, in the Tirol, gives the effect of being at an immense distance from the beholder. Clearly and vigorously outlined, very grave and calm, she breathes with a spirit beyond space, a majesty beyond time.

In the murals of the Cathedral of Gurk, the original colors have faded and the impression depends almost entirely on design and composition. The figures, niched in a painted architectural setting, have no artistic space of their

own. They represent statues, and though volume is scarcely indicated, they gain in depth by the pictorial background. As Romanesque painting was gradually made to conform to its position and location in the building, it lost its original independence of form. Those exclusive relational values were abandoned for the requirements of an architectural environment, and size became important.

While the Romanesque style is in many respects similar to the Byzantine, the space in Romanesque painting calls to a space within man himself, whereas the space represented in Byzantium is transcendent, miraculous.

To reconcile Christianity with the conditions prevailing in fierce medieval Europe required a tremendous effort of the spirit. Romanesque art did not altogether reject external reality; in painting the human body was at least intimated, while in sculpture the figures, although not rendered convincingly, had mass, volume, and weight. Thus, some attempt was made to bridge the gulf between matter and spirit. As the main stress in the Romanesque style is always on subjective reality, any relationship with the sense-perceived world was sought in those terms. Objects were never considered objectively; in the measure that they were felt they were recognized and given a place. What distinguishes Romanesque painting from that of any other period is its indifference to both two- and three-dimensional form, an indifference resulting from a shift in the focus of man's attention. Essential to the style is not motion, but the flow of emotion; all elements refer-

ring to this are stressed, whatever their actual status. Concepts as well as purely emotional currents are represented in such a direct and immediate way that a corresponding feeling is at once evoked in the beholder. We are confronted with a new and unique sight, incongruous but consistent, a hierarchy of inner values projected in physical terms without being transformed, and subject to its own laws, much as *le coeur a ses raisons.*

This is the picture left us by medieval man; a scaleless style involving the fusion of many devices, eclectic as to means, original as a whole. Events and actors are secondary to its main theme: man's inwardness. Epitomized in those illuminated manuscripts, Romanesque painting is a challenge to Goethe's cry: "When the soul speaks, alas, the soul no longer is speaking."

10

Gothic Imagery

The Gothic period created among other forms the
Specific Miniature Style, which made the folio its own
artistic domain. Illustration, decoration, drolleries, and
text unite in a rhythmic performance throughout the
illuminated manuscript. Their never-ending motion
suggests further phases, elucidating a trait peculiar to
Gothic form: its being "transitive."

ROMANESQUE painting and sculpture commun-
icate a virtual realm independent of proportional
values in the known world. The statues of the
Freiberg *Crucifixion*, columnlike in appearance, were
placed on the arms of a cross high in the church interior
and, though physically unrelated to one another, formed
an authentic group. While here the distant wall of the
choir serves as a kind of background, other works give a
group effect without it. The high-relief sculptures on the
Romanesque Angoulême Cathedral, separated from one
another by arches and columns, are distributed at various
levels over the façade of the church, each in its own partic-
ular area. Viewed in the ordinary way, they are isolated,
each within a framed world of its own. Yet the figures are
charged with an intensity that links and refers them to a
space beyond the wall. They appear to recede into an in-
definable depth and to unite in a mind image.

When statues on the façade of Gothic churches occupy niches or clearings they also are separated from each other, fitted into small spaces, roofed by a canopy or baldachin; however, these statues, by their architectural frames, refer unmistakably to the larger context of which they are part.

In Gothic paintings—altar pictures as well as others—figures are represented in similar settings, indicative of the church, a body above and beyond any particular form. What the painting loses in individual wholeness it regains by association with that greater entity. Since Gothic pictures give a relieflike effect, the relief style of the period is perhaps the best approach to the painting style.

The difference between the Romanesque and the Gothic conception of relief sculpture is evident from the works of Nicola Pisano and his son Giovanni. All of Nicola's reliefs are statuesque or architectural in character, his bulky figures almost fully rounded and arranged in tight groups. Packed together, they occupy every inch of space, choking out the background. In Giovanni's reliefs the background becomes essential; whether his figures are crowded together or not, it is this element that stresses their dramatic power, quickening them and catching their shadows. Like a depth of darkness, it is intensive as well as extensive, a profundity that, in the words of Heraclitus, "can never be fathomed." This background neither blocks nor leads the eye into distance, but endures as a silent agent known only by the communication it engenders.

This quality of relation exists even in Giovanni's free-

standing group figures. Nothing is confined, nothing limited to itself, be it the *Sibyl* with her visionary anguish, the *Madonna and Child* with their gaze, or the *Adoration* with its telling and lyrical gestures. While Giovanni's art by its passion and intensity transcends that of the other sculptors of his time, the reaching of his figures beyond themselves and their participation in a universal order are characteristic of the Gothic style as a whole, the ever transitive.

The *Sower* of Notre-Dame in Paris, well set in his frame, steps across the field. Illustrating the month of October, he is, like Langland's *Piers Ploughman*, a poetic symbol of man in general, so much the sower that even now without hands he scatters the seed, without head or face goes on sowing. His ground is the world, and, receiving the seed from the harvest of the past, he prepares for the endless tomorrow.

The calendar figures on Byzantine ivories are purely allegorical, on San Marco they are ornamental, on the Amiens Cathedral they become anecdotal—genre representations. The tiny *Sower* on Notre-Dame de Paris, embodying ceaseless action, attains to universality.

What the Gothic statue gained by its incorporation into the building the relief figure has by virtue of its background. Only since the Renaissance was pictorial space conceived in terms of mathematical perspective. Whether involving scenery or not, Gothic art has its own space.

In Gothic illuminated manuscripts the folio constitutes a unique space analogous to the *locus mathematicus*. Illus-

tration, decoration, and script dwell in it. The size and texture of the page, ornament, picture, and lettering, all enter into polyphonic relationship. The painting skims the glazed surface with just enough volume to allow for the dance of figures, birds, and butterflies. Flowers sprout from the text itself, swaying over the letters, people and buildings balance on a nothing. All belong to the composition, all are interrelated. However freely they flow, they are rooted in rhythm and follow each other, silently singing, page after page, throughout the book. The folio alone is their space, the air they breathe; without it they would lapse from their lyric stance. When later the space of the page was broken up, the ornamental motifs presented rationally, and the illustration severed from the text, the delicate treatment of single things never compensated for the loss of the orchestrated whole.

These illuminated pages derive their formal value from an order granting each element a freedom within the mobile context, the common framework of the book. In the Queen Mary Psalter the painted figures are more like delicately carved and glittering ivories. Whereas in the Romanesque illuminations forms are separated by clear outlines, they are in the Gothic softly shaded, as if modeled. The lines, ebbing and flowing, are so tender, color applied with such subtlety, that the figures, etherealized, are scarcely bodies at all. Thus the grisaille method, which gives painting the effect of relief sculpture, was introduced.

The blending of figures with the parchment, character-

istic of the Gothic miniature style, was abandoned as a basic principle after but a short time. It was still evident in the *Livre d'heures* made for the Duc de Berry at the turn of the fourteenth century. From then on everything was treated separately—illustrations were given painted frames, decorations became pictures in their own right, the lettering was left in formal solitude, the illuminations were placed apart. This trend indicated a shift in the human attitude; close integration with the community was increasingly felt as compulsory and inhibiting; men began to insist on their individual rights regardless of society as a whole. The medieval structure was visibly shaken. Illuminations began to compete with panel painting and the Specific Miniature Style disintegrated just as, long before, the stressing of volume in the figure and its emergence from the background had spelt the end of the Specific Relief Style in Greek sculpture.

The school of Siena carried on the Gothic miniature style but attempted to use it on panels. Hence the pictures, lacking a space of their own, a substratum analogous to the parchment, had to account for themselves. Simone Martini, by intensifying line and color, achieved originality, his paintings sometimes dramatic in the rendering of gesture, sometimes emotive by their delicacy. For centuries Sienese masters adhered to a fairy-tale effect that gave their art the full charm of the unreal while depriving it of force.

Gothic panel painting in general was related to its architectural setting either by a real or by a simulated frame.

Today when pictures are assigned no formally relevant place we often do injustice to the Gothic whose full effect depends on their position in and connection with the building. These works are not meant to be isolated, their incompleteness is essential to the style. Removed from a church to a museum, they retain their loveliness of form, but appear somewhat forlorn. They are supposed to be clearer when seen alone and in a good light, but actually, like the solo voice in polyphony, they lack fullness and seem unsustained.

While space in Romanesque painting is subjective and self-contained, space in Gothic painting is a structural continuum. Saints, courtly figures, costumes, and jewelry, flowers, fruit, and animals—all are included under the reigning Gothic order. This relation of the part to the whole can be demonstrated in a church, but how imply it in a single picture? In the Specific Miniature Style it was indicated in the interweaving of illustration, decoration, and text, the following of page after page, the rhythmic pause and resumption of the formal movement, the ideogrammatic character of letter-to-leaf-to-flying-bird.

Sculpture had preceded painting in the grouping of figures for dramatic representation. Biblical events and the lives of the saints were enacted impressively on the façades of churches, while the miniatures of the period, richly ornamented with all kinds of painted comments, were light, lyric, and satirical. At a time when the commonplace had superseded the monumental in Gothic sculpture, Giotto created a style of painting, firm, ob-

jective, and grave. His *Justitia* in the Arena Chapel at Padua is statuesque; his frescoes in Santa Croce have painted settings reminiscent of Gothic relief borders. There is in his pictures no room for the small things rendered by other painters of his time with such care and tenderness. Giotto deals only with essentials. His figures have neither the delicate articulation nor the *élan* of Gothic forms. His style is less characterized by the passion of Giovanni than by the sternness of Nicola Pisano. Giotto, however, instead of overcharging his background, uses it as a stage to set off his figures. The brightness or darkness of the spare scenery gives the theme its tone. The composition gains in effect by the clear stratification of planes, the limited depth, the controlled use of light and shadow as dictated by the form. Terse in their lines, often dressed in the manner of statues rather than in the elaborate fashion of the time, his figures, poised in their gait and gestures, are strangely powerful. It is precisely this blending of reserve and eloquence that grips the beholder. On returning to see the frescoes in the Arena Chapel one is amazed at their small size, having enlarged them with the inner eye to their intrinsic dimensions. The severe economy of means and the marked simplicity of the composition give his work a penetrating directness, a starkness, comparable to that of the interior of Saint-Front.

In Giotto as in Dante two epochs meet. The *terza rima* of Dante's *Divina Commedia* is Gothic in form, one stanza overlapping into another with a mathematically infinite

succession of rhymes, while Dante's sonnet, Latin in struc-
ture, is definite and whole as a Romanesque church. These
two stylistic trends are operative in Giotto as well—the
Gothic in his relating of figure to setting, the Romanesque
in his mighty reserve.

Romanesque painting had never achieved the compact
effect of Romanesque architecture. Unlike Provençal po-
etry, painting was out of touch with the earth. Figures
retained their abstract character until, with the emer-
gence of the Gothic style, they entered into communion
with the manuscript page, just as the statue acquired sub-
stance by its incorporation into the architectural setting.

Giovanni Pisano was the first medieval sculptor to ex-
press his own deeply personal feelings in his work. The
relations between man and man are presented from the
standpoint of the individual. The link of a common back-
ground or of a close physical connection is no longer es-
sential; Giovanni's statues are brought into communica-
tion with each other by the expression of an inner power.

When Giotto's figures gaze at each other there is no
gulf for them to overcome; the pictorial surface brings
everything into reciprocal relation, securing the subtle
impact of a look. From Giotto's time on painters were no
longer content with purely mental pictures; scenes form-
erly represented as inaccessible by their space relations
came gradually closer to the beholder by their resem-
blance to the seen world. Pictorial space, though not yet
perspective, was no longer ideational. As forceful a per-
sonality as he was an artist, Giotto did not personalize

his figures as was done in the Renaissance. It is the clarity of each form, the unity and organization of the group, the monumental and dramatic character of the whole work that he achieved, fully and in his own way.

The striving for individual development in both the artistic and political spheres, the struggle for more freedom within the Christian community, and the oppressed peasants' claim for consideration of their rights within the social structure did not abate from the eleventh century on. All efforts to quell this trend led only to a muffling of the spirit or to fanaticism and bigotry. The attempts made to revive local self-government and the dawning of a more organic, hence flexible, society were abruptly cut short. Though this *vita nuova* was crushed in southern France and upper Italy, the unrest it evoked continued in distorted form. The despotism of individuals and ruthless factions usurped the law's authority until the once valid demand of the people was twisted beyond recognition.

All established values were thrown into question by the papal schism. Medieval France, badly damaged by the Hundred Years' War, survived in her art but only for a time. Italy, split by party dissensions, sounded her future glory through masters such as Giovanni Pisano, Giotto, and Dante. All three towered above their contemporaries and, embodying the best of the medieval values, had an intuitive, creative, and emotional power on which posterity was to draw for a long time. They mark the transition from the spirit of medieval Christianity with its stress on inner reality to that other spirit which was to devote

itself so ardently to the outer world and to sensory experience. Space in their work—the world—is still artistically conceived, still related to a transcendent order; but space is changing. Mathematics was soon to invade painting, the conception of the world to become increasingly scientific, and sense-perceived reality to predominate in art.

11

Renaissance Architecture

The soaring and yet poised effect of the outer dome form is here considered as the outstanding feat of Renaissance architects. Although the lofty vaulting of the interior had been achieved a thousand years before, it found only now its response on the exterior.

LANGUAGE is generally considered to be the most precise and effectual form of communication; yet art, even as a historical source, has greater directness than any written record. While the meaning of words changes, works of art stand, eternal witnesses to man's basic attitudes and conceptions.

The term "nature" has meant various things down the ages. In the Quattrocento, when Cicero's works became so influential, it is doubtful whether the man of the Renaissance understood the word "nature" as Cicero did in his *De natura deorum*. The Quattrocento, which claimed such a close relation to antiquity, was still bound to the medieval tradition. The Middle Ages, not only historically but spiritually, were the link between the new era and the ancient world.

While Plato's *Timaeus* had been known since Roman

times, his other dialogues began to be translated from the eleventh century on and played an important role among scholars. The Greek heritage came directly or indirectly via Byzantium. Nicholas of Cusa, as late as the Renaissance, refers back to Dionysius the Areopagite, who had certainly been influenced by the writings of Gregory of Nyssa. The Greek fathers had been the first to fuse ancient philosophy and Christian ideas. Pico della Mirandola went even further, insisting on the essential unity of all religious and philosophical systems. While this ability to merge heterogeneous conceptions produced only a barren syncretism in philosophy, it characterized the Renaissance and proved extraordinarily fruitful, at least in art.

Gifted with a rare sense of form, the architect Alberti stamped his credo into words and stone. Though only slightly influenced by the Middle Ages in his art, he wrote about nature in much the same terms as the monk Hugo of Saint-Victor three hundred years before: *"natura est in interiori qualitate."* The similarity, however, is more in their words than in their meaning, as becomes evident if we compare the Renaissance and Gothic styles. The Gothic's amazingly natural representations of animals, plants, and certain human features all refer to a greater context, just as the cathedral refers to a transcendent order. Thus, the goal in the Gothic era is always beyond nature, while in the Renaissance it is predominantly nature.

Both epochs sought in their own way to solve the problem of order through number and to find the principle of harmony in art and music. Gothic architects with their

rationally calculated structure achieved a transcendental effect; Alberti, in the early Renaissance, obtained a well-defined structure, regular in its proportions and clear in design, though claiming that *concinnitas*—harmony—cannot be calculated mathematically. According to him, the essence of form is apprehensible only *in anima*. Art has always that mysterious *nescio quid*, the *je ne sais quoi*.

A century prior to the West's discovery of the tonal plurality of each note in music and of the latent dissonance between the struck note and its inherent overtones, Alberti sensed that an indefinable something is essential to a vital harmony. This tension in music is not endemic to architecture, where pure thirds and fifths can be rendered structurally, as they can never be sounded in music. Alberti did not choose to do this; he introduced contrasts to break every easy consonance or barren unison. Although his knowledge of Greek architecture came solely from the writings of Vitruvius, he had a natural feeling for Greek form. Catching something of the Hellenic spirit in the Roman ruins, he resuscitated it in his own terms. He never had the opportunity to complete an edifice, and his ground plans were often altered or carried out by other architects. Nevertheless, in his kinship with the classical period and his foreshadowing of the Baroque, Alberti personified the Renaissance.

In the San Francesco Church at Rimini, one façade and one side of which Alberti remodeled, the sober stateliness of the Roman style is evident. Functional elements, however, were now given an artistic value: the deep

arched niches sheltering the sarcophagi have a grave rhythm and severe purity of line. Shadows break and transform the otherwise symmetrical façade. Deliberately exploited in the design, every change in the light creates a new effect. Thus, Alberti brought that *je ne sais quoi* to bear on the strictly calculated church exterior.

In his writings he emphasizes the values obtained by the interrelationship of all parts in a representative building. He speaks of the "music of the edifice," resorting to a metaphor only because of the impossibility of conveying an essential harmony in ordinary language. The harmony itself is directly expressed in the work of art alone. He does not always succeed in blending the various elements in his design, but prefers an unresolved conflict to uniformity. The side of the San Francesco Church that he built is in complete contrast to the main façade. In not attempting to mitigate this discrepancy Alberti further proved his determination to avoid any obvious solution. The forms he rejected throw as much light on his aesthetic conceptions as the forms he chose. He discarded the combination of arch and column, as had the Greeks, using the angular pillar as a structural support and the pilaster to vary the general architectural effect.

With the Church of San Francesco he only remodeled the exterior; in Sant' Andrea of Mantua he made the ground plan. Its spatial form and outer structure are his, not the lighting and decoration of the interior. While his contemporaries were indulging in elaborate details, Alberti designed this church with an immaculate simplicity.

Unlike centrally planned structures where various elements, equidistant from the crowning cupola, converge toward the center, Sant' Andrea has but one nave; massive pillars line it, arches rise in solemn preparation for the high vaulting, and the chapels on either side of that single vista appear to withdraw reverently.

According to Alberti, the distinguishing feature of the dome is *dignitas*. Had the original plan of this church been carried out unchanged, Sant' Andrea would have expressed that quality to perfection. The interior of San Marco in Venice shimmers mysteriously, rather as in Santa Sophia; in Sant' Andrea the space form and its boundaries are clear. Saint-Front is a configuration of solidly integrated spaces; Sant' Andrea is not. Roman in character, it is not copied after any Roman building. Pendentives support the solitary dome, these spherical triangles having come into use again in the Quattrocento. Curving, they rise, their upward thrust reaching home in the round cupola. Form succeeds form as if one grew out of another. Conflict matures into contrast, and through the active interrelationship of parts emerges an organic structure, a spacious realm moving greatly toward its fulfillment. The essential action occurs in the dome; even at a distance the choir echoes that final peace, the pillars to right and left introducing its dominant theme.

Alberti's designs were used in the Baroque period, and the changes then made, though slight, altered his style. On the façade of Sant' Andrea he created a new and artistic device that remained in use for centuries: the through-

going pilaster. Rising over three stories, it unifies the façade, its vertical thrust counterbalancing the horizontal motif of the structure without encroaching upon it. Not only do the pilasters link the stories, but they integrate the whole building, bringing the gable into relation with the ground floor and reaching with their capitals straight up to the architrave. In this way Alberti set forth what he could never express in words: harmony became visible.

The gray majesty of the Palazzo Pitti is strongly reminiscent of Alberti's style. Its impressive character is in large part due to the building material and to the stratification of its heavy blocks. As in Saint-Front every joint is visible, but the stones of the Palazzo Pitti are rocklike, jagged, the furrows between them enhancing the effect. It is the interplay of such contrasts that suggests Alberti's work. In the shadows cast by those rough blocks the intangible element comes into being again, giving artistic life to the strictly stereometric design.

The Palazzo Pitti was later extended far beyond its original length without any distortion of its form. Moreover, its proportions were changed, and proportions, according to Alberti, determine artistic effect. How, then, was it possible to change them without ruining the form, to refashion a finished building into a new whole? It could be done with the Palazzo Pitti by virtue of its structural principle. Everything in it is functional, the mechanism constituting the architecture; no single part has any value in itself. Although the parabolic windows are recessed, and hence darker than the rest, their frames

merge into the total design. The double row of stones wedged above the arches of the windows runs into a horizontal line and supports the arcades. Since the structure is articulated in no other way, its effectiveness rests in the reciprocal relations of the stories. In the Palazzo Rucellai each window is set off by an ornamented transom under the arch and all windows are separated by pilasters; in the Palazzo Pitti the windows form an uninterrupted curved sequence. The two upper floors are identical; the ground floor has alternating large and small windows. Otherwise the same design prevails everywhere. In view of this invariant metric system one cannot speak of formal members, but of technical parts.

A drawing of the building as it was originally planned has been preserved. The Palazzo was given its present form about a hundred years after its construction began. Out of the original compact body evolved the present disproportionately long structure. Only from a distance can it be seen as a whole. Though completely different in character from the original, this building is uncommonly effective. Its great length is reminiscent of the aqueducts; like them, it progresses and could go on endlessly. It was to eliminate the pretty details fashionable in the Early Renaissance, and create a harmonious and purely functional structure, that the architect turned to Roman utilitarian masonry. He must have seen in the aqueducts the possibility of an artistic form. He compressed their endlessly repeated theme; by this compression a tension gathered in the structure until the lengthwise movement, sus-

pended, rebounded on itself and released in the height, gave the building its harmonious proportions. The extensive potential of the form became apparent only when the Palazzo was altered in the Baroque period.

Form, as it was conceived in antiquity, came to life in Alberti's works; after more than a thousand years the Roman style struck new roots. He almost completely disregarded the works of the intervening centuries. Petrarch's *Epistolae*—his letters to the great classical personalities—reveal the poet's longing for communication with the past. To Alberti the past spoke; he was by nature at home in antiquity. A severity such as his was not popular in the Quattrocento, which, despite its contempt for the Gothic style, adhered to traditional forms.

Brunelleschi reverted to Romanesque architecture; his structures, though massive, are composed of independent units. His Pazzi Chapel has a light, airy quality and is based on simple geometric figures. The rings between the half circles and the pendentives seem to float, arches to rise of their own accord, and the inset medallions to be in motion. The cross-beam at the entrance of the chapel gives the effect of oscillating on the apex of the triangle over the door. The archway curves from the upper-story pilasters in a swift and flowing gesture. The Sacristy of San Lorenzo, an early work of Brunelleschi, has even more animation. Forms appear to carry on lively discussions, each of them distinctly audible.

In the Madonna delle Carceri at Prato, Giuliano da Sangallo created a strictly mathematical form, eliminat-

ing everything in the structural frame that might divert from the primary relational values and the basic cubic shape. In the interior of the church the clash between round and square bodies is resolved as though of itself. Placed over that square where the rectangular naves intersect, pendentives support the cylindrical ring, which in turn supports the dome. The gratifying effect of this arrangement is manifest in the spatial form. The exterior of the church, though equally well calculated, is less inspiring. On the outside, the cylinder dominates, giving it the appearance of a lid. As late as the Quattrocento, the exterior still failed to express the inner form of the church.

Bramante's Tempietto is universally admired, though it owes its fame to a rather questionable quality. The fact that concentric circles are compatible with each other is not particularly surprising. A unity so intrinsically devoid of tension is scarcely an achievement. Neither the Tempietto's columns with their paltry capitals nor the balusters suffice to animate the structure, while the triglyphs merely emphasize the meaningless ornamentation of the frieze. In the Doric style triglyphs constituted a contrast to the spirited battle scenes and the rhythmic figures on the metopes; here they function as a kind of a mechanical stress in a stereotyped *décor*.

According to Bramante's original plan, the Tempietto was to occupy the center of a site framed by a second ring of columns. There it would have stood more freely and not have been dwarfed, as it is now, hemmed in by cloister walls. On the other hand, a further repetition of the

circle would have given the building an even more schematic appearance.

Bramante's real creative achievement is the outer form of the dome. It was later reinforced and additions were made, but its effect is still evident. It no longer seems static, heavy, earthbound. For the first time it surpasses the interior vault in poise and bearing. Its grandeur is unmistakable, despite its small size and inappropriate locality. In the interior one is cramped as in a covered bowl. A vault, if it is to give man a sense of liberation, must soar high above him. Only when it recalls the mystery of space by its own spaciousness does architecture suggest the immeasurable distance between the human being and creation.

The dimensions of the Pantheon are crucial to its overwhelming effect. Standing in the rotunda, man loses his physical significance, and the mind, awed by the inaccessible vaulting and the powerful circumference, becomes aware of a mighty and unbreakable order. This is only possible where the magnitude of a space form is out of all proportion to the size of the human body. Comparison precluded, the spatial effect becomes absolute.

On the exterior a relatively small dome can reveal its intrinsic stature by its formal bearing in space. Even in its humiliating position between walls that exceed it in height, the Tempietto dome retains its dignity. Impressed by the balanced construction of the Tempietto as a whole, Bramante's contemporaries were scarcely aware of his essential contribution. He never had the opportunity to

build another dome, one that would have had the neces-
sary dimensions and been responsive to the *élan* of the
vault. His sketch for the exterior of St. Peter's shows a
dome again superimposed rather than floating on its
cylinder. It is doubtful, after creating the Tempietto,
whether he would have been satisfied with this draft. The
Renaissance was bent on bringing all that it valued of
inner reality to the outer light.

Bramante's development as a master builder can be
traced through its various stages. During his sojourn in
Rome his work changed. Instead of avoiding tensions he
confronted them, his pseudo-classical tendency giving way
to an original and integrated style. The ground plan of the
Tempietto is by its basic principle devoid of conflict; his
design for St. Peter's has a unity rising from the ordered
arrangement of heterogeneous forms. Independent domed
structures were to surround the Cathedral's domed center.
In Bramante's Tempietto harmony is pre-established; in
his plan for St. Peter's it is achieved.

Michelangelo altered the plan, enforcing structural
unity and compressing the spatial effect. He deprived the
lateral domed structures of their status, until they seemed
merely to bow to the central authority, to exist only for its
sake. The balance of power was destroyed. The sovereign
dome holds absolute sway; nothing escapes its dominion.

Michelangelo's model of the dome offers quite another
picture. All conflicts are resolved in its ineffable repose.
The cupola, as it is now, follows this model only as far as
the drum; the rest deviates from Michelangelo's plan in

every essential feature. The dome was made to rise more steeply, but, instead of gaining in lightness, appears on the contrary to rest more heavily on the cylinder. Michelangelo had given it a purely spherical contour, thereby releasing it from the effect of gravity—a release for which he himself yearned in his fierce restlessness.

Never before had the soaring effect of the vault been reproduced in the outer dome. Mighty as the cupola of the Pantheon is from the inside, it is absorbed on the exterior by huge ramparts that almost hide it. In Santa Sophia, where the walls seem to dissolve in a spray of light, the space form is indefinite within and undefined without. The vaults of Saint-Front appear suspended, its outer domes weighed down. The impressive effect of the Madonna delle Carceri is wholly limited to its interior. Michelangelo's meridian rings, like a choral accompaniment to the main theme, follow the rise of the poised dome.

In one of his poems Michelangelo prays to overcome all that burdens his spirit; though in his life he never succeeded, the consummation of that prayer is in the dome form. Had it been built for St. Peter's Cathedral, it would, as the image of man's longing fulfilled, soar high in the peace of its sky counterpart.

12

Renaissance Sculpture

*Renaissance sculptors expressed man's inner life no less
in his body than in his face and gestures. They created
him whole for the first time since Greek antiquity. The
full range and dramatic impact of human experience
rendered in stone or bronze brought out all the more
the conflict between man's finite state and his infinite
longing.*

THERE are fundamentally only three methods of
construction in architecture. The first, that of the
Greeks, is based on the relation of post to lintel;
the second, the late Roman and Byzantine, uses the arch
and vault to discharge vertical pressure in a diagonal
thrust; and the third, the Gothic, directs the weight and
strain of the vaulting on to piers and buttresses. Strictly
speaking, the Renaissance invented no new system; it used
devices inherited from the Roman, the Byzantine, and the
Romanesque periods. What it did create was a significant
outer form for the dome. The mighty *élan* of that shape,
complementary to the interior vault space for the first time,
was the sole original contribution of the Renaissance to
architecture. In this way the building achieved a whole-
ness unknown before.

In sculpture a like degree of integration was obtained

with regard to the human figure. The pose of the head and the face itself had been given expression in the Gothic period. The Renaissance sculptors were not so much concerned with simulating human features as with making the body organic.

The reliefs made for the doors of the Baptistry in Florence are generally considered to be the first works characteristic of the Renaissance. Yet Quercia's *Fonte Gaia* in Siena, dating from the same time as these doors, is far more significant. One of the reliefs on this fountain shows the expulsion of Adam and Eve from Paradise. The representation is neither narrative in character nor, as was the fashion, contemporaneous in its setting. A three-figure group renders the event with a singular immediacy, embodying three specific attitudes. The Angel is Law in action; Adam is man; and Eve is the mourner of man's fate. This work of Quercia is not the account of a moment, it *is* the moment, involving man in his entirety. Adam's body, mutilated as it is, preserves its dramatic impact unimpaired.

The nude figure appears in Medieval sculpture not as an agent of human feeling, not for its own sake, but for something beyond it. Its life is in gesture and facial expression; the body is denuded rather than naked. The only nude female figure by Giovanni Pisano symbolizes truth and, though classical in cast, is more an abstraction than a woman. Quercia's Eve is a real woman suffering and reluctant to step forth. Her feelings are in her shape and bearing even more than in her face. Here again the

geometric outline is inseparable from the theme. The three figures are fitted into a circular frame; cutting through it, foreshortened and to one side, is the gate of Paradise, constituting a second geometric figure within which the Angel stands. Adam and Eve are just outside the gate. The circular framing of the whole unites the figures into a group, while the gatepost, dividing them, implies the dawning separation between the ineluctable and the tragic. The force of the Angel and the dread apparent in Adam and Eve are stressed by the ordering of both their crossed and their parallel limbs. The relief gives no scenic past or future, only the crucial present in the gate and the three forms. The Angel, his hand against Adam, propels him forward. The event communicates itself in the dynamic stance of the three figures. Adam's bent torso and forestalling gesture are in sharp contrast to the vertical gate. In his bowed shoulders is the destiny of man. Vital, erect, the Angel stands, legs spread, powerful torso blocking the entrance.

This relief marks the breakthrough of a new conception in one stroke, without any preliminary groping. For the first time in the Renaissance man as a natural human being is represented in his own right. The soul is no longer stressed at the expense of the body, but rather by and through it. The nude figure makes its appearance, simply and unashamed. Quercia is at his best when he lets the body speak for itself, drapery serving as a mere adjunct; only in the tomb sculpture of *Ilaria* does the robe with its flowing peace exempt the figure from time.

In his later reliefs on San Petronio in Bologna Quercia treats the expulsion from Paradise in a different way. The background and the figures are more closely connected, the depth given pictorially rather than three-dimensionally. Bodies only seem to have volume and, though pure and vivid in outline, lack the motility of his Siena figures. In *The Creation of Eve* the movement of the two bodies is contrapuntal, the figure of God generating and directing the action.

The heads of Quercia's statues are varied in character, sure of design, and often graceful, but it is in the body that the sculptor achieves his mighty fusion of spirit and matter. Joachim of Flora's dictum: *renovare hominem*—the renewal of man—is carried out in Quercia's work, not by the returning of man to a prime innocence, a heavenly state, but by bringing him to integration. The gulf between body and soul, characteristic of the Middle Ages, is no longer; from Quercia's hands man emerges whole.

All of his figures, naked or clothed, including the statue of the *Madonna* in Paris, vary as to expression and posture. Even the dead *Ilaria* appears to be slumbering, motionless, not rigid. His works are characterized by completeness of form; unlike the Gothic, they do not point to anything beyond themselves.

Quercia stands alone among his Sienese contemporaries, most of whom clung to their medieval memories for yet another century. Only the Florentine Donatello equaled him as a sculptor, though artistically they have little in common. Donatello is incomparably more versatile. It is

hard to say if his style is better represented by his serene and harmonious works or by those where tumultuous action threatens to burst the frame. In the relief of *The Lamentation for Christ* the grief of the figures not only distorts their faces and limbs, but breaks up the form. In his last work on the pulpit of San Lorenzo everything is racked, harrowed, wild. At the end as at the beginning of his career Donatello approached the late Gothic style, not because of any romantic predilection for the past but by his despair at the inadequacy of all means of expression. He resorted to excessive measures in a huge attempt to render life's tragedies more truly. Statues such as *The Preacher in the Wilderness* are as jagged in rhythm as the calm forms of his Madonnas are lyrical.

Donatello's Madonna-and-Child groups give either a contrast or else an affinity between two states of being. In the Verona relief of the Metropolitan Museum of Art, the Child is framed with the Mother in her enfolding shawl. The rounding off of the Madonna's formal outline by the baby's head brings the play of forms quietly to rest. In the *Pazzi Relief* in Berlin the two forms are only slightly raised from the background, their figures softly modeled. The marble gains in transparency, giving forth a shaded radiance. Mother and Child commune, an ineffable tenderness in the touch of their foreheads. With all its subtle emotional intensity the form of this work is clearly defined.

The Charge to St. Peter is a mystical event past understanding, its meaning intimated, not revealed. Action dis-

solves in an uncertain space, whereas in the Pazzi *Madonna* the relief background provides a secure space for the two figures.

In his Padua reliefs Donatello made a great effort to comply with the laws of perspective, but the lights and shadows on the bronze cancel out all his painstaking calculations. These Padua reliefs were not his only attempts to render objects and depth geometrically. However, such a method of representation is almost always out of place in relief art, and it was rather when Donatello created his own space that he achieved true form.

In his *Cantoria* in Florence he had given an effect of space by means of the figures themselves. Between the trellis columns and the background children play and dance. Whether slightly raised or almost fully rounded, the small figures are very animated, some naked, some scantily clothed. The Byzantines had never depicted children, but rather cupids disporting themselves on ivory boxes and other objects of daily use. Donatello's *putti* are real children, merry children, their wings incidental. The dance is riotous, carefree, its rhythm pure joy.

Donatello expresses tenderness and depth, the crude and the gruesome, ardor and shrill lament, asceticism and exuberance. He was the first to re-create the Specific Relief Style; his *Pazzi Madonna* lives and moves and has her being by the unique relation of her form with the background. Intense and delicate as a dream, she appears to have been wafted into the marble.

What a difference between this relief and his massive,

very controlled figure of the *Gattamelata!* Enthroned above the market place, this equestrian statue of the *condottiere* embodies authority. Calculated to be seen from a distance, the statue could hold its own any place. Whoever *Gattamelata* may have been, Donatello portrays him not as a despot but as a man qualified to lead others. His features are sharply rendered, with none of the cruelty of Verrocchio's *Colleoni.* Stern, sure of bearing, self-mastered, he stands, the epitome of a great warrior.

In all of Donatello's works it is the theme that dictates the artistic treatment. Gothic art, while ranging in topic from hell to heaven, from Satan to Saint, is always similar in style. Everything is subservient to that one form with its fixed system of values. Donatello's answers are always given in terms of the problem faced; each object is dealt with individually, no one style covers them all. He presents us with the spectrum of human experience. With certain Quattrocento sculptors the urge to individuate everything led to the projecting of a merely private world and never attained to universality. Donatello achieved a re-objectification of the world through the self. Most Renaissance artists had a tendency to transpose Biblical scenes into everyday settings. This was done more and more as sculpture lost its significant place within the architectural context. Gothic statues, their areas preassigned, were always related to the building they occupied. But now, even when statues were in niches, they no longer referred to their surroundings. In reliefs on façades, perspective destroyed the surface effect of the wall or else figures protruded too

far from the background. With the geometric standard all but gone, geometric perspective began to interfere with sculpture, the space of the outer world impinging on artistically created space. Quercia's achievement was almost forgotten until the advent of Buonarroti.

Michelangelo's primary concern was body and volume, not space for itself, but space as a means of giving the body power and motion. In every stone he sees a figure imprisoned that must be delivered and brought to light. Creation to him is incomplete; man must intervene and further quicken it while freeing himself from bondage. Michelangelo's idea of form, like the immanent teleological cause, becomes the goal toward which his works aspire. It sleeps in the stone, as Dionysius the Areopagite saw God hidden in man's soul.

The *Madonna and Child* at Bruges shows the Mother enthroned in her niche like an icon, small but monumental in form. The lights and shadows of her robe are muted in that lofty head. The Child, shielded by a surge of drapery, is included in the rituallike setting. Within the security of its mother's presence the Child, clinging gently to her knee, revels in sensuous pleasure. This statue could stand without its altar niche, for its form is its space.

In the *Bargello Relief*, the background has a share in the relating of the figures. The work is unfinished, but this incompleteness only stresses the emergence of the actual from the potential form. The Madonna is not so much held within her circular frame as come there by choice. While motion is latent in her compact figure, her face is in-

herently calm. Her contour repeats the cubic shape of the stone she sits on. The Child leans playfully against her, confident and relaxed, his naked body in contrast to her robe, his gaiety to her grave concern. The Madonna's head is austere and given in front view; the Child's rounded shape varies the almost rectilinear effect. The majesty of the Mother is a criterion for the natural as represented by the Child. From the tension evoked by these two figures—between Idea and Nature—a space comes into being. Implicit in this space is man.

Much later Michelangelo treated the same theme in a new form for the Medici Chapel. The Child squirms around on its Mother's knee, seeking her breast. The Madonna, steadying herself with one hand, holds him with the other, gazing out on some invisible sorrow. She appears to sway ever so slightly, a quiet compassion in the bend of her head. The Child is utterly lifelike in his instinctive motion. Of all the forms in the Medici Chapel only this Child moves freely. The others are heavy-laden, their waking oppressive, their sleep unforgetting. Figures such as Night and Day, racked by inner visions, writhe and strain, their intensity almost shaking the Chapel. Shadows collect everywhere in sinister masses, while, torn by conflict, these mighty personifications struggle against themselves, against fate.

Here again Michelangelo brings sculpture and architecture into close relationship. Whereas in the Gothic style the round pillar had delimited the space of the statue and brought it into the community of upward-rushing

forms, the structural parts of the Medici Chapel are so particularized as to have almost a being of their own. Pilasters and pediments, consoles and cornices, are crowded into that small area along with the statues. Figures overlap their sarcophagi, increasing the effect of restlessness, the demand for more space. Giuliano de' Medici is braced for action, Lorenzo sits brooding; they both veer to one side and project. Only in the upper stories of the Chapel is this violent movement brought to rest.

In the *Tomb of Julius II* the disproportion between mass and space, striking in the figure of *Moses,* was to some extent due to the enormous difficulties involved in finishing the work. Plans and orders were changed so many times that Michelangelo referred to it as "the tragedy." The disproportion evident in the Medici Chapel, however, was wholly intentional on the part of the sculptor. The thinker is harassed, the man of action cramped, the dreamer threatened, the awakened profoundly disturbed. The will has reached an impasse, and out of these huge discords achieved by throwing everything out of balance, form rises, a style is born.

If Michelangelo, attacking the marble, had sought only to give an illusion of motion and power, his figures would merely ape life. They would not have the universality that strikes us so forcibly when meeting them. Here is no illusion, but reality itself: the tragedy of the human spirit before human limitations. These sculptures are man's struggle against bondage, his unquenched and unquenchable desire for redemption, the despair at his own in-

sufficiency; they are the conflict between yearning and fulfillment, the discrepancy between vision and fact.

In his sonnet on Dante, Buonarroti states that he would accept all the bitterness of exile were he but granted Dante's greatness. It was in his work, and in his work alone, that Michelangelo attained to his innate stature.

During the Renaissance man no longer lived as did Dante, within a tradition-bound and fairly integrated community. In Michelangelo's era man, like the statue, was thrown back on himself into the solitary, unprotected space of experience. More conscious of his power as an individual, he was also more conscious of the gulf between himself and his vision, his achievement and his conception. Pico della Mirandola exalted man as creator. Events such as the sack of Rome by Christian armies, however, cast a certain doubt on the validity of this new conception. In Michelangelo's art there is scarcely a trace of the glorification of man as such. The epithet "Titan" does not apply to him; he does not wage war against the gods, but against himself. As a Christian he is humble; only as an artist is he imperious, bending matter to his own purpose until, at the end of his life, renouncing all he had won, he laid down his will.

Michelangelo's last *Pietà* reaches such a pitch of emotion that what was once music becomes a thread of sound. The two bodies, lost to volume, dwindle to almost nothing. This is expression's extreme, here silence begins. Slipping away to the last frontier of the possible, life, in the act of

departing, breathes something back and steps fainting
into the unknown, eloquent as few things on this earth
shall be again.

Quercia returned man to his body and the body to man.
In this he went far beyond Medieval pantomime sculp-
ture and, indeed, came so close to life that one hesitates
to call his work dramatic; it is drama itself. Just as the
dome in the Quattrocento gained an outer form appropri-
ate to the inner space of the vault, so sculpture came to
represent man as a whole being. While Medieval sculptors
remained unsurpassed in their elimination of everything
save what suggested spirit, Quercia re-established the
body as the soul's agent, not its prison. Thus, matter that
had been judged as but the medium of experience became
the prerequisite of meaning itself.

Space in art is not always, as conceived by Kant, a
"mode of perception"; it is the artist's servant, not his
master. With the discovery of geometric perspective, how-
ever, the spacing of things as we see them supplanted any
artistic rendering of space. This new tyranny imposed
itself even in relief sculpture. The laws of projection be-
came the order of the day, and it was assumed that any-
thing could be called art, provided these laws were
obeyed. The Church had proved unstable, but mathe-
matics was independent of man, rooted in nature and
therefore absolute. Donatello's *Pazzi Madonna* is free of
such treatment and melts into the background as into the

sphere of her own being. Only the frame is geometrically foreshortened, and the Madonna, thus set off, is all the more resplendent as an ineffable reality.

Michelangelo reckoned with space only in terms of the solid, except for the *Madonna on the Staircase*, a very early relief, where he used the background to give a spatial effect. His later figures, moving in all directions, are nowhere at rest. The early Christians sought to represent the spiritual with as little of the body as possible; Michelangelo, through the body itself, strove for fulfillment. St. Augustine's conception of restlessness as a search for true peace is borne out in the sculptor's work. In his last *Pietà* he mutilated the block of marble, wresting from it an expression whose frailty of form is eclipsed in the tragic power implied.

All his other works embody man's will, man's drive to outdo himself. Had his dome been built, it would have stood for that victory. The problem of how to achieve freedom absorbed Michelangelo's whole life, his work a dialectical progression toward its solution. His last answer is the experience of all mankind.

34 Giotto: Fresco
Madonna dell' Arena, Padua

36　Michelangelo: Model for Dome of St. Peter's
Vatican Museum, Rome

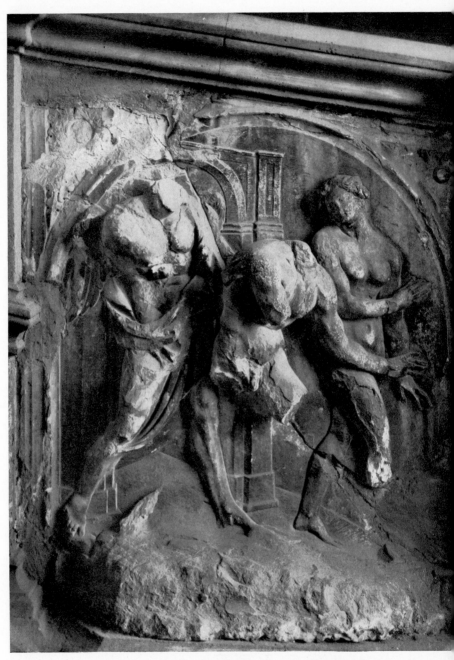

37 Quercia: Relief from the Fonte Gaia

Siena

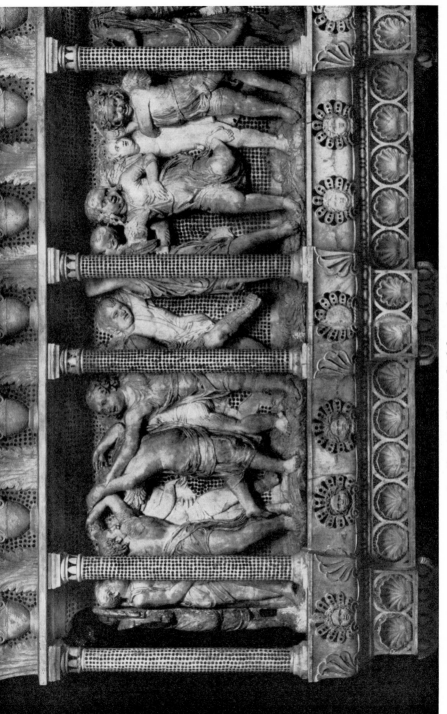

38 Donatello: Relief from the Cantoria
Museo del Duomo, Florence

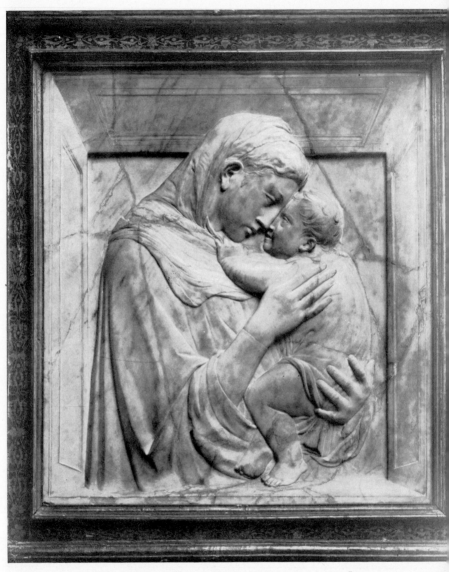

39 Donatello: Relief of the Pazzi Madonna

Kaiser Friedrich Museum, Berlin

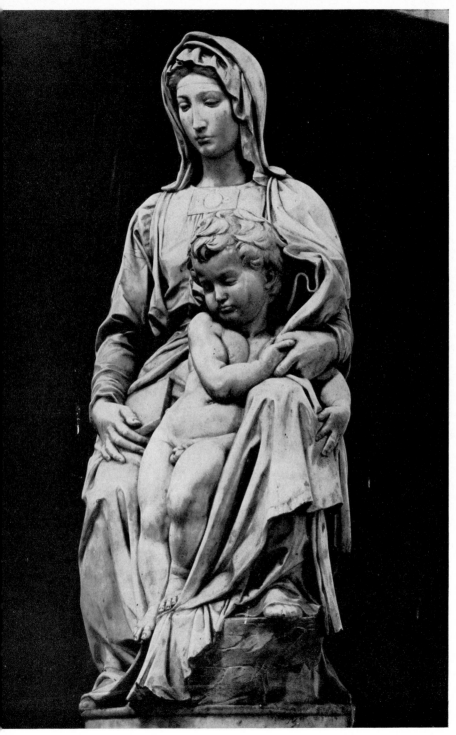

40 Michelangelo: Madonna
Notre Dame, Bruges

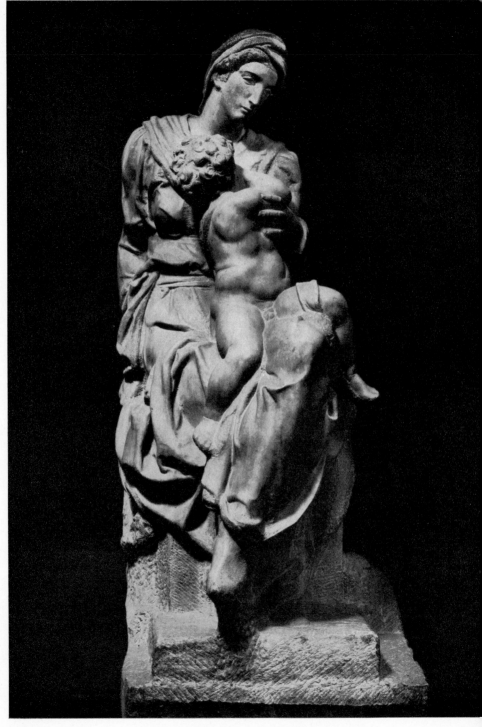

41 Michelangelo: Madonna Medici
Cappella Medicea, Florence

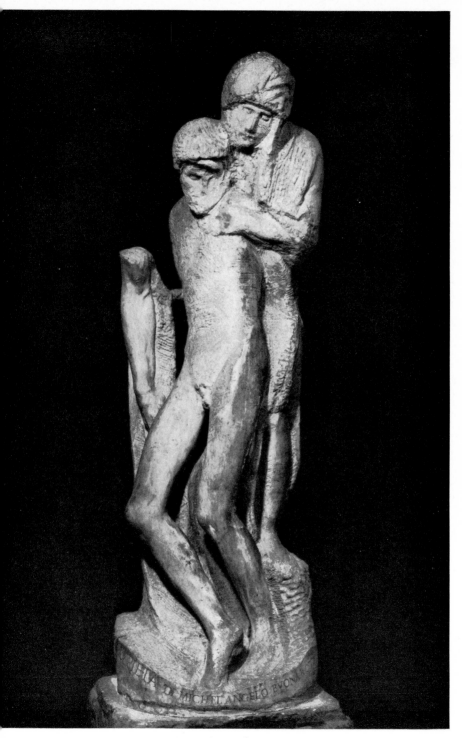

42 Michelangelo: Pietà

Palazzo Rondanini, Rome

43 Leonardo: Drawing

The Metropolitan Museum of Art, New York

44　Michelangelo: Detail from the Sistine Chapel

Rome

45 Titian: Christ Crowned with Thorns

Alte Pinakothek, Munich

46 Santa Maria della Pace

Rome

47 Pillar from the Monastery Church
Weingarten

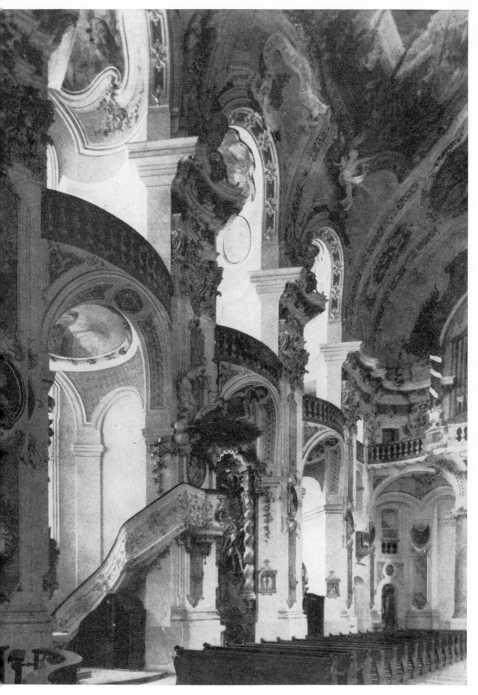

48 Interior of the Monastery Church
Osterhofen

49 Palladio: Villa Zeno
Cesalto

13

Renaissance Painting

The laws of perspective found in the fifteenth century were conscientiously applied by Renaissance painters. But only the greatest masters disclosed in their pictures a dimension beyond the third. Their "perspective" represents a reality transcending the sense-perceived world.

WE HAVE no language proper to the complex of our inner life. Expressions such as the world of ideas, the realm of fantasy, the heights and depths of the soul, are familiar spatial terms used to qualify invisible human realities. As long as we remember that they are only metaphors, we are justified in using them; indeed, language has no other way of communicating what they signify. Space and its laws, of course, have nothing to do with the so-called space within man. In that space not only thoughts, as Schiller said, but also feelings, "fit readily side by side," no matter how incompatible they are in the objective world. In outer space it is the distance between oneself and a specific object that determines its apparent scale and proportions; in the space within ourselves the object furthest from us may be the closest, that which is nearest far away, while the scale of

each thing depends solely on the value we attach to it.

Thus, however much we give spatial terms to phenomena of thought and feeling, it is clear that our inner way of seeing corresponds not at all to visual perception. The objects of the mind's eye do not follow any given order of succession. What constitutes background in the outer world may be foreground in the inner, yet appear perfectly consistent with reality. Though mindscape is dependent on the outlook and point of view of a period, it is never subject to the relations holding in the physical world.

While these facts are perfectly evident to everyone, works of art have nonetheless been evaluated for centuries in terms of their conformity to the laws of perspective. However, the sense-perceived world is not the real world; it is merely the world as it seems. Since art bears witness to an intrinsic reality, there is no reason why it should be confined to the exact reproducing of an optical illusion.

Plato objected to the painting of things as they appear, on the grounds that art should imitate true being and not illusion. True being, or reality, to Plato was the world of Ideas. Those who hold reality to be the phenomenal world alone require that art mirror things precisely as we see them. But both attitudes rest on the assumption that the function of art is to copy reality—however the term be understood. When reality is conceived as Ideas, art is to imitate ideas; when reality is identified with the sense-perceived world, art is to represent things as they appear

to the senses. This last is a matter of skill, not art; it might have been useful to natural science and history, but with the invention of photography it could have been dispensed with entirely.

Those who claim geometric perspective to be a prime requisite in art do not realize the implications of such a view. They might argue that since works of art are concrete, they should conform to the laws of other concrete objects, as do architectural and sculptural works. But architecture transcends the laws it obeys, as, for instance, the Gothic structure that, by virtue of its form, overleaps itself to infinity, or Santa Sophia, where an extraordinary technique was used to eliminate any impression of technique and to make solids appear to dissolve in an unearthly radiance.

In Egyptian painting, figures remain two-dimensional, movement is given by the unbroken line, and the picture is an abstraction of a kind familiar to the intellect but baffling to the untrained eye. This art belongs and refers only to itself; what it presents exists nowhere in the visible world.

In Byzantine mosaics the visions of the mystics appear before us, technical feats serving supersensory ends. Mass, plane, and volume vanish; again a new space comes into being, sufficient unto itself. While there is here absolutely no resemblance to the sense-perceived world, other styles do conform, but only to a very limited extent. Neither two-dimensional nor visionary in effect, Medieval painting contains foreshortenings and suggestions of perspective.

Its space, like language, is metaphorical; it uses spatial terms just as we do when we speak. This space was represented only to the extent required for the unfolding of inner processes, nor was it the space of everyday experience, but inner space, its relations figurative, not literal.

Thus, the visual arts bring hidden values to light. How futile in comparison to reproduce the merely familiar appearance of things! When this became the goal of painters and all energies were directed to the projection of sense-perceived reality by means of geometric perspective, painting lost both independence and significance. Only a short time before, flowers sprouted anywhere on the parchment folio, dragonflies were as large as a human figure, hares ran on thread-thin flourishes, houses balanced perfectly in air. Now, everything had to be justified, reason rode roughshod over the manuscript page. A narcissus was painted with a pin to show how it was held in place; a special shadow served to set a flower off against the surface. However admirable its technique, however delicate its colors, a picture done this way reveals nothing that cannot be seen better in a living flower.

Committed to the laws of projection and lacking that frame of reference provided by a universally accepted set of values, painters had to find new ways of revealing inner vision. When they succeeded in communicating the transcendent through the known, they achieved what amounted to an extension and deepening of the empirical world.

Only a narrow line separated the wasteland of descrip-

tive geometry from a new and original space. Formerly, even a mediocre painter could express emotional values without first having to come to grips with science. But in the Renaissance the effort to reproduce things exactly as we see them was such that meaning was often lost, the geometric representation of space becoming an end in itself. It needed more creative power than ever before to break the new spell, liberate painting from science, and restore its expressive value.

Masaccio painted houses, streets, church naves and porticoes all in perspective, yet the space of his pictures is not absolutely subject to mathematics. The eye is not drawn into depth along a vanishing line; the painting is extended in width so that the spectator is nowhere bound to a fixed point, but can shift to right or left without the impressions' being distorted. Masaccio's organization is not so much spatial as centered around bodily form; he is, so to speak, the first painter in the round. He did not compete with sculpture, as was often done in the Quattrocento, but gave volume to his figures by loosening their contours with chiaroscuro, while preserving the pictorial unity. The unifying medium is neither light nor air, but rather an indefinite something that encompasses and connects his individual figures. Space in no way dominates or does violence to the forms. His frescoes in the Brancacci Chapel in Florence are as clearly delimited as panel paintings. Unrelated to the architecture, their particular space has nothing in common with their setting in the chapel. Here is no enchanted realm;

on the contrary, the familiar is the means by which meaning is revealed.

We use the terms "light" and "shade," in speaking, not merely as symbols, but as synonyms for clarity and dimness of thought or feeling. Thus, while spatial terms give a certain measure to inner realities, brightness and darkness give a certain color to spiritual or emotional states. In religious writings "the dark night of the soul," "twilight," and "illumination" recur again and again. Since the time of Proclus light in the mystical sense has had its prophets and interpreters. This inner light becomes the object of subtle discussions in Medieval Christian philosophy. In Santa Sophia the play of light gave the effect of miracle but never clarified relationships. The golden background of medieval paintings transports the figures into a special and radiant space.

The two Limbourg brothers who illustrated the *Livre d'heures* of the Duc de Berry were the first in the fifteenth century to paint the scene on the Mount of Olives in nocturnal gloom. Somewhat later, thanks to the unknown master who illuminated *Le Roman du coeur d'amour épris* and his Italian contemporary, Piero della Francesca, darkening and lighting became essential elements in painting for the expression of emotional values.

Piero in his frescoes combines monumental form with special light effects. He uses perspective according to his needs, modifying it when he chooses, without patently violating its laws. The function of light in his paintings is to represent space and clarify meaning. This brings about

a transparence of form nowhere dazzling but luminous. His light values are not derived from the sense-perceived world, nor do they render a mystical vision; they have the toned-down but definite lucidity of the intellect—enlightening, not revealing. This definiteness is also apparent in the profiles of Piero's figures. Void of all density and opaqueness, his paintings have an extraordinarily liberating effect. In the portrait of Prince Federigo da Montefeltre the prince's head dominates the scene, and to counterbalance the foreground, the river and landscape in the background are stressed by means of clear color contrasts.

Mantegna attacks problems of perspective with all the zeal of an innovator. In his early frescoes in the Church of Sant' Agostino degli Eremitani in Padua, the point of view, or perspective, changes from one picture to another, though only a narrow painted border divides them. His figures call for space, often overlap each other, lead the eye into depth, and are arranged in such a way that they mark off distances like milestones. Mantegna's main concern was not so much spatial relationships as three-dimensional form and its organization. Things as they appear could now be rendered with mathematical precision, and Mantegna, fascinated by the new knowledge, painted his early works in strict accordance with the science of geometric projection.

His *St. George* might well be a symbol for the turning point in the history of art, the slain dragon representing the end of an epoch and the Saint, in the forefront of

the frame with the medieval landscape behind him, signifying man's spirit about to step into the new world. Thus, the emphasis in art shifted from the inner to the outer world, and with it the fundamental attitude or point of view of the West.

In the early Paduan painting of *St. Christopher* Mantegna produced a baffling effect by deliberately foreshortening the main figure to the point of distortion. Later, in his *Dead Body of Christ* he went even further, sacrificing all feeling, expression, and artistic form to virtuosity. If we did not have his *Parnassus* in the Louvre and his *Madonna* in the Berlin Museum we would admire his technique but scarcely consider him a creative artist. The rhythm and the well-shaped figures in the *Parnassus* fulfill the requirements of art forms, while the austere outline, terse design, minimum of perspective, and restrained use of color in the *Madonna* convey emotion without display.

How could a master capable of such achievements have indulged in tricks of perspective? Perhaps because his epoch's fixation on science as the ultimate truth misled him to the point of mistaking mathematics for the final criterion in art. The urge to conquer a new world in painting, as had been done in other fields, the joy of understanding the mechanism of visual perception, and the knowledge of how to reproduce things exactly as we see them—all this may explain why so many artists of the period gave priority to the geometric rendering of space and thereby forfeited artistic value. This emphasis has

gone unquestioned ever since, although it is in strong contradiction to the main trend of Western art up to the Renaissance.

While East Indian sculpture had represented the unrestrained instinctual life with all its absurdities, European art had sought consistency through form. Deviations were allowed as long as the underlying order held. This regulating principle in Western art was considered more valid than the natural order, and capable of transforming it. It was this principle which gave art a certain independence, independence in the sense that the artist both determined and obeyed the law. Technique and medium were thoroughly mastered for the sake of form, and in this way artists re-created the sense-perceived world, rendering space according to their vision. This independence was now threatened by the demands and pressures of the new knowledge of optical and geometric laws. On the whole, however, it was rare that artists utterly succumbed to the nonessential in their concern with science.

Botticelli, while not clinging to an old-fashioned style or affecting a medieval manner, scarcely ever allowed mathematics to overrule his art. Though he adheres more or less to the familiar appearance of things, neither his *Primavera* nor his *Birth of Venus* nor his *Madonna* is primarily spatial in character. The woods in the *Primavera*, rather than opening up a depth, function as a terminating background, their dark color setting off the rhythmical movement of the figures in the foreground. Thus thrown into relief, each of these figures is defined by the contrast

between translucent and opaque colors. In most of his Madonna pictures a host of angels, their heads close together, are crowded around a central group. Even in the Florentine *Annunciation,* where space is mathematically projected, figures occupy one plane. Against the headlong movement of the angel the scene in perspective is simply a *décor.*

The triangular composition became popular at this time. Those who mastered it were applauded, and to this day many an expert claims that this schematic arrangement has value, though, actually, artistic form is irreducible to any formula and consists ultimately in a quality impossible to define.

As an engineer, explorer, anatomist, and technician, Leonardo da Vinci is unsurpassed by any of his contemporaries; as a theoretician he adheres to certain clearly established laws; as an artist he gives evidence of the subtle unity of all things, even seemingly discrepant ones; as a pantheist he discerns form in the misshapen, the degenerate, just as much as in the noble. Like other men of his time, he conceived the cosmos as animated, but he was the only one to reify this conception in his work.

Michelangelo's world is composed of three-dimensional bodies that invade and conquer space, while Leonardo's figures, wherever they appear, are at home in their own space. Whether emerging from it or submerged in it, they originate and remain there. His sketches, even his casual drawings, reveal everything, however insignificant, as dwelling in that indivisible, omnipresent element. Fol-

lowing rapid changes with a keen eye, Leonardo repre-
sented motion without arresting it, yet was hesitant when
painting, as if afraid to violate "the simultaneous harmony
of all relationships." His drawings show the extent to
which he succeeded in rendering this harmony, show it,
that is, when their original subtilety has not been de-
stroyed by the well-meaning attempts of others to clarify
his design.

It may be of help in grasping the almost magical del-
icacy of Leonardo's art to compare it with some four-
teenth-century illuminations and some Greek sculptures
in the Specific Relief Style.

Medieval miniatures evolve from the glazed surface
of the parchment, the page constituting the space of an
otherwise spaceless world in which script, flowers, birds,
human figures, and ornaments belong and live together.
In Leonardo's drawings space acts as the womb of crea-
tion, harboring and giving birth to forms. Everywhere
implied and hence present, it is reminiscent of "universal
substance," as conceived by Spinoza. In it, forms rise or
fade away, never wholly lost. As in certain Medieval
miniatures, these figures are not sharply outlined; un-
like the miniatures, however, Leonardo's space is un-
limited, forms taking shape in it before our very eyes.

As in the Specific Relief Style, his figures also hover on
the threshold between dream and reality, the coming-to-
be and the being. Lacking the relief background, he
makes of the page a universe where form is implicit even
in the formless. His vanishing outlines unite his figures

with this one indispensable element, any strengthening of their contours only weakening or killing them. In the original sketches, the empty areas of the paper are significant in themselves. Line and surface merge, intimating, without imitating, space. Leonardo evokes, but never imposes, his vision. Now tender, now powerful, his lines dive into the limitless silence of the page.

A draftsman tracing a line can be compared to a violinist bowing the strings; touch and release, legato and pause, determine the effect in each case. Just as sounds die away in music, yet continue vibrating in us, all interrelated in time, so Leonardo's lines, fading, endure nonetheless, sustained by that space which holds and unites them. As the source and goal of the visible world this space conceives, begets, and preserves form. Whatever sinks into it dies not, but slumbers. Neither a projected nor an illusory space, it is an emanation of life itself—metaphysics in action. Perspective is present, but with Leonardo the familiar is strangely revealing. He is not concerned with the eternal, the immutable, but with the perpetually active, the ever-creative.

His triangular compositions, in contrast to those of his pupils and imitators, have a specific meaning. In his sketches for the St. Anne he rejects this pattern, and the group remains in indefinable space. In his painting of St. Anne, on the other hand, he groups the figures in pyramidal form; like a bunch of flowers, they serve to center the varied shapes and colors of the scenery. Expressive as this painting is, the sketch surpasses it by

virtue of that space which, because it is more elusive, is more suggestive.

It is conceivable that *natura naturata* and *natura naturans*—nature created and nature creating—are two aspects of one and the same reality; but to render this conception in art necessitates not only the study of natural processes in various fields but an unfailing intuition and a powerful integrating faculty. As an artist Leonardo remains the seer, the visionary, painting rather as St. Francis spoke: my sister the rock, my brother the lake, the ether. To him a living breath pervades the universe. *Ruach* in the Bible, *pneuma* in Hellenistic philosophy, *spiritus* in Latin—it is the same. Out of his own creativity Leonardo gave life to all things without exception, life to him being spirit. Strong or faint, his pencil animates the page throughout.

He reserved one expression for man alone: all things speak, all things have a face, but only the human face has a smile. Enigmatic, disquieting, it suggests much, tells nothing. In it man seems to pass in a moment from his creature state to participation with the Creator.

While Pico della Mirandola found all truths to be essentially one, Leonardo, evoking scene after scene—real or fantastic—out of a space that relates them all, leaves to each its specific integrity.

At first, Renaissance artists conceived space as a static entity affording objects the possibility of extension. Michelangelo, in his treatment of the *Holy Family*, is purely sculptural; later on, in his *Creation of the World* in the

Sistine Chapel, he gives a new quality to pictorial space. Leonardo's space is imbued with form; Michelangelo's bodies usurp space; giving way to their violence space shares in their movement. The double figure of God creating the sun and the moon appears to turn and as it turns to become one and to set space in motion. The less room there is in Michelangelo's paintings, the more explosive the effect of his figures. While Leonardo's forms suggest the "simultaneous harmony of all relationships," Michelangelo's figures are never appeased. Driven as from within, they strain toward the unlimited, their eyes in the future. Like them, Michelangelo's thirst for fulfillment gave him no respite, and this same momentum is not only an attribute but the essence of his work.

To Raphael space did not have to be transformed, transcended, or represented as the primal source of being. Whether treating of inner or outer processes, his paintings open no hidden dimension. He is not concerned with the universal One, the boundless, the mystery of self-realization, or any unquenchable striving. There is no violence in Raphael; his figures yield to him without resistance, an order pervades his work, each element has its fitting place, and the composition as a whole delights the eye. His painting is a visual confirmation of the known world and the tenets of the known faith—effective without being obtrusive. Michelangelo's heaven-storming figures, on the other hand, either repel the spectator or grip him.

The peace that Buonarroti contradicted in the act of

seeking becomes repose in the art of Giorgione. His figures are at rest, in harmony with the landscape, self-fulfilled. The deep soft colors and rounded forms in his pictures determine the relations between values. Everything appears effortless, conflicts are subdued, and space is natural.

The Venetian painters represent the world as a harmony of soft tones, taking unity for granted, while the Tuscans conceive space as the unifying principle. The idyllic quality of Venetian art was spiritualized by Titian, who, bringing out a supersensory element, created a new pictorial space. Even his drawings are shaded, shapes rendered by means of different tones. For all Titian's warmth and softness of color, his portrayal of Ottavio Farnese, in *Paul III and His Nephews,* reveals him capable of a pitiless insight. Smooth and insidious as a snake, the young prince in glittering costume approaches the Pope, fawning. A drama unfolds in the exchange of glances and the cold calculation in the faces of the two men, contrasted with the mellow tints in the background. In the portrait of Paul III in Naples, the Pope is represented alone. His psychological delineation is given with the utmost economy of means; only three colors are used, yet the more one looks the richer they become. The combination of mulberry, ivory, and brown in the portrait, transposed into muscial terms, would constitute a minor third with its tonal affinities and latent tension. The straight mouth and closed lips are inflexible; the narrow-fingered hand has a firm grasp. Thought has molded this forehead, and

the Pope's gaze does not stop with the visible world. While in a reproduction of this painting the colors are sharpened till the Pope appears as severe as he does in history, the colors in the original glow around the dark velvet robe till the figure is softened and this mild radiance melts, leading the eye into an undefined depth.

In the *Christ Crowned with Thorns,* in Munich—Titian's last finished painting—he repeats, but how differently, a theme he had treated thirty years earlier. At that time he had contented himself with the purely dramatic effect of the cruel scene. Now, though the picture is organized much as before, everything in it is transmuted. The torturers are no less brutal, the martyrdom is no less terrible, but the whole scene has attained artistically to the rank of tragedy. A supernatural light falls not only on Christ but on his persecutors as well, making them not the conscious actors but the oblivious agents of an event whose significance they ignore. The source of this light is a gloomily burning torch that flickers above the criminals and envelops Christ in a mantle of beams shot through with shadows. Colors glimmer in the dark, radiating an incomprehensible brilliance that penetrates the night like a promise.

Prior to Titian, color had been considered a self-evident property of substances and objects, a *character indelebilis;* whether darkened or brightened, it was essentially the same. Even Leonardo warned against painting a leaf in the sun, on the grounds that its form would be blurred. The Platonic conception of reality still dominated, though

reality was no longer conceived as the world of Ideas, and bodies were considered to change according to their position in space. Foreshortenings were allowed as being consistent with the laws of perspective, but any drastic change in a particular color was judged tantamount to destroying its inherent quality. There was no scientific method to prove that colors, like bodies, alter in appearance according to light and placement.

All this changed with Titian. In his late paintings color ceased to be an immutable property of things and became instead an effect of light. For him pigment is the stuff of color, light its value. Thus, light became the new power, and the myriad hues latent in each single color became evident.

When mathematical perspective made its appearance in art, colors were used with great freedom, as though to counterbalance the geometric rendering of space and to stress the importance of figures and objects. While Botticelli used moderate tones in most of his paintings, he chose varied and glaring colors when working with perspective.

Titian's portrait of Charles V is organized around two sharply contrasting colors: red and black. Only in the distant landscape are they reconciled. With the *Christ Crowned with Thorns*, in Munich, one can scarcely speak of colors as such, but rather of a colorful shimmer and glow, a tonal dimming-away and a vibrant darkness. The light in this Munich picture brings out the variations, and not only the shadings inherent in the colors. On the green

velvet of one of the torturer's sleeves bright silvery spots appear, while elsewhere the green fades away into darkness. Color used like this is no longer color as it was before and cannot be called *indelebilis*. Without being iridescent in itself, it unfolds into a bouquet of tones, each related to the fundamental tone, and all creations of the light.

Those Renaissance artists who failed to meet the demands of their age and rejected mathematical perspective remained bound to the past. Those who succeeded in breaking through to the timeless, while fulfilling the requirements of the present, were the ones to render a truly spiritual vision in terms of the sense-perceived world —Leonardo with his original space as the universal source of being, Michelangelo with his dynamic space and his striving through the body for freedom by extension, Titian with his revealing of the many tints in the single color, all under the sovereignty of light. In each case a significant insight was experienced and made visible. Such, then, is the "perspective" that, leading beyond the knowledge of a given period to a further vision, points through man's creative spirit to the spirit of creation itself.

14

Baroque Architectural Styles

Architecture of the Baroque is shown here to belong either to the Dynamic or to the Rational Style. In spite of its bewildering leaps and bounds, the Dynamic Baroque is consistent if seen in the light of its own logic, which demands that architectural forms move in time before our very eyes. However, the Baroque, indicating by its dual style a breaking apart of what had hitherto been integrated, is an ominous symptom.

ARTISTS, during the Renaissance, drew inspiration from the forms of antiquity, infusing them with a new life. Alberti based his work on ancient Roman architecture; Michelangelo, as an experiment, made a statue almost indistinguishable from a Greek sculpture, yet the achievements of both men were original in the deepest sense. Underlying Alberti's monumental proportions was the *nescio quid,* the *je ne sais quoi,* which, according to him, determines the essential value of a work of art. Michelangelo energized form with implicit motion, launching the solid object beyond its allotted space.

Alberti is representative of the early Renaissance and died more than ten years before Buonarroti was born. Only in the Baroque period did the work of these masters come to exert a decisive influence on art. Michelangelo's

dynamic drive became the theme of one of the Baroque styles, Alberti's restraint that of the other. Baroque architecture has two faces: one looks at the world calmly, reasonably, the other veers swiftly from one dramatic expression to another. The Rational Baroque stresses logic and law, the Dynamic Baroque flux and vehemence. The Rational Style develops *more geometrico,* in architecture as in philosophy; the Dynamic gives concrete shape to the phenomenon of change, making use of every architectural medium. Passion and will assume solid and spatial forms, human figures seldom appear and, when they do, play only a secondary role. Whether dominating or subjugated, structural parts never seem secure, those in power giving the impression of having to reassert themselves continually. The maximum effect of motion was wrested from the static structure, till it gained the appearance of a driving force, always seeking and begetting its own image. A synoptic view of solids in space was thus made to appear as a succession of forms in time. Transiency was stressed and form left undefined.

Leonardo had considered the time factor in music to be artistically limiting; it was this very factor that architects now sought to convey. As in an orchestra where various instruments, playing at unequal intervals, sustain the flow of sound, so various structural parts in Baroque buildings serve the main architectural theme, which is movement. Forms surge and break like waves, everything is in flux, in the act of becoming. Buonarroti's staircase of the Laurentian Library was the first definite expres-

sion of motion in architecture. A staircase in itself suggests a process, and eventually both stairs and steps came to play an important part in the Dynamic Baroque.

The Greeks overlooked the artistic possibilities of the arch because they considered only the solid; for them the void, the space under the arch, was forever formless. If we can switch from our way of seeing to that of the Greeks, why can we not also, when confronted with a Baroque structure, switch from our usual static perception, and meet it in its own dynamic terms?

Works such as the façade of San Vicenzo e Anastasio in Rome are difficult for the untrained eye to apprehend. Although this church does not epitomize the style, it is a good example of the Dynamic Baroque. All preconceptions must be relinquished. Structures are so tightly fitted together, so interlocked, that the effect of motion can be grasped only by concentrating till one begins to see through the apparent to the actual form. A succession of columns rushes toward us, each pressing on the heels of the next. This façade is more a technical feat than a work of art.

Santa Maria della Pace in Rome, while even more difficult to follow in detail, is immediately convincing as an artistic work. Stately in form, it has rhythm, gesture, and stride. Unconcerned with its location, it sweeps on, its structural parts moving at various speeds, in various directions, along straight or curved lines, now retreating, now advancing. Despite its small size, it suggests vastness, its motion having no visible boundary. Animated on

all sides, its potential thereby extended, the building makes room for itself.

Borromini's fantastic constructions often appear contrived, while South German works of the Emotional Baroque have spontaneity and freshness; even monasteries give the impression of dancing. A fanfare of towers soars blithely skyward, and it is hard to say whether faith or hilarity prevails.

The Church of Weingarten is inherently consistent as to form; at first glance the interior seems a bewildering mass of details. The longer we study one of those multiform pillars, the more it looks like a reflection from mirror to mirror; then suddenly the prime motif becomes clear: these repetitions present one and the same pillar moving forward with its capital and entablature, like a living thing.

Unless the whole has been apprehended, the singling out of any one part is more of a mistake in the Emotional Baroque Style than in any other; one becomes riveted to a detail instead of following the dynamic interplay of all elements. Everything should be viewed as if in motion. The building is a multiplex, its solid and spatial forms intercepting one another or clashing sharply. At one point an oval begins to take shape but falls short of completion; at another, a staircase twists like a vine between wall and pillar, reaching out to bind the pillar to the pulpit. The pulpit itself is not stationary; at one moment it floats, at another it totters without ever lapsing from its mobile stance. In terms of this dynamic form, that which flows survives, that which resists is lost.

The Emotional Baroque strives for incessant life, pushing forward as if to sweep every obstacle aside. Walls, roofs, pillars, the building itself, step forth and go on a journey.

Leonardo had already referred to motion when he envisaged the interrelations of various objects moving at different speeds in different directions. He retained, however, a fixed point from which all variables could be observed. With the Emotional Baroque this fixed point vanished. One might claim that it was also absent in the Gothic Style with its fluid, upward-rushing lines; but Gothic architecture has a goal, a destination, which orders all activity. Thus, the organization of the building is determined from above, the structure invisibly supported by what the mystics call the "upper root." Not as the prime, the immovable mover, but as the ruler of worlds, this "upper root" like a magnet attracts everything to itself.

The lines of force in the Emotional Baroque Style crisscross in all directions, their goal or point of convergence unknown. Yet this very stream of solids, imaging life, assures the style validity in its own terms, absolving it from chaos by an abundance of expressive forms. Form, it might be argued, is the expression of an inwardly experienced order, and where in the Baroque is this order? The style submits to no rules, is refractory to any definition, and follows no system. On the other hand, one must not confuse the intricacies of the style with its main expression. The Baroque must be grasped at a stroke. Since

every part shifts in relation to every other part, one has but to turn one's head or move a step for the rhythm of the structure to change. This experience leads to the substance not of the dual style as a whole but of the Emotional Baroque, which in itself presents an act.

The relation between variables in this style is much like that of a complex mathematical function. Countless elements have their own direction, speed, and rhythm, their interplay resulting in a total form, the theme of which is change. Every detail is in motion, each fragment is an incipient form, the dynamism itself proceeds in unbounded space-time.

An object rendered as stationary in space gives the effect of a fixed present, an object rendered as moving, the effect of extension in time. A building is limited as to its actual dimensions, unlimited as to its dynamic form.

Just as, according to Leibniz, monads, however insulated, belong together in terms of a pre-established harmony, so Baroque forms, however arbitrary, become consistent at the level of motion. Transiency is thus substantiated in this art form. The Emotional Baroque offers a cross-section not of the everlasting but of the ever-moving. It implies time by an organization of forms, which, instead of stabilizing the structure, makes it appear a continuum.

While the Emotional Baroque represents change, a stream of events as haphazard as that of life itself, the Rational Baroque demonstrates an indisputably logical

order. Both styles make use of traditional structural ele-
ments, the Dynamic Baroque incorporating them pell-
mell, the Static Baroque organizing them into an explicit
and well-ordered design. Opposed to a sensual as well as
to a mystical interpretation, the Rational Style rests on
the assumption that everything can be explained. Thus, art
must be reasonable. Such a postulate, however, is not con-
ducive to original form. This stringency may have come
about partly as a reaction against the political despotism
of the times, partly to counterbalance the extravagance
of the Emotional Baroque Style. Cognition, to Descartes,
was the science of proportions and relations; Laugier
accorded philosophers the legislative authority in art,
leaving only the executive power to the artist and thereby
stating what the Academicians had tacitly assumed for
centuries. He would probably not have formulated his
judgment in the same terms prior to the publication of
Montesquieu's work on the division of governmental
power. Be that as it may, the Rational Baroque Style had
existed long before Laugier specified the relation between
science and art.

Theorists had always taken proportions as the criterion
of the beautiful in art. Now Daviler praised Palladio for
ces grandes proportions, his method of duplicating, tripli-
cating, or quadruplicating the basic unit of measurement.
The absence of tensions in a form, resulting from the re-
peated use of identical quantities and their multiples,
was deemed a great artistic advantage. Such views reveal
not Palladio's main contribution to architecture but the

pedantry of French Academicians in the seventeenth and eighteenth centuries.

In the Villa Caldogno, although the basic unit of measurement is differentiated throughout the structure to produce contrasting effects, this very modification lapses into a formula. Palladio wished to animate the blocklike form by using regular planimetric figures at irregular intervals. The motif of the upper floor is a rhomboid over a square, that of the next floor an oval between two circles above a rectangular frame, while on the ground floor the windows are elliptical. In other villas geometric figures are similarly employed to diversify the structure. Thus, his method often consisted in a certain combination of fixed forms. Although proportions were calculated as exactly as possible, they do not mutually enhance or determine each other. The form of these buildings seems imposed from without, and all variations, though legitimate, appear arbitrary. Palladio's purpose was not to create spatial units, but to stress line and volume. In an age obsessed with motion and the transposition of static into dynamic, spatial into temporal elements, art to Palladio remained the ordering of lucid relationships within a clearly defined area.

A late work of Palladio, the Church of the Redeemer, in Venice, allows for spontaneous movement and spatial form. The aisle, widened by chapels, leads to the area under the dome, ringed with curved recesses; these in turn conduct to the apse and its space-shaping columns. On the outside of the church individual structures are

forced into relationship, their disaffinity thereby becoming more conspicuous.

While Palladio's development can be studied in his architectural works, his book on the five orders is a valuable additional source. He does not discuss method, but his theory on the evolution of society casts a light on his conception of architecture as well. According to this theory—by no means new—human history began with isolated individuals who later joined each other and formed groups. This conception is embodied in his art: one simple form is combined with another until, grouped, they constitute a formal system. Palladio considered the circle to be the epitome of perfection, on the basis that having no beginning and no end it is everywhere equal to itself, preserving at all points the same distance from its center. Moreover, it was for him the image of infinity; thus in his way he aimed at the same goal as architects of the Emotional Baroque Style. For him the circle, the "most perfect form," represented the "unity, uniformity, and justice of God." He contended that the loss of friezes and pediment groups should be compensated by perfect architectural form.

Not the initiator but a leading representative of the Academic Style, he has been cited by his adherents for centuries as an authority. His book, unlike other treatises on art by artists, is most revealing. The reconciliation of Christian and pagan ideas at that time is indicated by the candor with which Palladio states that the circle—Pytha-

gorean symbol of perfection—is the only form appropriate
to a church dome. He did not, as did the Byzantine artists,
use it to abolish boundaries and obtain an unreal, super-
natural effect; to him the circle itself with its unbroken
periphery was the sign of the divine, the hieroglyph of
the Christian God. Unlike architects of the Emotional
Baroque Style, who represented infinity by means of in-
complete and variable forms, he conceived it as present in
that one self-contained and ever-identical form. To the
Greeks the circle was finite, static; as Palladio saw it, the
circle is a movement without end, an image of infinity.

Occasionally he reverted to Alberti's methods, using
throughgoing pilasters to connect stories, but it is in his
attitude that he resembles Alberti more than in individual
features. Despite his preference for the academic, he was
an independent creator, and as such a pioneer, a herald
of the future. On the basis of purely objective require-
ments, he produced an absolutely severe architectural
form that as a whole is more than the sum of its parts.
In this capacity of a purist inaugurating an architectural
reform, he passed almost unnoticed, from his own up to
the present day.

The Villa Schio is a wholly original work. Had Palladio
bent all his energies toward this nascent form, revolu-
tionary in its simplicity, the Emotional Baroque would
have paled in comparison. No one could more effectively
have opposed the two extremes of his epoch than Palladio,
but apparently he did not trust himself without the sup-
port of pre-established and approved forms. Columns,

colonnades, consoles, outworn and meaningless even in Roman times, were highly valued in his day. Those who championed reason considered them a guarantee against irrationality and lack of restraint. Even architects of the Emotional Baroque Style made use of them, but only as raw material. It is mainly thanks to Palladio that an architectural form, austere and restful in design, endured at a time when the dynamic trend initiated by Michelangelo had gained wide acceptance.

Juvara, in the eighteenth century, erected a new monument in the Rational Style. The Superga, enthroned high above Turin, and visible from a great distance, is effective by its volume, size, and dominant position. Misled by its tremendous impressiveness, one might think it the climax of Italian Baroque architecture. Volume and weight, however, are no measure of greatness. The disparity between the pretentious appearance of this church and its actual poverty of form is disturbing. Moreover, the relation between its parts is forced, round and angular forms conflicting strongly with one another. Borromini's edifices are far more capricious, but in them everything is uncertain, about to change, to assume a new shape, while in the Superga each element is fixed in its place. Thus the Rational Style is at least as despotic as the Emotional, tyranny being basically common to both. The Dynamic Baroque is often tense to the extreme, its forms subject to an almost intolerable pressure, but nothing seems to last, nothing is irrevocable. Oriented toward the future, perpetually in motion, it suggests the possibility

of release, though none is achieved. The Rational Style, on the other hand, appears by its immutable order to have arrived, to constitute an answer, a finished form.

In the case of purely utilitarian buildings it is enough that they serve their purpose; representative buildings must do more. If they merely render, however flawlessly, what is already known, they are not, in the true sense, genuine works of art. Only when an inner reality has taken possession of and shaped matter does an artistic creation stand timeless.

In Italy both the Static and the Dynamic Baroque developed, stemming from the Renaissance Style. The Gothic, which in France had been a genuine national expression, was completely abandoned in Italy. There it had always been a foreign element, whereas in France, even with the revival of antiquity, medieval forms subsisted. It was only after central planning as a structural principle had been long established in Italian church architecture that Paris architects finally turned to it.

François Mansart, in his Church of Val-de-Grâce in the seventeenth century, succeeded in giving the dome a perfectly self-contained form, but for this no central plan was required. Shortly afterward Levau built the Collège de France, grouping the entire structure around the dome, which functions not as a restful center but as the animated head of an irregularly membered body. On the exterior it is poised without emphasis; inside it acts as a leading voice in a chorus of ellipsoid spaces.

At the end of the seventeenth century Hardouin-Mansart erected a large centrally planned church, the Dôme des Invalides. Similar in design to St. Peter's Cathedral, it has qualities that assure it an independent place in architecture. As compared to Michelangelo's ground plan for St. Peter's the Dôme des Invalides is not overruled by the central vault. This church, constructed from a purely radial pattern, contains a complicated network of passageways and spatial units. The high vault is crowned by a parabolic cupola that rivets the attention; everything else is static, finite, complete, but this second vault has a form that, different from all others, points beyond its sensible image.

On the exterior of the church a third and higher dome conceals both vaults of the interior. No one, before entering, can guess what the effect will be: each spatial unit is distinct, with steps leading up to it, while they all are in radial connection with, and give power to, the central form. Organized with reference to this center, all areas together compose an integrated spatial figure. The exterior, in contrast, consists of two distinct forms, the square and the circle, the house and the cupola. The drum, surpassing each of the two stories in height, separates them from the dome and makes them appear as its pedestal. In this way the substructure serves merely as passive support for the crown; only inside the church does every element share in the loftiness of the central vault.

In the Gothic period France had combined a transcendental effect with elegance, flexibility, and grace of form.

Now, in the eighteenth century, French architects found full scope for their versatility within a framework of delimited forms, following neither Borromini's pirouettes nor the flame effect of the South German Baroque.

In the Chapel of Versailles, built by Hardouin-Mansart, the architectural movement swings from pillar to pillar in the lower story, from column to column in the upper, and runs via the high arch above the narrow nave from one windowed wall to the other. All details—Corinthian capitals, crenelation, balustrade, and the pattern on the floor —derive from antiquity, but the rhythm and the sense of space they give are peculiar to this chapel alone. Structural parts, unlike those in the Emotional Baroque Style, are animated without crowding or overlapping each other. Here the life motion does not struggle for self-perpetuation but remains within its immediate area; the chapel is a place of harmony, a world in itself, whose forms, like living beings, delight in festive gatherings.

The term "Rococo" is used in art literature in various senses, sometimes to denote a fashion in decoration, sometimes to indicate the period of Louis XV, but always in reference to the Emotional Baroque. There is, however, one form among the many of that period sufficiently distinct from the Dynamic and the Static to be treated separately. It is this that will here be called Rococo.

The Rococo has many features in common with the Rational and the Emotional Baroque, but, unlike the Dynamic, it has a bland serenity and, unlike the Rational, a mobility of its own. Both variegated and composed, its

graceful forms co-operate, the leading one never insurging on the other; the Rococo is not a contest, but a concert. Characterized by joy, freshness, and sensuality, the style is neither ambiguous nor excessive. Basic proportions are not so much fixed as inherent in the form itself. Flowers, arabesques, musical instruments, and human figures, all have a life in common on the walls of buildings.

Brisieux, in his *Traité du beau essentiel* (1752), says that proportions were given to the soul by God, the eternal geometrician, and are not imparted to us through the senses; they are perceptions rather than sensations. Leibnitz says of God, *"Il garde toujours la justesse des proportions,"* and adds, *"Toute la beauté est un épanchement de ses rayons."* In the Rococo it seems that a *lex naturae* has granted each form a freedom in terms of its own nature, and hence a justice, a harmony.

Perrault's plea for free emotional and not just intellectual expression in art was scorned by the Academicians and applauded by Rococo architects. They abandoned strict formality, made the stately give way to the human, the impressive to the friendly. This trend, which later in the Biedermeier period resulted in the *intime,* the cozy, still had a certain courtliness in the Rococo. While pseudo-classicism became empty and repetitious, the Rococo had a rhythmic sweep. Pre-established forms were skillfully used time and again; while this prevented blunders, it also excluded creativity.

French Baroque architecture is craftsmanlike, its idiom as clearly defined as the spoken and written language of

that time. Certain voices rose, insisting that there was somewhere a deficiency in this flawless art of building. In 1768 Guillaumot claimed that excessive rationality had frozen invention. Earlier still J. F. Blondel had declared that architecture would create no more new styles, but merely adapt former ones. Was it possible that originality was really exhausted, or was this barrenness a consequence of having avoided conflict and favored relationships poor in contrasts, a course recommended by Blondel himself?

With its exuberance on the one hand, its sober calculation on the other, the Baroque Style appears hopelessly divided. The Dresden Frauenkirche, however, stands as a reconciliation of the two styles. Its vigorous central structure is surrounded with lively forms, while the whole culminates in a massive cupola, unique in architecture. The lantern on the dome must be disregarded; it was not in Baehr's design, and its strained proportions, weakening the compactness of the building, almost distort it. The Frauenkirche is so solidly organized that, although its joints are apparent, it seems hewn out of one block, an indivisible whole. In the center of a large area, unobstructed by the surrounding houses, the church rises over the city, its helmet-shaped cupola like the head of a powerful body, soaring straight from the beveled roof without the aid of a drum. Seen from a distance, it seems to hover in mid-air, self-entrusted to space. At close range its mechanism is clear, but the very weight of its supports

and abutting walls sustains the effect of buoyancy with a concentrated power.

Curving in at the base, the cupola contracts, then expands in a wide arc to the topmost ring. Rhythmic and flowing of contour, it has an austere repose. In its tall form, the eight façades of the church, each differentiated by curved or triangular pediments, are gathered and held. These façades are all treated individually, although none corresponds to an area within—a fact worth noting because Baroque architecture, even when there were interior sections, often omitted to represent them on the outside.

The interior of the Frauenkirche, although lofty, is less definite, less austere. A centrally planned Protestant church was a new undertaking in architecture. From the point of view of acoustics, the Frauenkirche is perfect; as regards spatial form, it is not, but to have made the attempt alone is remarkable. Its exterior complete and compact, the Frauenkirche is accessible from all sides. The streets of the city lead up to it, its dark-colored stone, high windows, and upward-pointing gables inviting all eyes.

The Radcliffe Library at Oxford also has differentiated façades, but its cupola, unlike that of the Frauenkirche, is not like the head of a multiform body. Ringed by another circular structure, the dome fails to consummate the building. While in the Frauenkirche only the dome is curved, the round form predominates in the Radcliffe Library. The octagonal shape of the Frauenkirche serves a purely artistic purpose; the interior does not require it; the shape of the library is also nonfunctional, nor is it uniform. Such

a system is unusual in the Rational Baroque, most architects having assumed that an aggregate of regular bodies was enough to constitute an artistic whole.

The Rational Style was never popular in Germany, that country having passed almost without transition from the Late Gothic to the Dynamic Baroque. In England, conditions were different; Gothic forms were preserved up to the seventeenth century, when Inigo Jones introduced the Palladian style. Among the great architects of the Baroque period Christopher Wren is eminent for having mastered the heritage of several centuries.

The Baroque, Classical, and Gothic styles were all equally familiar to him. Even when one structure incorporates them all, the form does not appear eclectic. St. Paul's Cathedral is dominated by the formal element, its vault towering impassive above the crossing of the nave and transept. Like a space apart, the cupola is not the structural point of convergence and retains an appearance of aloofness that it would not have had according to the original plan, where it was to be connected with eight secondary domes. On the exterior, severed from active relationship with the rest of the building, the cupola stands overlooking the city, a solitary monarch.

The Dynamic Baroque gave shape and volume to the ever-changing. The law by which events succeed one another is never clear, nor is there any sign of a goal. Forms clash, interpenetrate, recoil, and scatter, as if the forces of life itself had come to grips in solid and spatial terms.

This style can be interpreted in two ways, as signifying faith or utter skepticism. If we assume it to be faith, then what kind of faith? Faith, that events which seem meaningless are consistent in another sphere? That efforts frustrated on earth will be fulfilled later on? That in time all potentialities become actualized, though under circumstances different from those we know? Or that the process, extending to infinity, has meaning in itself?

What was present is past, the new present is slipping away. Individual forms are overruled by the dynamic power, yet each insists upon its rights, struggling to fulfill itself regardless of the rest. No end result is conceivable, for to *be whole,* each element would have to stand in appropriate relation to the others, all elements together constituting a total form. As they stand now, these partial shapes, fully unfolded, would have no relation to one another. Thus, the style indicates two mutually exclusive drives and leads us—if it leads us anywhere—beyond perception.

If, on the other hand, the only motive of this style is motion, then it represents a chain reaction infinitely extended, infinitely prolonged, all hope of meaning lost.

Whatever our interpretation of the Dynamic Baroque Style, an infinite process is involved, and to this shifting image the Rational Baroque opposes a permanent and immutable form, mathematically ordered. The clarifying of relative values through a common unit of measurement is as gratifying to the eye as the subsuming of diverse elements under one principle is to the mind. All contours run

along prescribed lines, everything is predetermined. The crucial element in this style is thus the distribution of parts. Nothing follows its own impulse, nowhere is there a creative *élan.*

Could Guillaumot have been right in his claim that reason had paralyzed the imagination? Had Blondel, when he predicted the end of all styles, sensed the fatal ebb in man's creativity? Different as the Emotional and the Rational Baroque are, neither creates a meaning, but represents one already there. The positing of reason as the only criterion of validity, the passive surrender to whatever happens, or the mere recording of change—none of these leads to great art.

As it turns out, Blondel's prediction has been confirmed. There have been no new styles since the Baroque. Architects have either reverted to the Antique or revived the Medieval, imitating the forms now of one, now of another period. Whether this came about because man began to think of himself as a mere instrument of history, to seek fulfillment only as an isolated individual, or to consider that life was a thing to be manipulated rather than invested with meaning—whatever the reason, it is certain that human energies and aspirations from the Baroque period on have not been directed toward any transcendent goal. Long before this change of heart betrayed itself in other fields, man's new attitude was evident in architecture.

15

Harmonics

The credo of Western man is evident in the visual arts, but it is best proved in harmonics, where the inter-relationship of tones is subject to exact measurement. While Baroque architecture—a static medium—appears to be moving in time, music—always in motion —gains new structural stability by resting on chords as on pillars.

A HARMONY of many forms, not uniformity, was the goal of Western art for thousands of years. This required a coming to grips with re-fractory material in both the inner and the outer world. The very thing that, according to Plato, an Egyptian priest criticized in the Greeks—their passion for change—pro-duced a rich variety of forms in the West, while a constant striving toward integration characterized all successive styles. In his desire for fulfillment man transcends limita-tion after limitation in himself and in the conditions that govern his life. After J. F. Blondel had prophesied the end of new styles in architecture, the West once again gave evidence of its originality—this time in music.

The main objective of the Greeks had been to interpret and overcome the discrepancies between spirit and mat-ter, subjective and objective reality. This is evident in the

Doric temple, in the antithetic structure of the Ionic column, and in the Attic tragedies. Since then, each Western style either resolved conflicting elements or at least attempted to do so. In the eighteenth century the West realized its creative potential in a musical form based on discords. With every tension there is a corresponding demand for resolution; the human being is mirrored in this art form, the spirit sending out its appeal and the spirit begetting its response.

Thus, the mythical figure of Harmonia, daughter of Ares, god of war, and Aphrodite, goddess of love, was at last substantiated, dissonance proving compatible with consonance and giving birth to harmony. It is precisely the tension between the two most discrepant chords, the first and the seventh, that leads most surely to release.

Tension, when it exists in architecture or sculpture, is both contained and transcended in the static form; in music, conflict and its resolution are presented successively. Each problem is given a full hearing before reprieve is granted. Tonal relations in music can be tested and proved; in architecture, sculpture, and painting, although proportions are computable, the intrinsic conflict and the formal resolution are too interlocked to allow a purely mathematical evaluation. It is for this reason that harmonics the science of musical sound, is best qualified to demonstrate the character of Western art.

At a time when Palladio was seeking definitive proportions in architecture, and just prior to Galileo Galilei's discovery of the laws governing the fall of bodies, Zar-

lino established the consonance of the major triad and therewith a theory that became the basis of the musical system of the future. A century and a half later, Joseph Sauveur, a deaf-mute, proved that every fundamental tone contains in itself not only its major but its minor chord. Sauveur, taking the keynote, or prime, as his starting point, counted the thirds and fifths up and down the scale, a method also used to determine ecclesiastical modes in medieval music. The lower tones covibrating in the prime can be considered its minor third and fifth only when the intervals are computed downward. Although contributing to the timbre of the tonic, these lower tones do not constitute a genuine minor in our scale structure; they form the major chord of the subdominant. Nevertheless, Sauveur's scientific exposition of the undertones as well as overtones implicit in the tonic extended Zarlino's theory and prepared the way for Rameau's complete system of Harmonics. Formerly compositions were bound to the key in which they began; now the inherent relation of tones in one scale to tones in another and hence the latent affinity of scales to each other allowed free movement within various keys in the same composition.

There are in the prime latent tones that, sounded in their own right, constitute the triad. Thus E and G are implicit in C and, struck together, vibrate in turn with their own thirds and fifths, their overtones. It is not pitch but tonal relation that is important in this system. The main dissonance contained in the C major chord, for instance, is the leading note B, which is the fifth of E and

the third of G. Thus, the tension in the prime chord re-
leased in sound cries for redemption in a further harmonic
chord. With each musical phrase one of the potentialities
in the initial chord is actuated in either the minor or the
major key, all avenues being open to the melody. Given
this modulation and chord structure, music gained in
freedom and order. Although Zarlino had formulated its
main principle in 1558, it was not until the middle of the
eighteenth century that a style was fully developed, based
on a new harmonic system.

Though movement is of the nature of music, freedom
of movement had to be won. For centuries music served
only to sustain and accentuate the text, save in the liturgi-
cal alleluia, where it could soar toward a fuller and more
eloquent expression.

Just as the naturalistic trend, long before it determined
art in general, had crept into Gothic ornamentation, so
music with the introduction of the *melismata*, or flourish,
gained in melody until it became independent of the text.
Thus, subject and ruler gradually changed places.

Latent energies of rhythm and sound began to stir, the
words from the Song of Solomon: "I sleep, but my heart
waketh," coming to life in the Polyphonic Style. All voices
take wing and go on without respite, like migratory birds.
Unhurried, they enjoy every stage of the way, repeating
the same phrase over and over, ardently and with varia-
tions, never quite arriving but linked with and held to
their goal. Just as in an infinite arithmetical progression it
is necessary to stop at one point in order not to go on for-

ever, so in a Polyphonic composition the final chord is never conclusive, but merely a means of halting the movement. Interwoven in the Polyphonic fabric, individual voices are hard to follow; they travel their various ways, convene for a fleeting moment for the sake of contrast, separate at once, and never assemble for a common performance.

Not before the inherent plurality of each single tone was discovered did the triad become decisive in the musical system. From then on the leading tone began to play a prominent part, and the tension-creating and tension-dissolving forces of Harmonics came into being. The chord now contained the melody in a potential state, held it, and then released and actuated it. With this new musical form our acoustic perception changed, so that today, when a single note is struck, we hear ringing within it its implicit harmonies.

Science and art in the West have always been interrelated. Facts, such as the latent presence of the major and minor triads in the fundamental tone, once ascertained by physics, were especially welcome at a time when man considered science the supreme authority.

Medieval music was based on certain physical laws, discovered early by the Greeks, which existed practically unchanged for two thousand years. With the Polyphonic style, the number of singing voices was multiplied and their progression varied until finally orchestral music developed. Man acquired organs of expression far beyond the range and quality of the human voice; instruments of

all types now gave form and substance to powers long muted within him, and with their help man refashioned his world.

At the time of Bach the term "symphony" referred to an instrumental interlude between cantatas and chorals. Symphonics is a more appropriate term for the new style, in that a community of tones is its underlying principle. Though each note is a unit, its inherent voices are not absorbed when the chord is struck, but rather stimulated to expression, to a flowing out of sound in melodic gestures. Just as Antaeus received strength whenever he touched the earth from which he was born, so voices acquire new life as they meet in the common chord. Released again, they unfold in myriad ways, their energy never exhausted. Every goal yields the possibility of further goals. A discord is allayed by a minor chord, the tragic half answer, or else struggles through to the affirmative major. The vertical chord structure is the music's present, its order of being, the movement of voices in time its order of becoming.

The potential energies of all tones are made manifest in this style, as if the Aristotelian entelechy were fulfilling itself: *dynamis* the tone's tension, *energeia* their release. Instead of an empty consonance or an enforced agreement that would limit the range and fullness of individual voices, the chord fosters melodic impulses, launches them forth to ring, and gathers them again, preparatory to new combinations. Every final chord, while constituting a

genuine termination, could also be the beginning of a new movement.

After the "imitative method" of medieval times, where an identical phrase was performed by each voice in turn, the monadic style gave the lead to one voice alone, the others acting as retainers. It was not until freedom of modulation was gained that a musical union was finally established in which all voices came to co-operate in the service of the whole.

The Emotional Baroque gave architecture a dynamic form in which all static elements appear to be moving in time. In the Symphonic Style each phrase unfolds as if prefigured in the initial chord, the whole composition resting on its chords as on pillars, while the movement swings from one to the other. The past reaches into the future, the future sweeps back, unforgetful, the present remains the order of being, the vertical form. Thus, music was given a face of its own, a new dimension.

16

Baroque Sculpture

Because the dramatis persona *of the Dynamic Baroque was change, sculpture in this style was at a disadvantage. While the too close simulation of life had already become a dangerous trend, some works still expressed more than the external features of human beings.*

THE Emotional Baroque Style in architecture is an image of tumult and change, structural elements struggling against one another without apparent order. Sculpture, when striving for the same effect, presents human and animal limbs as scrolls or twisted ornaments; a complex of shapes in a whirlpool of movement, the dynamic form stresses the inconstancy of all phenomena.

In Permoser's *Apotheosis of Prince Eugene* a tangled mass of creatures, drapery, and emblems rotates and whirls. Figures are inextricably confused, as if thrown together pell-mell, the spiral motion concentrated on the complex mass and overruling individual shapes. The form is unrelated to the object represented, the turmoil such that it is quite irrelevant whether a person or a thing is in-

volved. Every part appears the plaything of a relentless force, the whole work being more a monument to the dynamic trend than to Prince Eugene.

Where fleeting movements are essential to the theme itself, as in the works of Asam, the Emotional Style is most appropriate. The postures of Asam's figures are almost untenable; garments flutter, gestures are alive, solid and static elements dissolve, all that remains is a process, an image on the move, constantly changing. In the Klosterkirche of Rohr—a late Baroque work—Mary ascends to heaven with the speed of a rocket, while those witnessing the event appear beside themselves with joy, reeling and dancing. The action occurs as in a flash of lightning, form scatters into flames, limbs and garments into sparks and leaping shadows. The figures, terrified or enraptured, seem unable to control their motions, overwhelmed not by a blind power but by the miracle itself.

Apart from such works, Baroque sculptures give the impression of being more acted upon than acting, as if driven by an outer force that, like a storm, rushes through space, sweeping everything before it.

Michelangelo's figures are equally driven, but they are not subject to external compulsion; motion with them appears more the result of some passionate longing. In the works of many of Michelangelo's followers, the effect of movement is merely a display of power, violent rather than active. In the Baroque Style, drapery, curls, and trimmings often constitute the sculpture, the body serving mainly to accelerate movement. Baroque portrait busts,

despite their grave imposing mien, are somewhat theatri-
cal, pretentious, while character masks in the same style
are strangely eloquent. Thus, impersonal types were
treated as personalities and actual men as figureheads,
possessing only social rank.

Bernini's bust of Louis XIV, though similarly conceived,
is more expressive. Neither swamped with drapery nor
overburdened by the full wig, the face is motionless amid
a surge of curls, its gaze imperious. The drapery, as if
caught in a high wind, billows out, while the king endures,
impersonal, aloof, authoritative.

In contrast to this, the form of Bernini's equestrian
statue of Louis XIV at Versailles is lost in a mass of
flourishes, spirals, and zigzags. The tail, mane, and head
of the horse, even the posture and the hair of the rider, are
all treated as ornamental motifs. Here, the decorative ele-
ment is in keeping with the Versailles garden, the lilt of its
trees and the splashing of fountains. Bernini's equestrian
relief of Constantine in the Vatican, on the other hand,
equally decorative, stands in a prominent position on
a huge stairway. This work is supposed to represent the
emperor absorbed in a vision of the cross. Unfortunately,
the alternation of light and shadow, as if more important
than the event itself, tends to dissolve all form. Drapery
usurps the main role, and Constantine, in a welter of
creases and folds, is somewhat lacking in dignity. The
bulky relief background looms up like a natural force,
threatening to engulf both the man and the horse. The

whole work resembles a heraldic emblem disproportion-
ately enlarged.

The movement in this type of sculpture stems from
Leonardo's dynamic horse-and-rider sketches, but the
treatment of the theme is radically different. In Leonardo's
style the play of forms never impinges on the figures rep-
resented. His *Neptune* sketch at Windsor and *The Battle
of Ensigns*—known only from Rubens' copy—both in-
volve a geometric pattern that stresses the rearing and the
prancing of the horses. Leonardo achieved this reconcilia-
tion of opposites in a free-standing statue as well: his
Model for an Equestrian Monument in the Museum of
Budapest. Head, legs, and tail sprawling, the horse simul-
taneously whirls around its own center and leaps into
space. Thus, it appears to push out radially in all direc-
tions. With each shift in the spectator's position, the pic-
ture changes, while the "simultaneous harmony of all re-
lationships" remains a constant from every point. Such
harmony results from the interplay and counterplay of the
life motion and the formal design. Organically, the stal-
lion follows one set of laws, formally another, given in this
case by a revolving wheel whose spokes are the spread
limbs of the horse. In thus representing the animal's un-
ruliness in terms of order, Leonardo, not in the Greek but
in his own way, proved the irrational compatible with
law.

Instead of harmony in the Emotional Baroque, there is
a bustle, some elements predominating as if by chance

and others almost disappearing. The style depersonalizes, and hence generalizes, all vital forms, and this in order to render life. Thus, life becomes an arbitrary and compulsive process.

Sculptors tried to overcome the limitations of their medium, particularly when equestrian statues were represented as galloping. Horses are shown leaping violently forward, with the result that they seem suddenly arrested in space. Only Falconet succeeded in implying continuity of motion. His *Peter the Great* is a monument of extraordinary boldness. High above the projecting ridge of a cliff, the rider moves upward and forward, guiding his horse firmly. Silhouetted against the sky, this equestrian statue rises triumphant against space, its outline running obliquely from the horse's tail to its pointed ear, and more acutely from the animal's tail to the rider's head. The curve of the horse's belly contrasts sharply with the straight cliff ledge, accentuating the effect of a rearing upward movement. Three different forms of motion are thus represented in the rock, the horse, and the rider respectively, the dynamic element progressing from inert matter to organic life, to the human will in action. The three participants are ranked according to degree of freedom and relative function. The natural rock representing the cliff juts out into the shoreless sea of space, the horse responds to the rider, and the rider, a self-determiner, confronts infinity.

Unlike Michelangelo's figures, which struggle for ful-

fillment beyond space and time, Falconet's rider arrogates vastness to himself. Meeting with no resistance, he remains nonetheless bound by the very will that moves him.

In the Emotional Baroque Style the boldest schemes were carried out with apparent ease, but only rarely was an inner vision rendered in original artistic form. The Rational Baroque eventually lost its severity and withdrew into a private realm, while at the same time the Dynamic Baroque lapsed into a gentle, more playful rhythm. The difference between the two decreased until, almost similar in form, statues of both styles were to be seen in living rooms, side by side with knickknacks.

With Houdon sculpture again attained distinction. His *Baigneuse* moves naturally, freely, in her own artistic space, subtly inscribed in a geometric figure, the pyramid angle repeating itself at various levels. In this unobtrusive way the sculpture is encompassed, set apart, the outside world kept at a distance. Thus delimited, the form and lively bearing of the figure are secure. In Egyptian sculpture a geometric casing was imposed on the statue; in Houdon's *Baigneuse* the geometric pattern serves only to protect the figure and insure its freedom.

The Emotional Style was already at an end when Houdon began his work. His was not a decorative talent; he neither indulged in the sentimentality then in fashion, nor was he a slave to antique forms. Few people realized that these forms had become stereotypes; moreover, the newly excavated sculptures, popularized by drawings and

engravings, impressed everyone. Some were of a high artistic value, but the copies made of them, prettified and weakened, had little or no significance.

A bust by Houdon gives the whole man and something more, something beyond the strictly personal. In his portraits of boys and girls, childhood itself comes to life, yet each face retains its specific charm. The laughter of his wife is joy itself, and the bust of Gluck resonates as with an inner music. Passion dominates Mirabeau's mighty head, the form imbued with the orator's own eloquence. Voltaire is all astuteness, his mouth as caustic as a bon mot from his pen. Never content with the apparent, Houdon sounded the depth and rendered it—as in the visionary gaze of Molière.

In two of his works—*St. Bruno* and his *Self-Portrait*—Houdon could dispense with an accepted physical like- ness and bring to light the being within the man. Still young when he made the statue of the Saint, Houdon was already a mature master. Seven hundred years separated him from the monk, and in creating this work the sculptor had nothing to guide him but his own trenchant insight.

In ancient robed statues the body was veiled; here it is entirely concealed. Volume and structure are cylindrically determined, the figure stands erect as a column, hands crossed in front. From the monk's cowl, above the flowing robe, emerges the silent drama of the face. Unlike medi- eval sculptures, the figure is in no way bound to its cylin- drical shaft, but abides there as if by choice. The head and hands are expressive of self-abnegation. It is not

necessary to know St. Bruno's history when faced with this form eloquent of withdrawal and renunciation. A whole life is gathered in the stillness of that bowed head. Forehead and skull dominate the sensuality lurking in the mouth. The Saint gazes inward, all his senses listening to the spirit. The humility involved in such self-vigilance reveals the monk's power, the simplicity of this statue its intensive magnitude.

Houdon's *Self-Portrait,* no doubt a study, has all the freshness of a sketch. Diverse elements are left unblended, and this affords a new insight into the artist's technique. A great variety of forms, grouped in the compact mass, come together in the crossed arms, while the head emerges peremptory at an almost defiant angle. The arms are quietly braced, the face alert; the knitted brow, and the clear look from deep-set eyes express vision and resolve. This is man as creator; here once more is his intrinsic image—the last creative act of a dying age.

For about twenty-five hundred years the relationship between the human figure and the geometric standard was a decisive factor in Western sculpture. This relationship continued in the Baroque period mainly because tradition was preserved by the academic trend. It was inevitable that sculpture should lag behind architecture in the Dynamic Style, where the *dramatis persona* is life, motion, change. Architecture, as a complex of many forms, permits a fragmentation comparable to that of life itself, and impossible in sculpture. Moreover, it can represent

motion by means of geometric figures so arranged as to appear to burst their immediate area and, crowding one upon the other, give an effect of indefinite extension. Sculpture, which deals primarily with man, must be intact as to organic structure and thus, in the Dynamic Baroque Style, had to fail or become merely decorative.

Art in the West had always stood for the integration or at least the reconciliation of conflicting forms. With the Baroque period, however, such a synthesis was no longer sought, and contradictory principles declared themselves absolute. Whether conceived as heteronomously decreed, or at the mercy of time's meaningless flux, man had no real choice or will of his own. Long before Hegel wrote "All-devouring Time makes tools of those in power," this conception had been given a form in Baroque art.

This style was the last in the history of the West. From then on the individual was thrown back more and more on his own resources. If as a creator he sought integration, it was within and for himself. Individual works still existed, significant in form, but there was no universally accepted frame of reference, and hence no sovereign style.

Formerly sculpture had embodied the Idea of Man throughout the changing forms of Western civilization. With the Baroque period the Idea began to degenerate into a mere abstraction and the sculptured figure to become more and more a mere imitation of man. The statue gradually entered into relationship with the spectator, ad-

dressed the world familiarly, and renounced its impersonal character.

The change in the West's attitude toward space indicates what happened. In the past, the area of a statue had been determined geometrically. In the Emotional Baroque Style the dividing line between the statue's artistic space and space itself was abolished, each statue projecting out beyond its own field of energy, and not, like the *Nike of Samothrace,* moving in and by it. Thus, sculpture gave the impression of having outshot its orbit by dint of a compulsive drive.

17

Baroque Painting

Baroque painting reaches out for the infinite by various devices. Parallel lines seem to rush toward their meeting point; the horizon recedes or vanishes in the glare of the sky; the fusing of landscape and dreamscape implies unlimited possibilities; and when the dim, the dark outshine brilliancy, a glimpse of the unfathomable is granted.

B AROQUE architecture and sculpture extend our perception of space by their dynamic form; Baroque painting, rarely deviating from the laws of mathematical perspective, gives space itself an expressive power.

Tintoretto's figures are often foreshortened to the extreme and appear to have been hurled onto the canvas, while space, as if in motion, carries men, animals, and buildings along with it, or leaves them stranded in its wake. Space, with Tintoretto, becomes an image of time. The foreground rushes headlong into the distance, events as they occur seem to be passing, parallels race to their vanishing point, impatient to meet in infinity.

In his *Last Supper* (San Rocco) a blaze of light cuts across the background, intensifying its obscurity. Figures,

drastically foreshortened, shrink as the distance grows almost beyond recognition. Space rushes on, heedless of everything, even the figure of Christ. Byzantine mosaics give a vision of eternity, Tintoretto's paintings a flash, a signal, from another world. While insignificant events loom large in the foreground, revelation occurs but once —a second of Life breaking through life, that leaves us transformed in time.

The extreme perspective in this painting of *The Last Supper* strengthens its supernatural effect; the treatment of space in *The Flight to Egypt* is less startling. Behind the exiles extends a broad landscape, in front of them— nothing. Yet the light on their figures seems to come from a distance ahead, extending space beyond the pictorial area. Dimensions in Renaissance painting can be gauged; with Tintoretto they are immeasurable. The actual scene of *The Flight,* as if by sheer intensity, seems to reach into its own future.

Italian Renaissance artists delighted in geometric perspective and the representation of space by volume. The Venetians were less enthused with these techniques, though Veronese, in his Villa Maser, adopted them. In the sixteenth century, Flemish painters, having discarded the Burgundian style and fallen under the Italian influence, had lost their intuitive grasp of space. The young Rubens, in the Baroque, was not so much concerned with perspective as with the Venetians' treatment of color.

The rustle of drapery is indescribable, Rubens paints it; the feeling of touch is indescribable, Rubens paints it;

the eloquence of motion is indescribable, Rubens paints it. Fleeting sensations, gathered and enriched as never before, emerge into the light with the animation of life itself. From the darkness of things felt, instinct takes voice and speaks to the eyes. This power to depict the indefinable grew in Rubens until every sense experience assumed color and shape. Nothing is translated, all is transformed, converted into outer reality.

In actual life, sensations, feelings, and mental pictures are scattered; in Rubens' work they are fused, subtilely and with a consummate art. Plato's Ideas divest phenomena of their sensory aspect and sublimate them into noumena; Rubens invests noumena with a sensory reality and projects them as phenomena.

Certain critics condemn him for his sensuality, while his admirers consider this secondary. Gifted with an acute sense of touch, sight, and hearing, Rubens welcomed sensations, whatever their source, and used them all as material for his creative power, giving visual form to intuition as well as to sensation. The conflict between body and soul never disturbed him, his erotic feelings united directly and naturally with his spirit. While there is in many Late Hellenistic and Baroque works a crude sensuality, Rubens shows no coarseness whatsoever, but a sensuality that transcends itself in form.

The theme of the Emotional Baroque Style—movement and change—is evident in Rubens, with the difference that his subject matter has its own field of energy and moves in and by it. Only in works such as *The Fall of the Damned*

—and there for good reasons—are figures represented at the mercy of some alien power.

Between the spaceless space of Byzantine art and the actual world, there is an unbridgeable gulf. The pictorial field in Rubens' work, while distinct from outer reality, is strangely familiar. The bit of landscape in *The Massacre of the Innocents* at Munich is decorative in character, but it is this very patch of sky and earth that relieves the horror of the scene, opening up a new horizon beyond the victims and their agony. The central figure of the woman, her empty arms crying out to heaven, is mild and harmonious in tone, color tempering and form emphasizing the power of the scene.

About a hundred years before philosophers conceived of substance as force, architects working in the Dynamic Baroque Style had, to a remarkable extent, concreted that idea. Almost all Baroque buildings are either in the Dynamic or the Rational, known as the Classical, the Academic Style, and only at the end of the period were these two trends reconciled in sculpture. In painting the styles were less extreme.

In the Early Italian Renaissance, and occasionally in Flemish paintings like those by the Master of Flémalle, space is completely occupied by objects and figures. As early as the beginning of the fifteenth century an entirely different conception of space was introduced by Van Eyck. He rendered it as a vista, with tones rather than lines. In the seventeenth century, Dutch painters still followed this technique while using mathematical perspective. Such

pictures lead the eye by gentle transitions from the fore-ground into an indefinite depth.

Space in this subtle way achieved an artistic validity be-yond that given it by the emphasizing of mathematical perspective. St. Augustine's story of the child trying to scoop up the sea with a spoon might be applied to those Italian painters who labored so hard to capture space.

A sense of boundlessness is given in many Dutch pic-tures of the Baroque period by the high skies and flat fields that reach on and on. The landscape shrinks as it recedes, but seems to keep on extending, never cramped, never blocked. This phenomenon can be explained neither by aerial perspective alone, nor by the gradation of color values, nor by the use of the straight horizontal line as a direct image of infinity; it is the result of all these to-gether.

The Dynamic Baroque Style suggests endless duration by a swift succession of forms. Those unpretentious Dutch pictures have an immeasurable spatial presence, remi-niscent of Spinoza's conception of Infinite Substance, wherein alone extension and consciousness unite. There space abides and light fluctuates.

In Kalf's paintings light enlivens the fruit and earthen-ware, in Vermeer's it gives a still-life quality to human figures. There is, in the Rijksmuseum, a picture of a stair-case without architectural interest, almost without color, in brown tones; yet far from being monotonous, it grips the beholder, its wooden steps and corners coming to life.

The insignificant acquires value by the play of light and shadow on those winding stairs. Clearly not the work of a great master, this picture shows what a modest painter can accomplish in such a style.

Dazzling effects were unduly admired in the Baroque period, artists of the Dynamic Style tending to regard the sensational as an end in itself. No one was wholly immune to virtuosity, Rembrandt included. In his early paintings it is the brilliant light effects that are important; in his late works the accent shifts and darkness becomes the essential. The central figure in the early version of *The Supper at Emmaus* is illumined, whereas in the later work Christ is enveloped in twilight, his form dim. A pale glimmer penetrates a window, indicating the group without defining it, and scarcely illumining the room. Christ is *there,* his presence made more real by the irreality of his form. In the *Christ at the Fountain* (Berlin) Christ is a shadow only, his outstretched hand ethereal. Again dimness exerts its inexplicable power, faintness suggesting strength, and pallor illumination.

The absurdity of the order of precedence and rank in the world is set forth in the painting of *Saul and David.* Iridescent colors and the metallic glow of Saul's robe light up the inner ruin of his face and somber gaze. He stares at nothing, lost in the void, wretched in his magnificence, while next to him David plays his harp happily in a realm of soft tones, absorbed by the music as by something miraculous. His childlike posture and simple red coat are

in keeping with his expression, while the discrepancy between Saul's resplendent robes and desolate face accentuates his state of mind.

At first, Rembrandt sought to transform the world by focusing light on the essential; later, disposing of light according to the world's values, he proved them void. In *The Night Watch* he had concentrated all radiance on the child, leaving the figures of the men, who had commissioned the painting, in darkness. His later works treat of the disparity between things as they look and things as they are. In the last *Self-Portrait* there is a weirdness in Rembrandt's expression that belies his apparent gaiety and the luster of his turban. Even Saul's wretched state is less disquieting than this laughter, this inverted contempt for the world. From that mask of mirth emerges uncalled for —the face of tragedy.

The deeper Rembrandt's feeling, the greater the stillness he rendered, until, in his last paintings, visible content is almost without form. Color alone communicates, a touch of color or a colorless shadow. The dark warmth of the formless calls, inviting response. Since time immemorial there has been a mysticism of the light, light having always signified a spiritual value, even when the doctrine was ignored. To Jakob Böhme darkness became the "birthgiving womb," and in Rembrandt's last pictures it is "the darkness that surpasses all light," the "divine obscurity," referred to by Dionysius the Areopagite, that constitutes the prime idiom, the sovereign expression.

"The last shall be the first" becomes with Rembrandt:

"The last are first," the light prevailing in the shadow, the darkness paling in the light.

Leonardo transmuted a sheet of paper into a universal space, while Rembrandt with a few strokes of his pen unfolded a landscape extending into measureless distance. One of his drawings (Metropolitan Museum), a memory, emerges like a dream into consciousness, though its spatial relationships are no different from those we know. The scene hovers, a mere breath, communicating an experience otherwise lost to all but the inner life. This is what stays when details have fled, this is recollection made visible. Sprung of man's inaccessible self, it is the essence of a lived hour.

The atmosphere of Northern landscapes does not make for sharp outlines, but rather for tonal relations. The bright light of the South separates objects distinctly, defining their volume and position, while distances are measurable with the naked eye. However, none of the great masters coming from the North to paint Italian landscapes stressed geometric delineation. Claude Lorrain sought lucidity of quite another kind.

Never a learned man, and with little or no mathematical training, he united clarity of mind with a developed capacity for seeing. According to Descartes, cognition and sense perception are two entirely separate spheres, cognition alone involving awareness. Were this true, sensation would be cut off from the conscious mind, and the world forever divided. The paintings of Claude Lorrain refute this view, presenting a clear fusion of cognition and sense

experience. Space is transfused with the mind's light, awareness quickened by things felt. The far-off background emanates a steady glow, clear, brilliant, and nowhere interrupted, that elucidates every object. Sight becomes insight, and it is by virtue of this further reality that the landscape gains meaning.

Velázquez, in his portraits of the royal children (Vienna) when they were still tiny, used a decorative style, bringing out their frail and natural charm by means of the formal design. Neither light nor motion is an essential factor. Dignified, almost stately of bearing, the Infanta makes her appearance; only her light-blond hair, dark eyes, and the black lace at her throat and wrists deviate from the delicately harmonized triad of gray, rose, and soft blue. Though without specific contours, all forms delimit each other. Be it a hand, a vase, or a dress, each thing has an aura, a space wherein color seems to breathe. The little princess has a flowerlike, almost elfin, quality, the total impression resulting from the contrast between the picture's reality and reality itself. The presentation is static in form, and this very immobility throws the smallest accent into relief. Velázquez's *Garden* picture in Madrid is bold and sparkling. Sunlight scatters from the leaves, dark and bright spots of color alternate, dispersing and setting forms in motion. In reproductions this method gives the effect of a snapshot, but in the original it is more like a tapestry.

Kant's statement that "art creates as nature does" holds true only with regard to the interaction of the formative

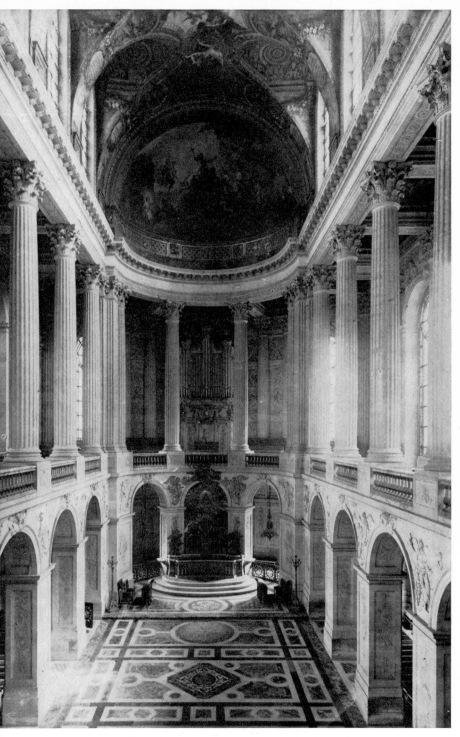

50 Hardouin-Mansart: Interior of Chapel
Versailles

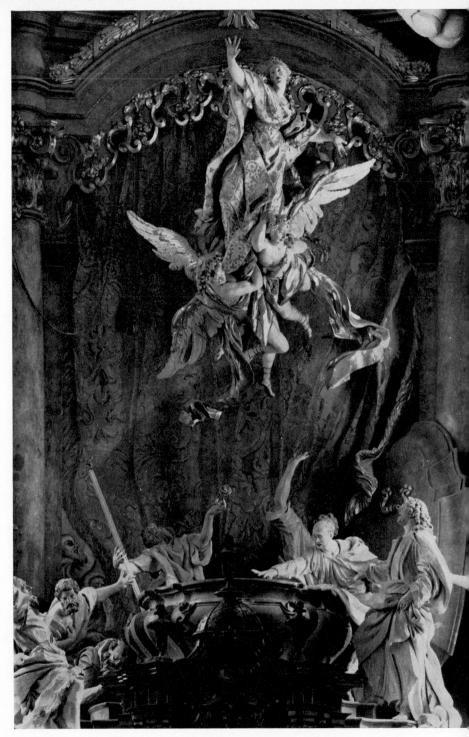

51 Asam: Ascension of Mary
Monastery Church, Rohr

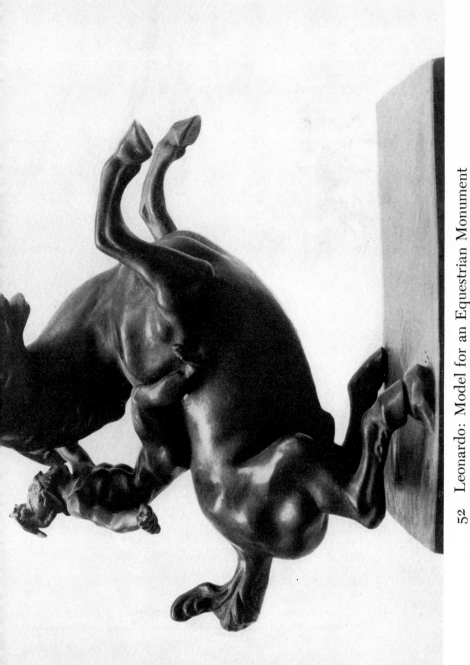

52 Leonardo: Model for an Equestrian Monument

Museum, Budapest

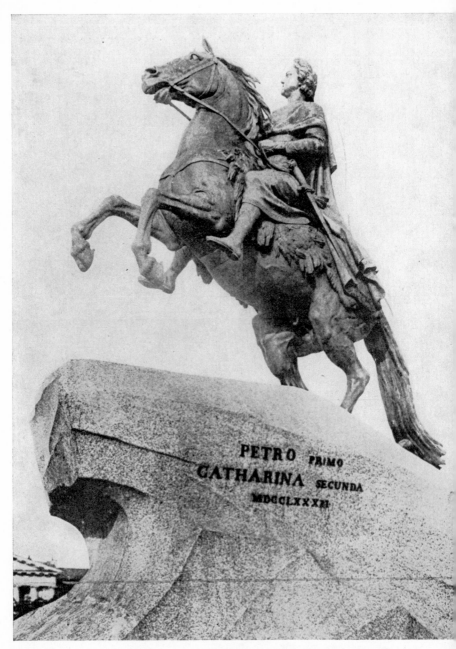

53 Falconet: Monument of Peter the Great

Leningrad

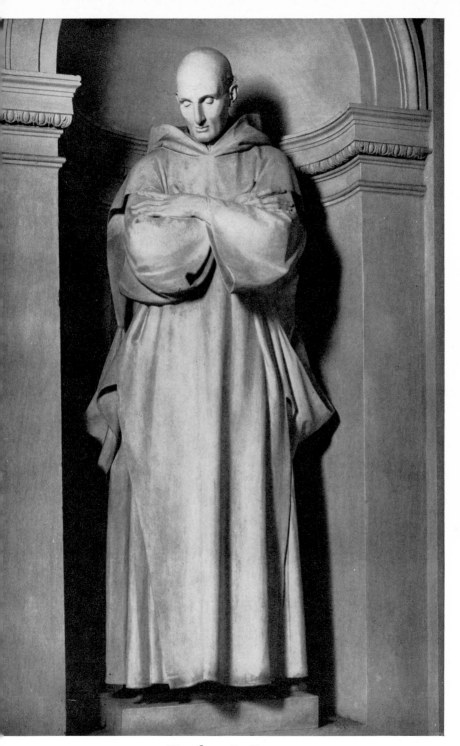

54 Houdon: St. Bruno

Santa Maria degli Angeli, Rome

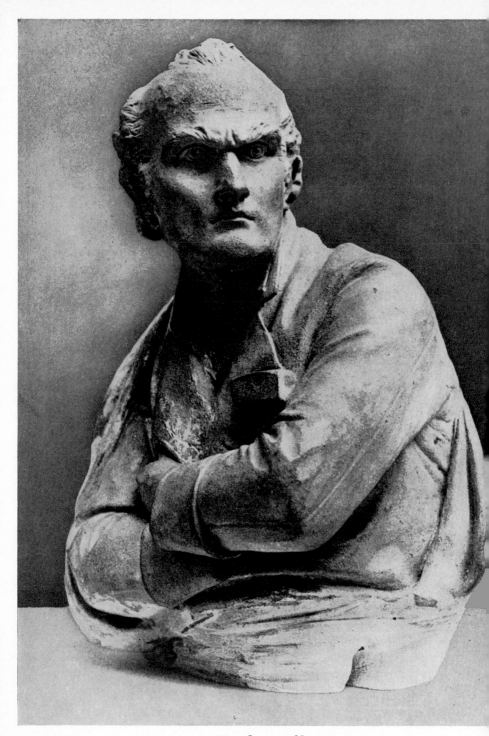

55 Houdon: Self-portrait
Formerly Perrin-Houdon Collection, Paris

56 Tintoretto: Carrying of St. Mark's Body
Academia, Venice

57 Rembrandt: Supper at Emmaus
Louvre, Paris

58 Rembrandt: Drawing

The Metropolitan Museum of Art, New York

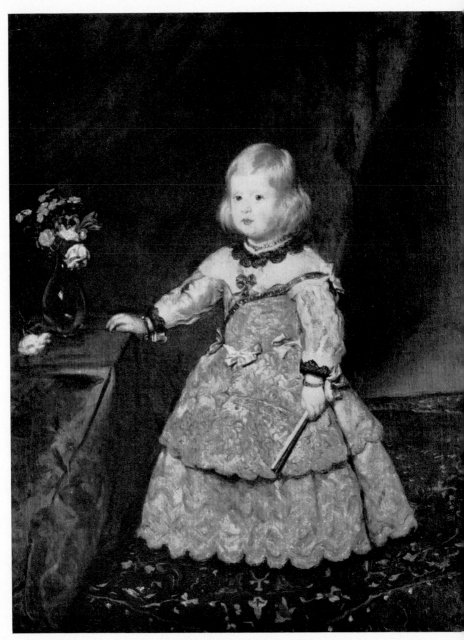

59 Velasquez: Little Princess
Kunstmuseum, Vienna

60 Guardi: Drawing

The Metropolitan Museum of Art, New York

61 Georges Michel: Landscape

62 Van Gogh: Starry Night

Museum of Modern Art, New York

63 Seurat: Fishing Fleet
Museum of Modern Art, New York

64 Picasso: Seated Woman

Callery Collection, Museum of Modern Art, New York

65 Brancusi: Bird in Space
Museum of Modern Art, New York

elements and forces involved in both. In all other respects, art and nature are fundamentally different. Though Gothic artists often rendered animals, foliage, and fruit with extraordinary accuracy, they arranged them as ornamental parts of an order remote from nature. In Baroque pictures, a natural effect was often given by the free adaptation of decorative forms.

Watteau's paintings involve shades of moods, sensations on the verge of being, which give an unreal quality to familiar scenes. In *The Embarkation for Cythera* the landscape is a dreamscape where cupids fly and a marble herma mingles with the human figures. Nothing preserves its shape, identity of form, or color, all contours dissolve, each tone escaping in a breath of colored wind. The lure of regions glimmering in the distance and the tranquillity of near-by trees are all there, held forever in the fleeting moment.

Decorative form follows a specific set of laws. Human figures and trees, landscape and sky, are insubstantial, fluid, yet each has a character of its own. Watteau suggests a new infinity—not the infinity at the vanishing point of parallel lines, but one at the place where fact and fantasy meet. In his paintings, even in his drawings, it is the color value that constitutes the form. His pictures are "photochrom" in that they seem painted not with pigments, but with the colors of light itself, wrested from the spectrum.

In Tiepolo's paintings the wind blows, clouds and garments billowing out like sails. He was the last painter in

the monumental Baroque Style, and his space has no limits.

Guardi's works appear playful when looked at closely, but from a distance are compelling. *The Conflagration* (a drawing in the Metropolitan Museum), if scrutinized, reveals only empty spots and meaningless scrawls. In the painting of *The Ladies' Concert* (Munich), figures whirl, the room vibrates, lights flicker—and all this as a result of disconnected patches of color. Form in this style has no relation to the ancient Greek or to any geometric standard; it is the archetype of a boundless vitality.

Fragonard lived on long after the frame of reference in which he was working was outdated. For him the value of a picture was determined by criteria other than the pragmatic, historic, or moralistic popular during the last decades of his life. He was not concerned with the Roman civic virtues so admired in his time, but with the limitless possibilities of the human being, the moment that is never wholly captured, and the eloquence of gesture. Be it a half-glimpsed profile, the surging folds of a dress, the branches of a tree or a curved ramp, everything in his work is instinct with life, antithetical elements all in accord. Not only in the *Vista of the Villa d'Este,* where the conical cypresses in the garden lend themselves to such a treatment, but in other paintings as well, he fused the formal with the natural order. Fragonard's art, an original and spontaneous creation, was firmly rooted in discipline, training, and tradition.

18

Art in the Nineteenth Century

The nineteenth century revolutionized the conditions of life and extended man's knowledge in time and space, but it failed to create a style in architecture and the applied arts. Only in painting can the true countenance of the period be recognized: the stress on individual views, even moods, the delight in the kaleidoscope of phenomena. Toward the end of the century a sharp turn was taken marking almost a break in the continuity of twenty-five hundred years of Western tradition.

THE vital link with the past, the lifeline of tradition itself, remained unbroken in Europe up to and throughout the eighteenth century. While the Gothic in Italy had been only an interlude, the Romanesque Style carried over into the Quattrocento; thus, the Renaissance was not so much a reversion to antiquity as a quickening on the way of a continuous development. In other countries Gothic forms lingered on, but with the Baroque period the Dynamic and Rational Styles became predominant in all Europe.

Around 1750, when J. F. Blondel was predicting the end of original styles, the term "style" still had a distinct meaning. With the turn of the century, however, the trappings of form were mistaken for form itself; Greek and Medieval art became the fashion, some claiming the Greek to be the

only valid standard for all times and purposes, others making a fetish of Medieval works. The continuity of tradition was broken, all styles came to be used indiscriminately, no new or total form arose, art lapsed into imitation and sterility. For the first time in the West no building, no piece of furniture, no utensil had any authentic character; yet, strangely enough, this lack went utterly unnoticed for a hundred years.

Individual artists were not inferior to their predecessors, but an architectural style is never the creation of one man alone. Architecture involves problems of load, thrust, and pressure, decisions as to the relation between the exterior and interior of a building; the way in which these problems are solved indicates man's conception of the social structure in his period, his responsibility toward society, his rights as an individual, and his notion of fulfillment—religious or secular.

How explain an age that would accept any or all past styles as adequate to man's immediate wants? The Enlightenment had postulated rationality as the highest good; the vogue of sentimentality involved no active concern whatever for life itself. Neither of these attitudes is conducive to the creating of a significant relation between the actual and the potential, matter and spirit. Hence, no style was possible. Buildings for all purposes were erected in imitation of ancient Greek temples. Quatremère de Quincy accused even the Academicians of not conforming strictly enough to rules. The fascination with the classical world and the longing for the Middle Ages were

merely different brands of the same romanticism. The individual still felt the tension between inner and outer reality, but as a private concern requiring no objective expression.

The spurious character of nineteenth-century architecture and applied art, when finally recognized, was blamed on the machine and mass production. However, it must have had a much deeper cause than that; style had been extinct when technology was in its infancy.

As science expanded, prehistory was studied, an investigation was made of countries hitherto unknown, the age of the earth and of geological periods was computed. All this and more man did and learned, but he remained strangely unaware of the revolutionary changes taking place within himself. Everything around him, everything he did, gave evidence to a drastic rupture with the past. What really distinguished the present from former times was recognized as little as the difference between true form and the imitative form now evident in buildings and furniture. New inventions were so breathtaking that their consequences to man himself were scarcely noticed. At first only certain industries were upset when machines in a few hours manufactured products that up to then had required weeks of labor. Yet this involved the destruction of a tacit unit of measurement constant since time immemorial: a day's work. With the appearance of the steamship and the railroad the world was revolutionized at a stroke, and the human imagination lapsed into a new silence.

Since the invention of the wheel prior to recorded history, distance had been considered in terms of the time required to get from one place to another. The Pharaohs, Alexander, and Caesar traveled the same distance in the same time as Napoleon. In the nineteenth century speed was increased to such an extent that almost overnight man was cut off from the experience of what he was doing. Thus, the old conception not only of a day's work but of a day's journey was invalidated. Hitherto man had sought release from limitation in fantasy or in creative work; now he could obtain, with no effort on his part, an illusion of freedom through purely physical means.

Space and time are not only, as Kant defined them, "modes of perception," but also forms of the intuition. A work of art transports us into another space; music supersedes psychological time with its own inherent time. Thought reaches its goal in immeasurably less than a second, and the mind, harboring countless things, separate in space and time, presents them to us anywhere at any moment. Events that occurred thousands of years ago in remote regions can change our lives, steer us in new directions, rouse us to action, and alter the present. Faith opens vistas into the unknown, man's yearning for fulfillment drawing him from frontier to new frontier. All this which we call inner experience is incommensurable with the phenomenal world. Art, sprung of this very duality, acts as arbiter between subjective and objective reality.

The disparity between man's two worlds is not elimi-

nated by the conquest of space, or by communications that reach us with a speed greater than that of the earth's rotation, enabling us to know in our today what is happening to men elsewhere in their tomorrow. The gulf between the two worlds persists, though we hear records of voices long silent, see Eskimos in sleighs on the screen one moment and a lion hunt in Africa the next, or observe the imperceptible growth of plants and the motion of molecules by merely adjusting a lens. We may cover tremendous distances with dizzying speed and fail to add "one cubit to our stature," or, conversely, may never leave a particular place and be totally transformed.

Only creative action, Plato's *poiesis*, can unite the two worlds. In the nineteenth century this venerable truth was discarded; man fell into confusion at the very moment when he thought he saw clearly. Praxis had caught up with *poiesis*, fabrication and manipulation with creativity. Man's integrative faculty was not equal to the new situation. He welcomed each triumph of technology as a dream come true and imagined that this was fulfillment. It required less and less boldness to travel around the globe. Inventions followed one upon the other with incredible rapidity, satisfying ever more demands and creating new ones. What would once have constituted a miracle was now an everyday experience.

The creative imagination withdrew to a private world, no longer reshaping life or integrating various elements into a significant whole. No style now linked inner and outer reality; the void between, decked with accumula-

tions from the past, gaped wider and wider. Man's long-
ing expressed itself more as a mood than as a search, using
word, sound, and color but never the hard stuff of build-
ings.

Technology was apparently granting man's wishes one
by one, though leaving him vaguely dissatisfied. Accord-
ing to the theory of natural evolution, he was merely the
product of a process over which he had no control. Con-
sidered in these terms, man's distinction as a human being
lay primarily in a useless awareness of the unalterable.
With the secularization of the Messianic and Christian
ideas, progress became an inevitable, hence automatic,
improvement of civilization. Since such a millennium is a
mere question of time, man was relieved of the responsi-
bility of investing reality with meaning.

The painter no longer rendered mindscape; he gave a
picture poem of his own sensitivity, his own moods. In
the sixteenth century there had already been two radi-
cally different styles in painting, represented by Caravag-
gio and Carracci. Yet the contrast between these two is
less striking than that between Ingres and Delacroix in the
nineteenth century. The maxim *"Le style c'est l'homme
même"* might now read, *"Le style c'est l'individu même."*
With the passing of original form from architecture and
applied art, painting alone preserved a character of its
own, almost exclusively determined by the artist's per-
sonality.

In the pictures of Ingres, the lines secure the position
of each element. Color and form are static, figures in mo-

tion somehow stilled; everything is secure, in balance.

In Delacroix's paintings nothing is permanent, nothing remains in its place. Colors blaze or fade away, form is emotive, effervescent; everything suggests extension beyond itself. Delacroix's works are monumental in their color and movement. Akin to Rubens, he was virtually a Baroque painter in the grand manner, not an imitator; but he lacked the advantage of an architectural setting appropriate to his style.

Georges Michel, almost ignored from his own to the present day, is so reminiscent of Jacob Ruisdael, the Dutch artist, that one would almost think them contemporaries. He conformed to no fashion and joined no group; his landscapes are neither Italian, nor Greek, nor idyllic. Throughout his long life he painted Montmartre over and over again, a rather barren, sparsely populated place at that time. His pictures for the most part are variations on a single tone. Hardly ever does a human figure appear or a patch of color animate the scenery. Yet the landscape, unimpressive in itself, becomes dramatic, darkened in places or caught in a rush of light. Nature, with Michel, has a look of destiny, impersonal, unfathomed as man's fate.

Nature, to the painters of the Barbizon School, had a familiar face. Their works can be identified by the species of trees and the time of day represented. Théodore Rousseau had a predilection for oaks and sunsets, Diaz for white birches and the midday sun in the woods, Corot for poplars with their silvery foliage and for still, misty

mornings. Each reveals his personal style in his manner of treatment and the tone of his color; each, acting as interpreter, makes nature his looking glass. Corot's early pictures are structural in form; later he painted the atmosphere, dissolving line and volume. Form passes into the formless, air remains the vital element, the breath of the world.

This affinity of man to nature is evident in all the landscapes of the Barbizon School, be they fused in a shimmering haze, clearly outlined as in Rousseau, or brightly lit as in Diaz. Formerly, landscapes had been represented at a distance, but with these masters, the woods, the ponds, and the fields became friendly, familiar. To the question, "Where are we going?," the poet Novalis had answered, "Homeward." With the Barbizon painters, home is assumed, there is nowhere to go, no question to ask. Something has passed from the world.

Turner, who began by adopting Claude Lorrain's treatment of light, was the first to paint the sun's glare, his forms dissolving in a dazzling haze. This method was later used by some of the Impressionists, to whom phenomena and nothing else were the objective. They never tired of catching the transient aspect of things; appearance had become truth, and method after method was invented to render it. Although their own feelings went into their work, they wanted only to paint what was there. In the very act of revolting, they were still linked with form.

For Manet the world was a problem in aesthetics, not

one to come to grips with, but one on which to reflect. This puts a certain distance between his paintings and the spectator, the same that existed between him and nature. He painted in such a way as to make his pictures depthless in terms of ordinary depth and spaceless in terms of the space we know; notwithstanding their remoteness, their almost proud reserve, they crowd the eyes as if too close to permit of scrutiny. In no way imitative, his art is a subtle response to the visible world. His brush must have been set in motion by the mere presence of flowers, skimming the canvas with their hues and painting fragrance as substance. These flower pictures are not so much impressions, as *impromptus;* they have a decorative quality in keeping with an old and specifically French tradition. But with Manet what had once been a craft became art.

In the works of Seurat color, applied staccato, crystallizes into simple general forms. This mosaiclike technique, which Seurat justified in terms of optics, may be somewhat cerebral, but through it light becomes vibrant, transparent. In Byzantine mosaics fragments combined into a whole, the form emerging from a patchwork of shards as an indisputable vision. Seurat through his pictures interrogates phenomena. Are they mirage, nothing but air in motion? Have they no consistency? His dots, scattered, gather again, giving subtle shape to a diffusely lit world. Something once more emanates through the apparent, the given; Impressionism has come to an end.

The Impressionists had freed painting from merely con-

ventional form and returned it to the living source of
experience, rendering the slightest color variations with
boldness and sensitivity. Living through their eyes and
devoted to the myriad phases of nature, which they un-
folded in ever-new ways, they moved with assurance
through the world of things seen. Were life what it ap-
pears to be, the Impressionists could be said to have
caught it.

While William Morris and Walter Crane were trying to
re-evoke some feeling for form by means of applied art
and various crafts, Hans von Marées was striving for a
monumental style in painting. The cardinal dimensions,
clearly set forth in volume and depth, provide for the
position and bearing of his figures. Though dedicated to
the problem: can painting give man his true image?—
Hans von Marées could not solve it, the prerequisites for
representative art being nonexistent. Monumental form is
possible in a panel picture as well as in a mural, but in the
nineteenth century it was out of place anywhere, and the
artist who attempted to create it was bound to fail. Iso-
lated in his efforts to re-establish basic values and demon-
strate new principles of form, this painter, unlike his
contemporaries, was primarily concerned with the perma-
nence underlying appearance.

Hans von Marées sought for a general unifying order;
van Gogh aimed at the essence of each particular. This
essence he saw everywhere, in trivia no less than in hu-
man faces. Painting out of his own sentient depth, he

imparted feeling to all the sober formal elements of his pictures until they spoke. Stressing the intrinsic nature of each object by means of outline and color, he defined, confined, delimited, and separated it from others. Everything in his pictures, however bent on relationship, remains utterly insular. No single form has composure, each stirs in its contour, alive and vibrant. Colors clash without transition, without compromise; each element is naked, alone, cut off from its neighbors, exposed as in a desert or frightened back into itself. In each successive work this stark isolation and van Gogh's desperate attempt to overcome it increase. Exertion thus thwarted becomes compulsive. The solution, never to be gained by violence, is violently sought, and this tremendous tension strains the contour, upsets the design, and imperils all stability. In his last pictures everything is out of joint, clouds and stars are sucked into the whirlpool, the whole of creation is ablaze with an anguish attesting to man's extremity. All things, created or man-made—a tree, a chair, a shoe—cry their forlornness. Unable to master or bear his life's vision any longer, the artist throws it into a stark light so that God may have mercy on this world.

In one of his early works van Gogh painted grass naturally, each blade akin to the rest. Man, though not represented, has a share in that scene, the grass being rendered as if viewed by someone lying on the ground. Later, his plants seem to struggle for space; flowers no longer bloom simply, they brace themselves, rigid of outline, or explode, glaring suns in the void. Everything in his

work aspires to relation, everything is self-imprisoned. Longing breaks forth as a conflagration in its attempt to leap the abyss. There is no completion, no fulfillment, nothing common to all save misery.

Were these works solely the evidence of a mental derangement, then some vital, integrated form should be apparent in the paintings of others. This, however, is not the case. As if fated to signal self-estrangement, van Gogh stood witness to man's split infinity.

Gauguin had another attitude toward life and the world; shunning civilization, he adhered nonetheless to the French decorative tradition. Space in his pictures is organized by means of color and remains two-dimensional no matter how marked the perspective; like a patterned carpet, it consists of an interplay of colors and surfaces. The human figures in these pictures are dull and inert, all vital expression limited to animals and plants. Roots grip the earth, trees rise steeply or bend, flowers lift or droop under their own weight, a horse inclines its head in a noble curve. All have their own gesture, all are alive. Clothes are bright, their red tones vocal; only man appears cramped or sluggish. Gauguin fled civilization to live a natural life. His paintings show what he found: man, a prey to anxiety, in conflict with his environment and himself. The return to primitivity solves nothing; man moves from being a stranger among men to being an alien amid nature.

Cézanne's art, remote from such discrepancies, is highly integrated, composed of many-colored, two-dimensional

forms. There is in his pictures an energy, an ever-renewed tension, caused by the meeting as well as the merging of refractory elements. Like blocks in a cyclopean wall, surfaces support and fit into each other, despite their irregular shapes; as in mosaics and gobelins, the difference between textures is ignored in the design, people and landscapes presented in a matter-of-fact way. This cool objectivity is particularly striking in Cézanne's portraits. Human figures and inanimate things, their value purely pictorial, are treated as objects of the same order.

This method of reducing heterogeneous elements to a common denominator initiated a new form in painting. Cézanne, like St. Augustine, stood on the threshold between two epochs. While he was the first to give artistic expression to a new attitude in man, his style is still linked to the Western tradition. Sometimes his work looks as if he had taken a sepia sketch by Poussin—a landscape with nude figures, for instance—and made it into a painting, strangely changed and structural. Poussin used his drawings as studies for a work that, completed, suggests a world in a sector. Cézanne made of trees and organic figures merely structural elements in a pattern of planes and lines. Poussin, when painting, sacrificed clear contours in favor of inner relationships. Cézanne's paintings are as concise as his sketches; from first to last everything is determined. Careless as they appear, his sketches are monumental in form; all his works are compelling, their effect often given by a few strokes or touches of color.

The painting from the Callery Collection in the Museum

of Modern Art is more a segment than the cross-section of a view. A tangle of branches and boughs against a background of vague tints, it is actually the decorative element in the picture that is fascinating and constitutes the real subject matter.

Though the Impressionists had adopted a purely optical approach to nature, it was not until Cézanne that a real turning point was reached. Gauguin fled to the primitives and, once among them, painted in a refined, somewhat sophisticated manner; Cézanne searched the old masters for a basic principle, which he then abstracted and set forth anew; with him Western art came to a pause on its more than two-thousand-year road, returned to its source, and began again in another direction.

The Greeks had achieved a mutual relation between the geometric and the organic, thereby indicating an order sovereign to both. Cézanne, struck by the geometric above all, used it as a neutralizer equating the animate and the inanimate. The dark outlines in his paintings not only define figures but trace the forces operating within a field, as the term "field" is used in physics. His pictures could almost serve as illustrations of Ernst Mach's thesis: "the will is not essentially different from the pressure exerted by a stone on the place where it lies."

Kant, in an early essay, reduced all save the living organism to two fundamental forces: attraction and repulsion. With Cézanne the organic, man included, is represented as part of an order identical throughout. He based his designs on distinctions between simple forms, thereby

according with Francis Bacon's scientific theory that form results from the difference between simple elements. Thus, form even in art was now regarded as a property of matter.

Mathematics had always played an important role in Western art, but hitherto had possessed an ideational character. The Egyptian pyramids, in terms of structure, represent the mathematical norm. In the Egyptian statue the human figure was geometrically delimited from without, and it was this relation, not yet reciprocal, between the organic and the inorganic that initiated the theme of Western art.

With the *Hera of Samos* the two orders became interdependent. The body vitalizes the geometric type, which in turn incorporates the human form into a deathless order. All subsequent styles in the West, however unlike the Greek they may seem, descend from this union. The dispute between nominalism and realism that once stirred the medieval mind continued uninterrupted in art, solved over and over again, each time differently. Though the relation between organic and geometric form varied, it remained unbroken. The fusion of rhythm and meter is manifest in Leonardo's statuette of the *Whirling Horse* and in his sketch of *The Battle of Ensigns*. The basic assumption and credo of the Western mind was the ultimate oneness of spontaneity and law in terms of a higher reality. With the Baroque period these two became mutually exclusive: spontaneity, cut off from the directive principle, veered into impulse, reaction, and tyranny; law,

similarly isolated, stopped with itself and lapsed into a formula.

The purely aesthetic approach already current in the eighteenth century threatened, with the Impressionists, to supplant all others; the ever-increasing emphasis on environment led to a conception of form as a kind of reflex action to history rather than as a manifestation of man's intrinsically creative being.

Identifying progress with improvement, people assumed that art would evolve automatically with everything else. Van Gogh's paintings could not but shock a public so complacent, while very few—and those for the most part artists—recognized the significance of Cézanne's work. The geometric order, which, in conjunction with the organic, had always stood for the idea of a higher law in Western art, became with Cézanne a masterly exposition of the forces at work in matter: attraction and repulsion.

19

Art in the Twentieth Century

Lacking an encompassing style, yet wrestling to find its own artistic idiom, the twentieth century has shown so far a plurality of incongruous modes and attitudes. Merely functional or else obscure, if not chaotic, the veracity in today's art may clear the way to a new orientation, a new integration of outer and inner reality.

T HE phrase "unity in diversity" was used in the eighteenth century to define the essence of a work of art. The term "unity" could apply to a pre-existing order, the term "diversity" to the myriad aspects of the phenomenal world. As a formula the phrase has little meaning, but substantiated as it was in Harmonics it becomes significant. Conflicts in this medium are stated, dissonance and tension voiced, harmony proving the result of a sustained creative act.

Most eighteenth-century theorists of aesthetics claimed that art should be pleasing above all, others that it should render the salient characteristics of reality. Both points of view stem from the Baroque period with its two distinct styles. The Rational Baroque achieved "unity" by the use of regular geometric figures; the Emotional Baroque expressed "diversity," taking change as the prime characteristic of life. Although the effect of motion took precedence

over every static form in the Dynamic Baroque, this in itself expresses a certain relationship between the contingent and the systematic; the Rational Baroque for its part still admitted of slight deviations from the rule. Thus, in both Baroque styles the theme of Western art endured, if only as an echo.

Nineteenth-century architecture and applied art lacked any real distinction; past forms were adopted, more as a fashion than as a genuine expression. Statues, aping life, became less and less alive, until sculpture no longer presented a true image of man.

While the passing away of original styles in the eighteenth century was scarcely noticed and never explained, the reawakening of a sense of form at the end of the nineteenth century was felt everywhere. Cézanne having marked a turning point in painting, architects and craftsmen now attempted to create a new style in their own right, *ex nihilo*. The *art nouveau* movement or *Jugendstil* —as startling in its effect as it was unoriginal in structure —was short-lived; the important thing now was to establish a sound principle for the designing of houses and furniture. Half a century earlier, Karl Boetticher, in his *Tektonik der Hellenen*, had stressed the relation between the classic architectural style and the building materials and methods of ancient Greece. Since his time, the connection between the appearance of an edifice and its actual construction has been completely ignored. Architecture having thus degenerated, the ornate and the osten-

tatious supplanted the artistic. A return to structure was indispensable.

The demand for functional form was far from welcome in an era of spurious grandeur. The new structural principle, indeed, foreshadowed revolution, though its consequences could not then be foreseen. The Amsterdam Stock Exchange, built in 1896 by Berlage, was one of the first bold innovations. Almost universally ridiculed at the time, it now seems quite traditional and not at all out of keeping with its period.

This trend initiated by Berlage in architecture was later carried out in painting by Mondrian, whose functionalism lies in the purely objective relationship of line and color. There is no perspective in his pictures, yet they give the effect of superimposed levels, each color establishing its own particular surface. Purely two-dimensional in design, his work illustrates the mathematical definition of a plane while confuting that definition's absolute validity. Geometric figures—straight lines, dots, and squares—combine into a nonrepetitive pattern. The interrelationship of these simple types has an energy that makes the painting a fascinating event in abstract space. Every detail could be drawn with a ruler; creative tension is sustained by the interaction rather than the interplay of form and color. This complex of relationships follows no set system and cannot be computed mathematically.

Time and again Mondrian investigated the effect of combining primary colors and lines, his construction

almost presenting a grammar and syntax of planimetric art. He carried this method to its logical conclusion, any further use of it permitting only of variations or of its adaptation to other ends.

Baroque art has two faces, modern painting many, all of them unrelated. Mondrian adheres to a strictly objective abstract design; Kandinsky aims at the release of purely subjective stirrings, which, bypassing the conscious mind, result in their own images. Painting to him is the tracery of a mood, and so, according to him, is music, the response of harp strings to the wind's touch. Color playing like sound, his brush runs over the surface and produces *Improvisations*. In contrast to Mondrian's art, where the relating of line to color is definite, Kandinsky's is like a primeval utterance, or an ophthalmopoetic expression. It cannot be grasped, but a transfer of emotion takes place between the picture and the spectator, as when a silent instrument vibrates to another that is being tuned. A precise response is unnecessary, since a mood is of itself indistinct. Kandinsky's pictures appeal to feeling, Mondrian's to the intellect. Each has a separate sphere, their idioms have nothing in common, neither speaks to man as a whole. What was separation in the Baroque period becomes divorce in the twentieth century.

The various forms in modern art are incompatible. Not only is subject matter unimportant, but each artist has a different objective. Mondrian is concerned only with the relational values of line, color, and plane, Kandinsky with emotional atmospheric pressures. Matisse and Braque lean

to the decorative, but their conceptions of color and form with regard to detail and organization are entirely divergent.

Picasso during the thirties was concerned with the juxtaposition of several views in one and the same painting. In the *Portrait of a Woman* (1937) the space represented is an aggregate of spaces. Various phases of movement meet, crisscrossing and intersecting one another; contours and colored silhouettes are snatched up, comprised in broad strokes; the circular motion is continual and unmistakable. While its theme derives from the Dynamic Baroque, this picture gives an effect of even greater speed. Brilliantly executed, it does not necessitate any knowledge of the Minkowski and Einstein theories, nor is it better understood by referring it to a four-dimensional figure. The signifying of a space-time continuum would require a new and unparalleled form, a re-relation between the abstract and the experienced—a mindscape, in fact, that has not yet come into being.

Picasso's other *Portrait of a Woman* in the Gallery Collection, painted in 1938, consists of a geometric figure whose parts rotate like a windmill. The representation of a three-dimensional form, it appears to shoot out in all directions by centrifugal force. Only the mouth and eyes are rigid, this contrast of the swiftly spinning and the static producing an intentional incongruity.

Before achieving this effect, Picasso first established a certain coherence in his pictures, as shown by an earlier work, the *Girl Before a Mirror*, where two different views

are combined without the same discrepancy. Dark stripes, circles, and ellipses give a definiteness to the intricated pattern. Some parts of the body are accentuated, appearing independently and repeatedly, others are blurred or absent. The profile and front views are clearly rendered within the full swing of the outline, welded together in the drawing of eyes, nose, and mouth.

In the *Girl with a Cock*, painted a few years later, the colliding, completely discrepant eyes and nostrils given frontally in the profile involve several obviously incompatible aspects. Were this work merely a caricature, it would be a masterpiece of sarcasm; as a huge work, monumental if only in its size, it becomes an indictment of our age.

Many people reject modern art as schizophrenic, backing their claim by the fact that drawings by lunatics have been presented as works of art. Such a judgment is in reality an evasion; art forms are indispensable for the understanding of current human problems. If, however, as other critics hold, modern art merely reflected the contemporary scene, it would tell us little. It goes far beyond that. Art today presents man as an arena of events without coherence taking place at disconnected levels.

Picasso practices many kinds of styles and, thanks to his remarkable talent, is master of them all; Mondrian and Kandinsky contribute two mutually exclusive forms; Klee and Chagall present us candidly with dream faces and fairylike or fantastic combinations of images; Léger mechanizes human limbs and transforms them into iron

pipes, outstripping the modern trend of forcing every-thing organic and vital into a technical formula; Henry Moore's sculptures give the biography of bones and stones. Futurism needs no interpretation; Fascist in theme even before the outbreak of the First World War, it glorified violence for its own sake and ended in a brutal reality.

Confronted with these diverse artistic expressions, one finds that they have this in common: none of them suggests a greater whole, each has its own private or broken order.

What is actually at issue is not explicit. Every form is provisional and self-contradictory to the extreme, however logically it is defined and however remarkable its execution. Those works still in the groping stage are the most stirring, in that they suggest a further and still unexplored area. Modern art is unintentionally as roundabout in its course as Buddha when indicating the center of "true knowledge" by the rejection of analogy after analogy, at every point of the mind's periphery.

In sculpture human members often become their own matrixes: one breast may be fully molded, the other its hollow counterform. Thus, a figure consists as much in what is omitted as in what is there; material and immaterial form are treated as identical. Brancusi shapes the path of a bird without the bird, condensing its traceless flight into a piece of metal. Here is winged motion, not the creature that moves, but the *élan*, the soaring itself, convincingly rendered.

A work of art requires that the beholder refocus his

attention several times to grasp it. Its various aspects cannot be apprehended synoptically, nor do they unite into a new perspective. This makes modern pictures uninterpretable in terms of any one criterion; no point of reference exists. The art of former times did not necessitate so much switching on the part of the spectator; even primitive and exotic designs are less difficult to follow. Modern art holds a mirror to man's fragmented self; there he moves, a plurality of mutually incompatible realms, each of which has its own language, its own spatial system.

Operating with mathematical equations, man arrives at new conclusions, which he then confirms by experiment; neither conceptually nor visually can he embrace what he knows in the abstract. Scientific facts, computed and demonstrated, escape any clear formulation in terms other than mathematical. Identical causes under identical conditions produce, as has been proved, radically different effects. A mathematical formula describes convincingly and with an absolute precision what, in words, becomes an absurdity.

Man's feelings and desires have no relation to his daily work. He knows much about man but understands him less and less. Between his personal and his public life there is a gulf that nothing bridges. Anxious and cramped in private, he shuts himself off as a human being when with others. No place exists for him where all roads meet.

Formerly art served as a link between the inner and the

outer world, recalling man to himself with his own voice. Long before Plato expounded the doctrine of "participation" in the Idea, it had been given form in the art of ancient Greece. The Christian longing for revelation was fulfilled in the interior of Santa Sophia; the call made upon man to surmount himself was answered in the vaults of Saint-Front. The *praeambula gratiae* of St. Thomas was set forth in the Gothic cathedral, the relationship between the individual and the species rendered in those stained-glass windows, the cathedral spire rising as an indicator of the goal. Quercia made man whole, uniting soul and body in the sculptured figure; Leonardo drew a space for form to sleep and wake in; Rembrandt breathed a light into the dark and made it speak. The incomplete had sought completion, the imperfect struggled toward perfection, while motion had taken solid form to meet with man's desire.

For thousands of years man was sustained by a faith in his own inherent freedom, style after style attesting to it. Since Hellenic times he had believed in the spontaneity of the spirit. Should this faith die, creativity would vanish and no action bear fruit. Man turns destructive when he despairs of meaning.

Schönberg's compositions evolve between planes, magnetic fields, layers with nothing in common. The melody cannot be followed, but emerges again and again, supported by nothing, sustained nowhere, incessantly overlaid yet never undone, never annihilated. It is not con-

tained in the tonal relationships, it stands in relation to them; traversing them all, it is often submerged, often silent.

Today we have no artistic world in common, no mindscape. At one moment we are in the midst of a deafening confusion, at the next overwhelmed and paralyzed by the void. A breath of the still unborn reaches out to us. Whether it will come into the world, we do not know; the world itself is doubtful, all conceptions of the universe have dissolved, nothing is in its place.

Kafka conceives of the unknown solely as a source of terror; Mondrian and Kandinsky throw us about in incompatible realms; Picasso races us into ever-new systems, from period to period, from picture to picture, or from one part to another within the same painting. That which man's spirit is dying for lack of is not within sight. The void of which we are becoming more and more aware is Chaos, in the original sense of the word; according to the Greek myth, it precedes Kosmos. To say what waits to be formed would be to create it. The more man discovers and explores, the more he feels himself at the mercy of the elements, homeless and lost, the battleground of hostile powers.

In *The Eumenides* of Aeschylus, man breaks from the chain of wrong action; he no longer believes that one crime expiates another. A new era begins, and man's spirit, signified by Athena, frees man from the bonds of blood, from the fetters of merely animal kinship and clan obligation. An inner relationship between man and man is

recognized, though not yet inviolably valid for all. "Neither anarchy nor despotism" points not to a state between two evils, but to a new dimension opening a new world.

In a period when matter and energy are synonymous, when anything can be shaped by mechanical means, when the continuity of Western thought is broken—in such a period, the term "form" is inadequate. Form, as we know it in nature, results from the interaction of the tensions and responses inherent in any given object. Form, as we perceive it in art, results from a re-relating of those tensions and hence a transforming of the natural into a qualitatively different order, an order solely relevant to man.

The manner in which this is brought about in a work of art is as mysterious as the manner in which forces come into play in nature. No law exists, no system has been made by which an artistic form can be contrived or duplicated. It would seem that man's spirit alone can come to bear *significantly* upon that which exists, in a creative act that, uniting law and human aspiration, motions toward freedom. The absence of original form in our day suggests that man, his creativity in abeyance, stands self-severed from the source of his own being.

The cleavage between inner and outer reality, between the felt and the formulated world, the very abyss that confronts us today, is essentially the same as that to which Western art owes both its origin and its greatness.

The credo of the Western mind was the ultimate oneness of spontaneity and law in terms of a higher reality.